Beautiful Nude Women from the Orient

A Journey through colonial Northern Africa

Jürgen Prommersberger: A Journey through Colonial Northern Africa
Regenstauf , January 2016

All rights reserved:
Jürgen Prommersberger
Händelstr 17
93128 Regenstauf

First edition by
CreateSpace Independent Publishing Platform

Foreword

Slavery and "honor" in Islamic societies

Slaves had in Islamic societies officially no honor. The status as a slave meant, that they lived a separate life, which was different from the life and status of normal people in regard of kinship, family and religion. Once in enslavement, social norms, resulting from kinship or religion, were completely ignored. Slaves were exempted from all social rights, including the right over their own bodies and their own sexuality, but they were also exempted from obligations, constraints and responsibilities, which were part of the lives of the free individuals in the social community. This was particularly important for the social value "honor". Every free individual possessed honor, no matter if man or woman.

The existence of a term as "honor" therefore means, that there must be something on the opposite side like "shame". A shame arises always from the violation of a universal, social norm. It is less important to know whether this standard is codified as law or whether it is a social standard. As a slave, a man or a woman had officially no honor, therefore there was also nothing for which a slave would or could be ashamed of. Where there is no honor, there is also no shame.

A free Muslim woman was breaking these social rules of honor, if she left the house without her body being completely covered. If you look nowadays to Saudi Arabia, to Iran and also to other countries in the arab world, then you have to realize, that this „Law" is still in force and a woman can get into trouble, when she goes out without the so-called Burka (a clothing, which is covering a woman from the head to the toes completely). On the other hand, female slaves could go out as light clothed as they liked, because nudity in public was no official offence for a person who had no honour at all.

This illustrated book shows such women. Slaves, dancers, prostitutes, masseuses. All girls and women, who possessed in the eyes of the „normal" society no honor and had therefore no need to be ashamed of their nakedness, no matter if only topless or completely nude.

These photos were taken mostly from the former colonial territories of France. So mainly from Morocco, Algeria and Tunisia. The pictures date back tot he late 19th century until around the times of the first world war.

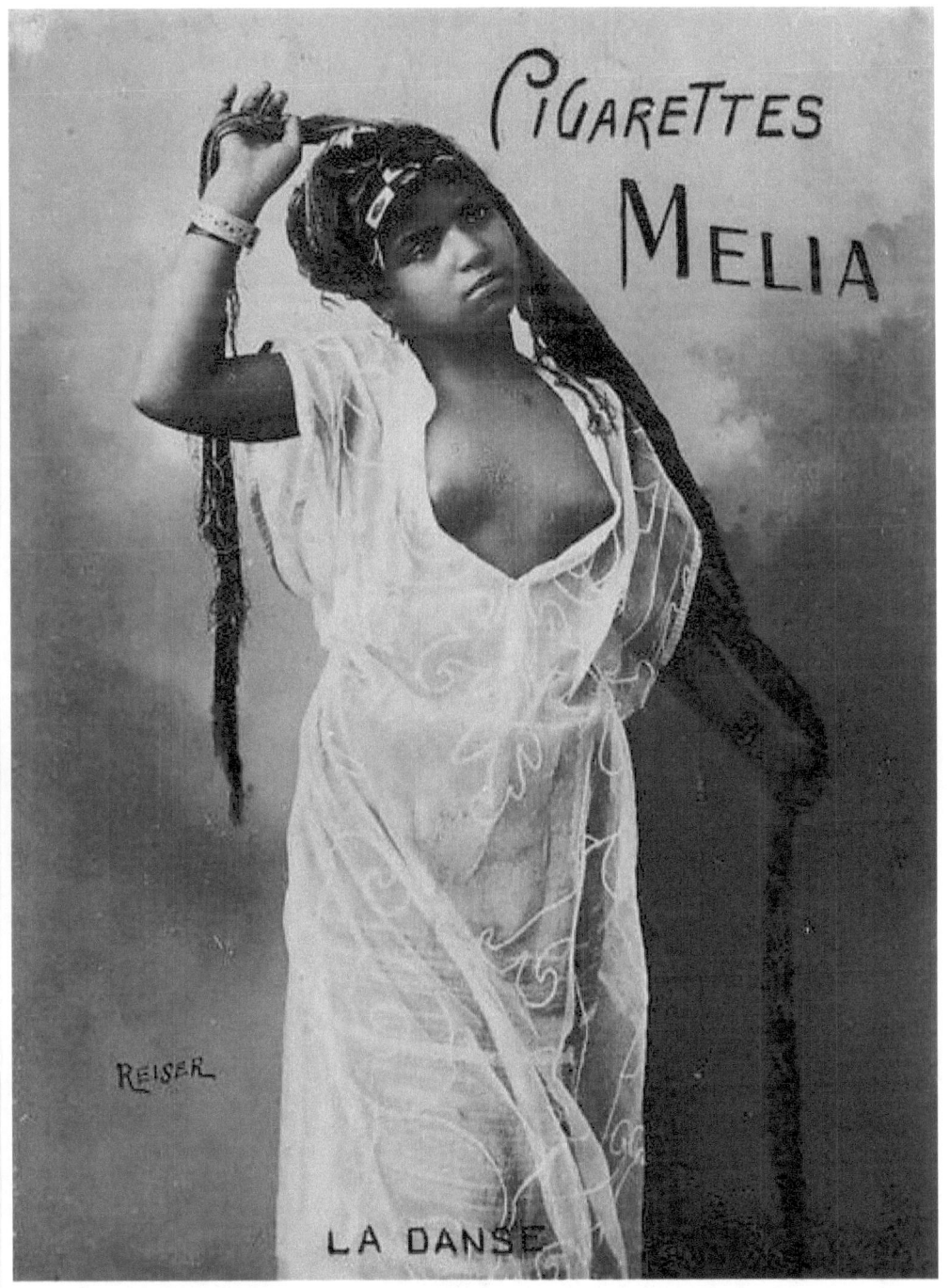

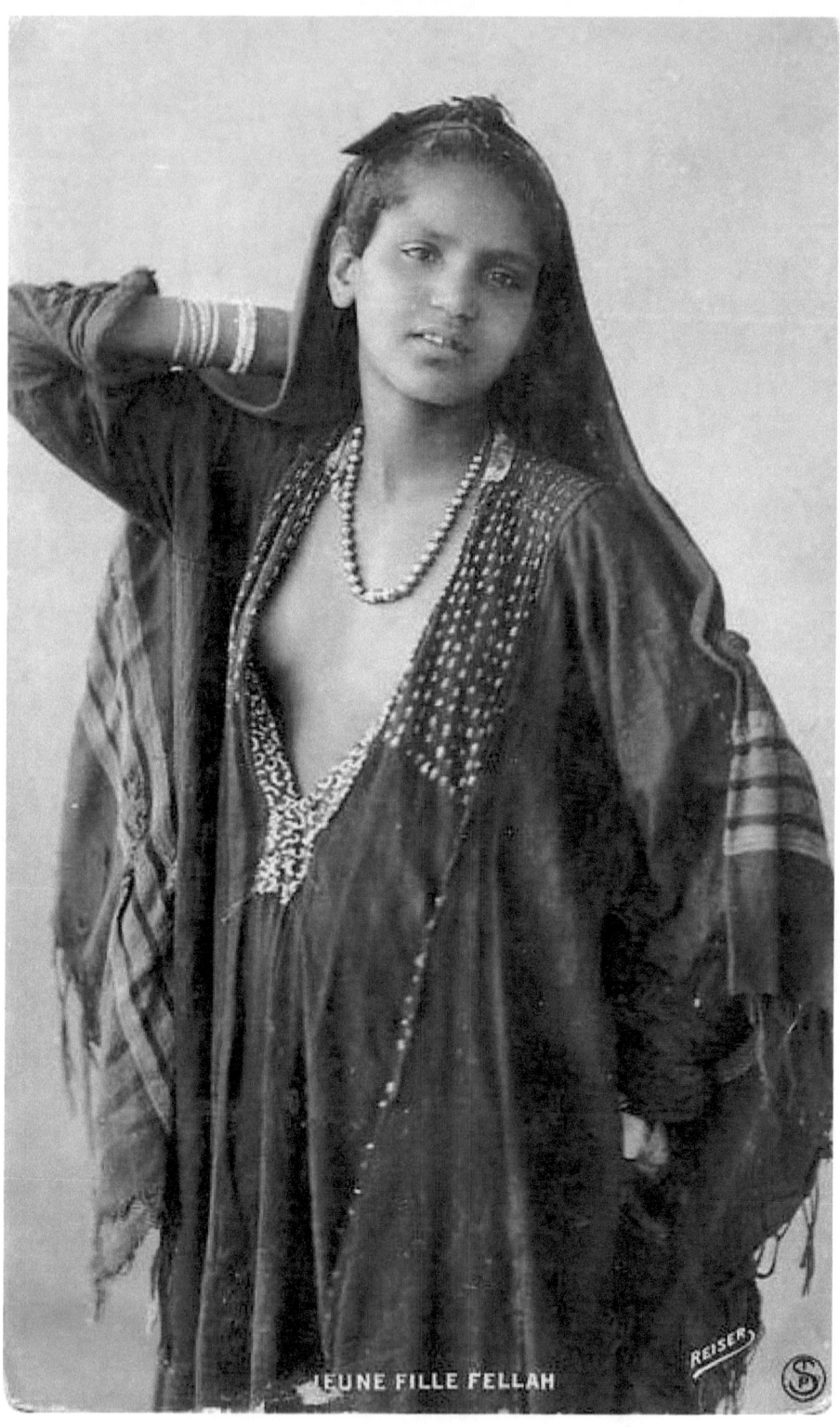

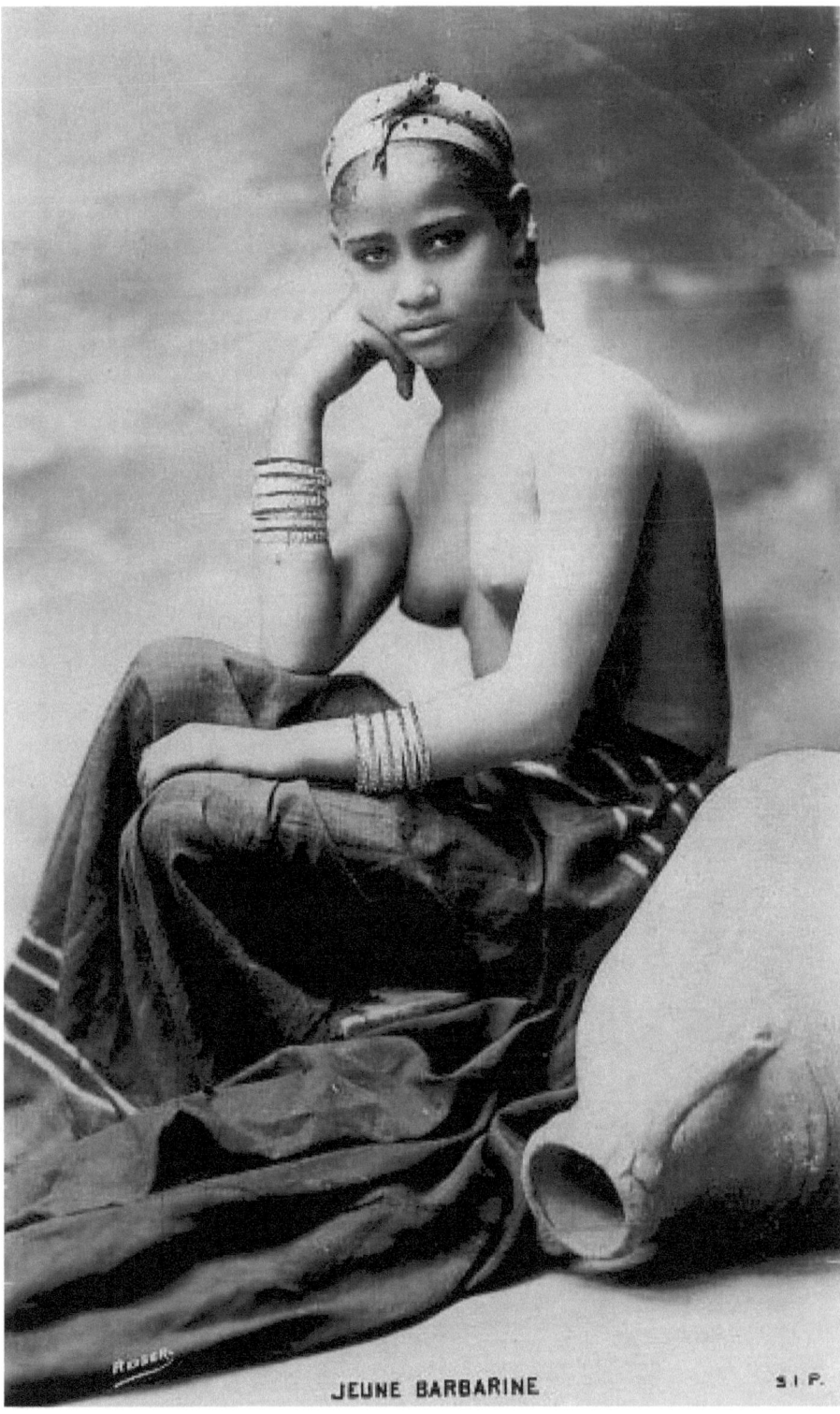

JEUNE BARBARINE

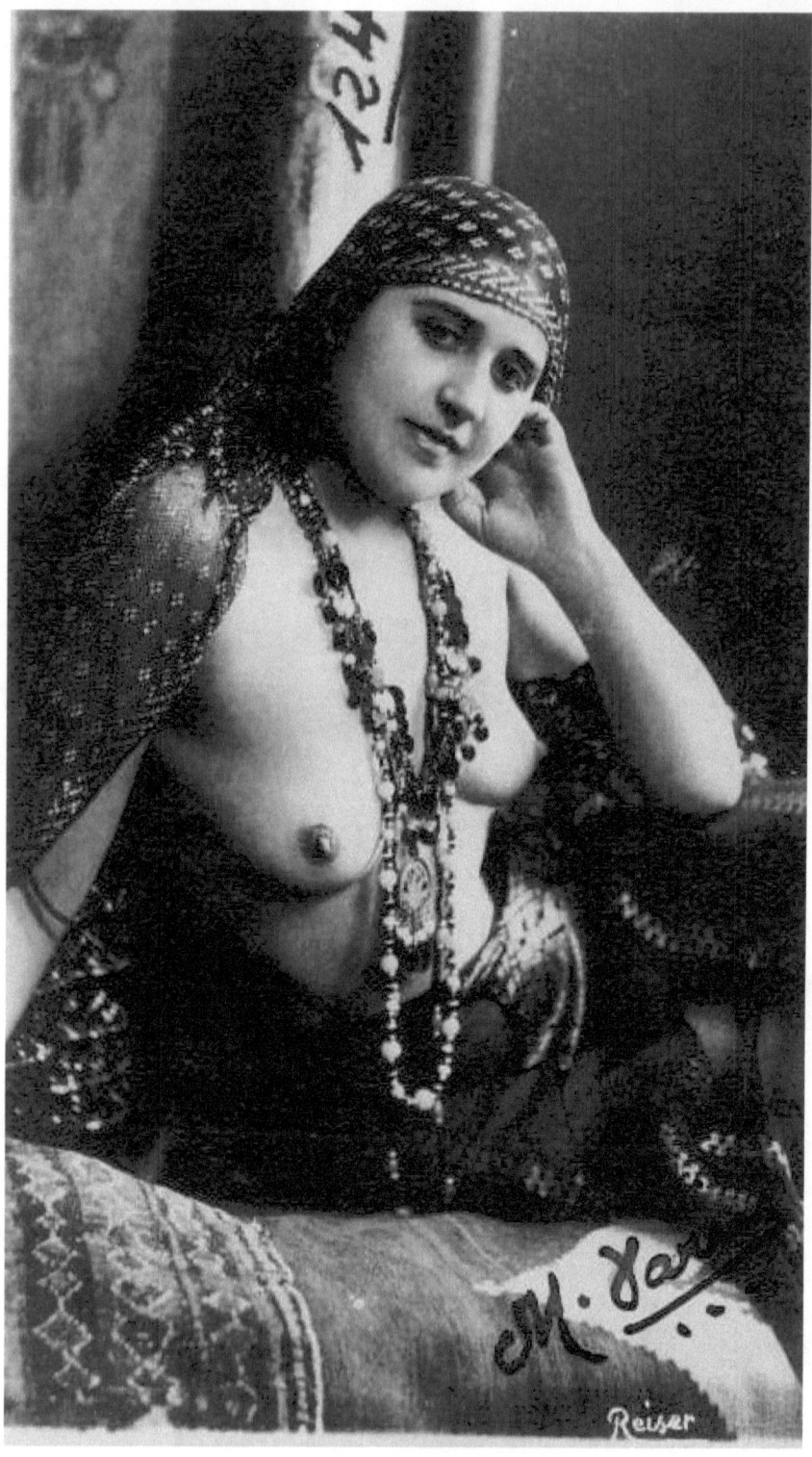

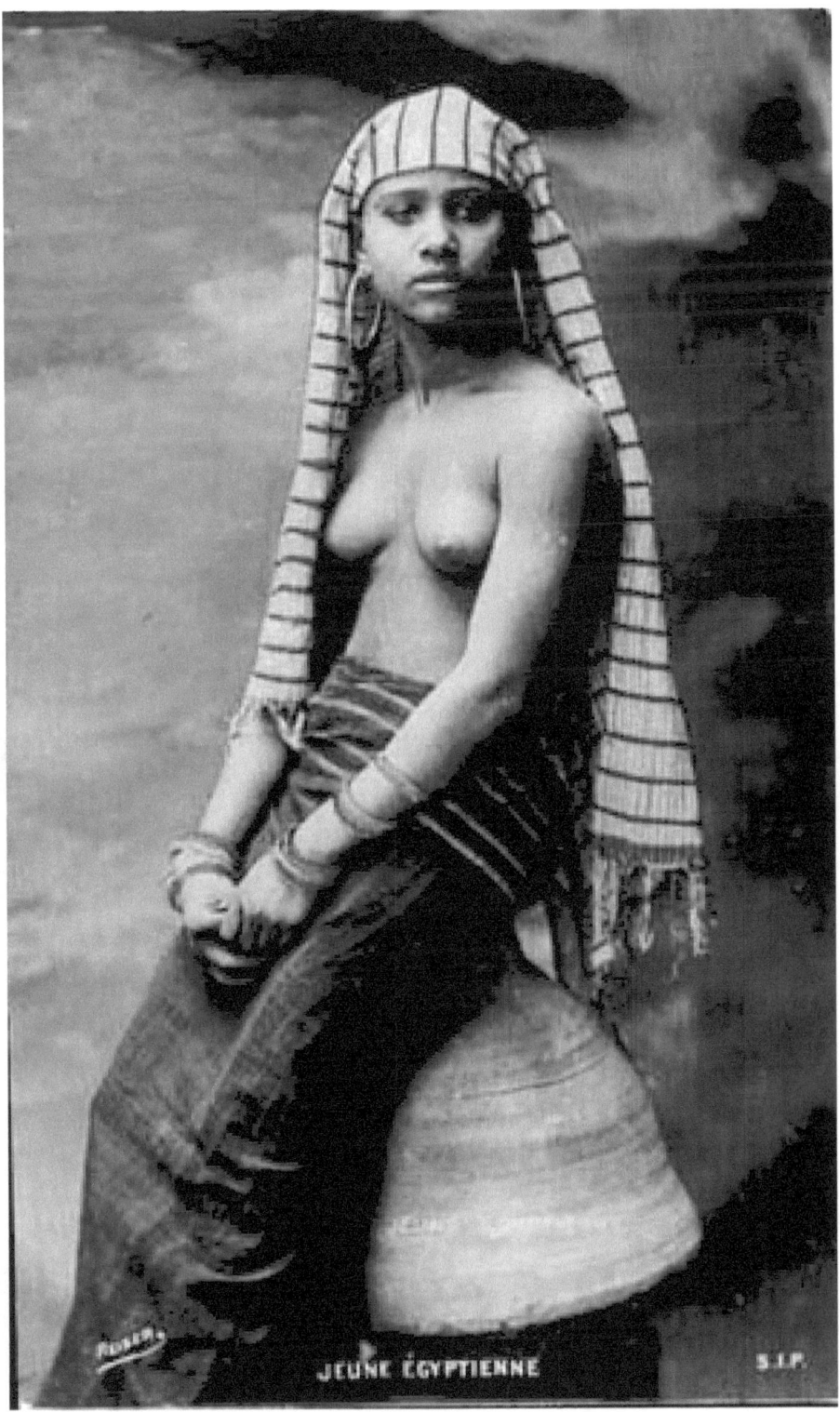

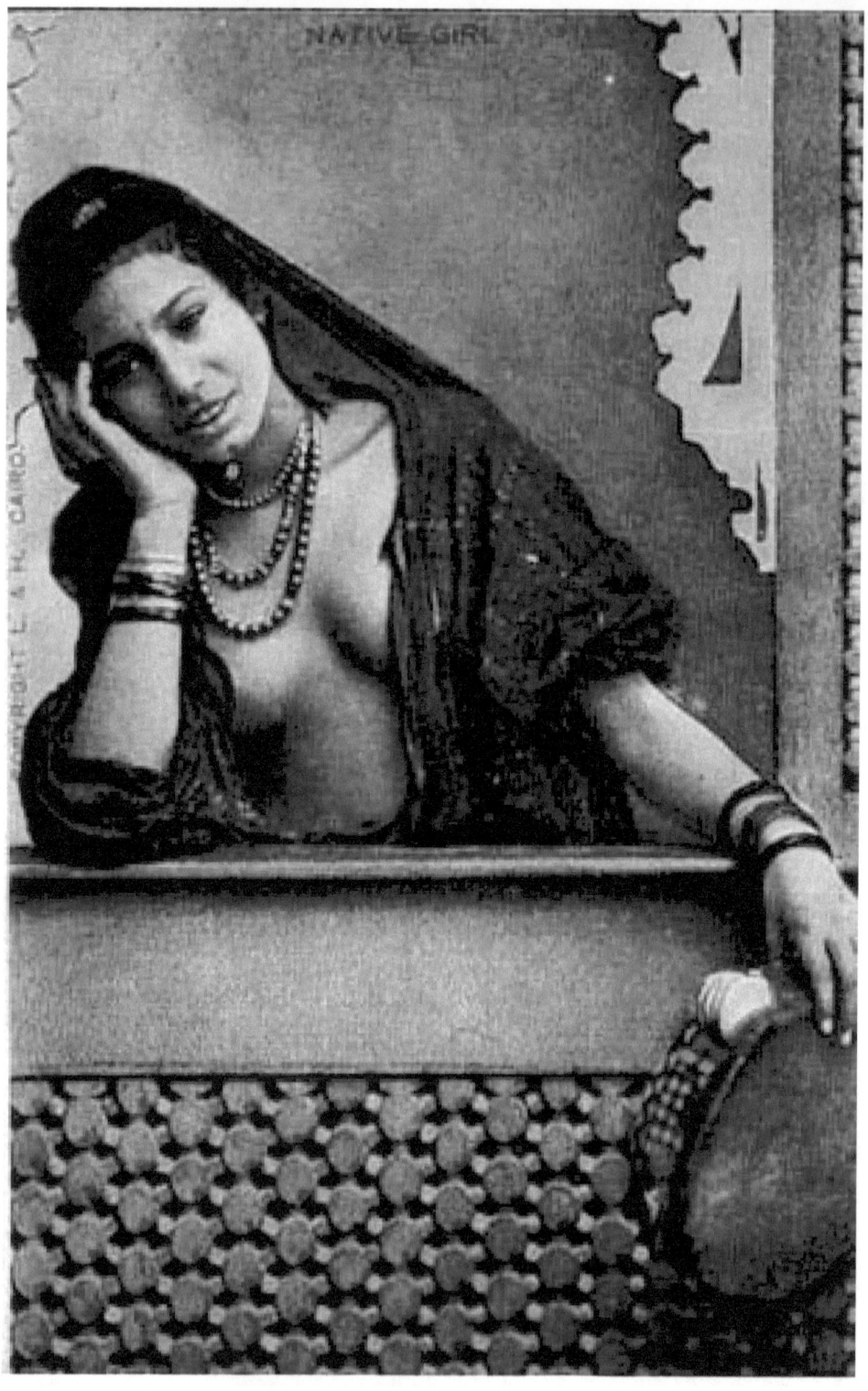

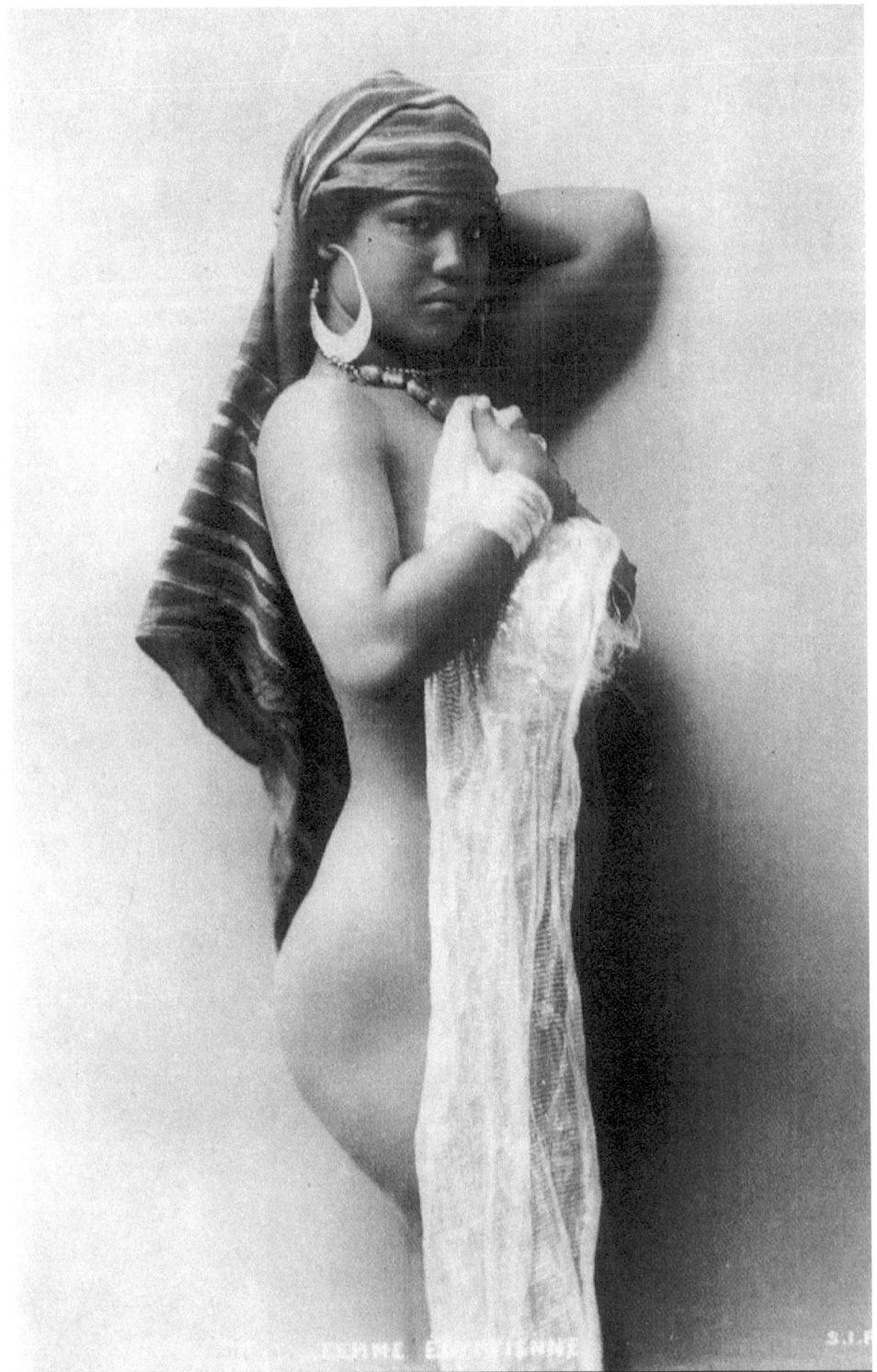

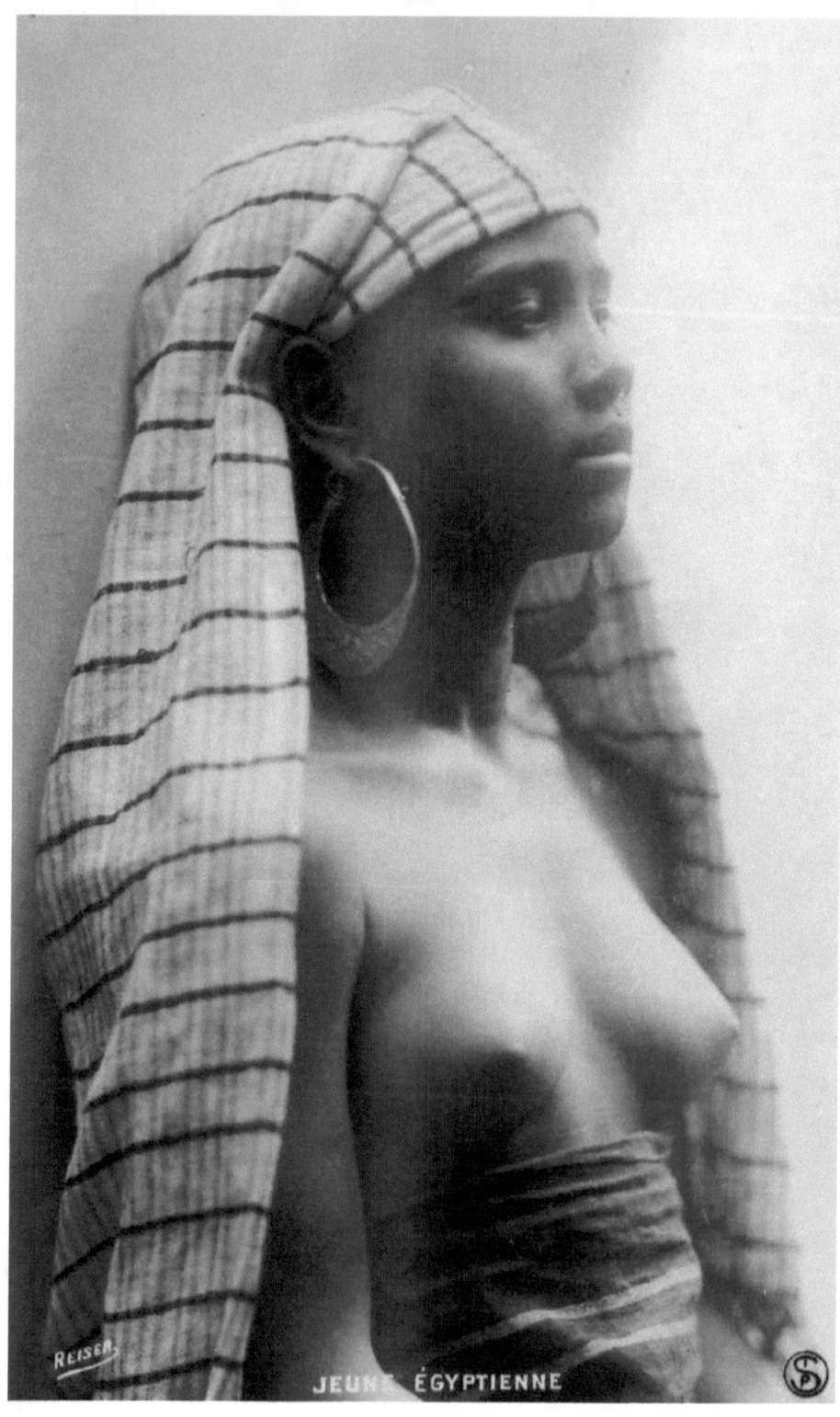

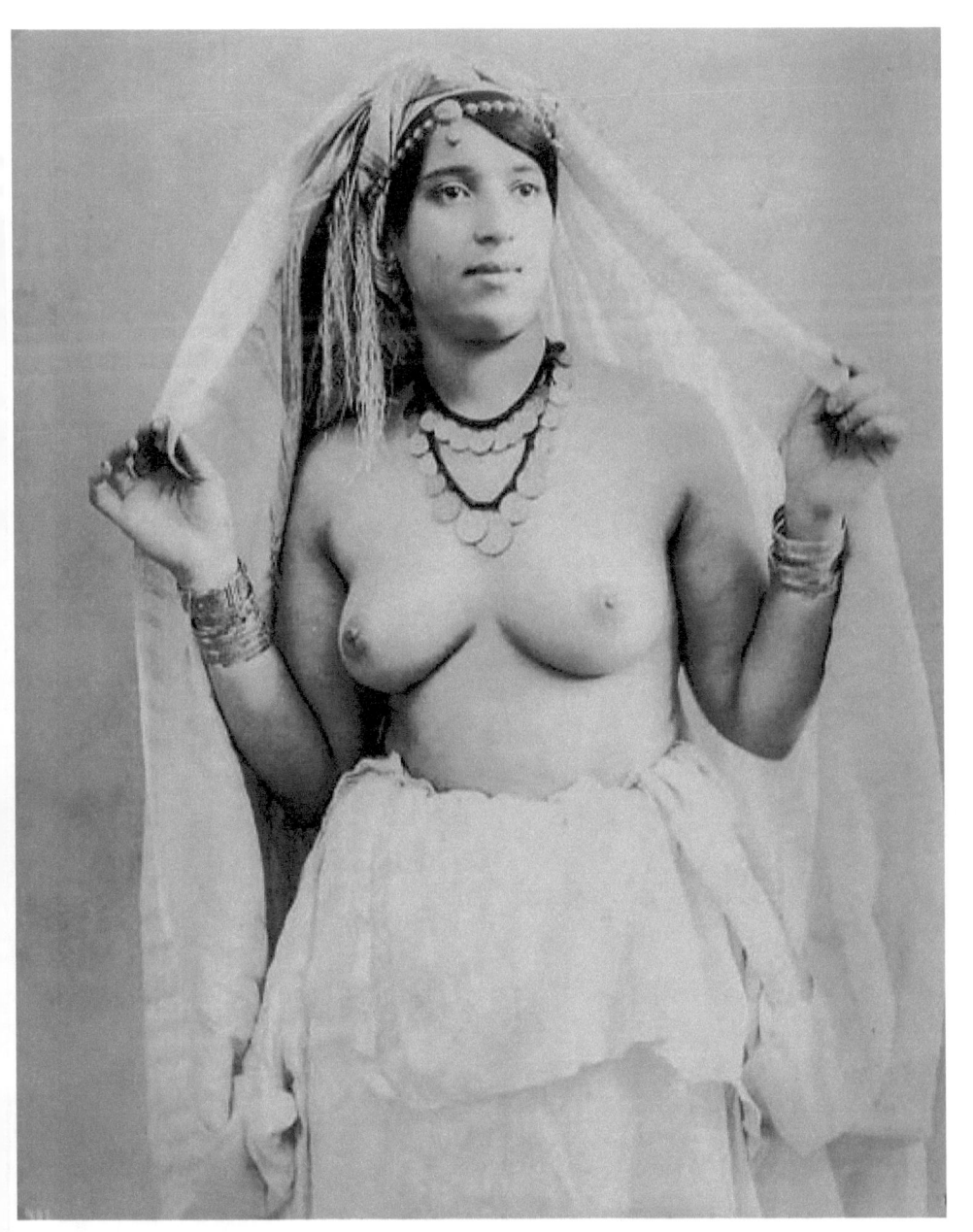

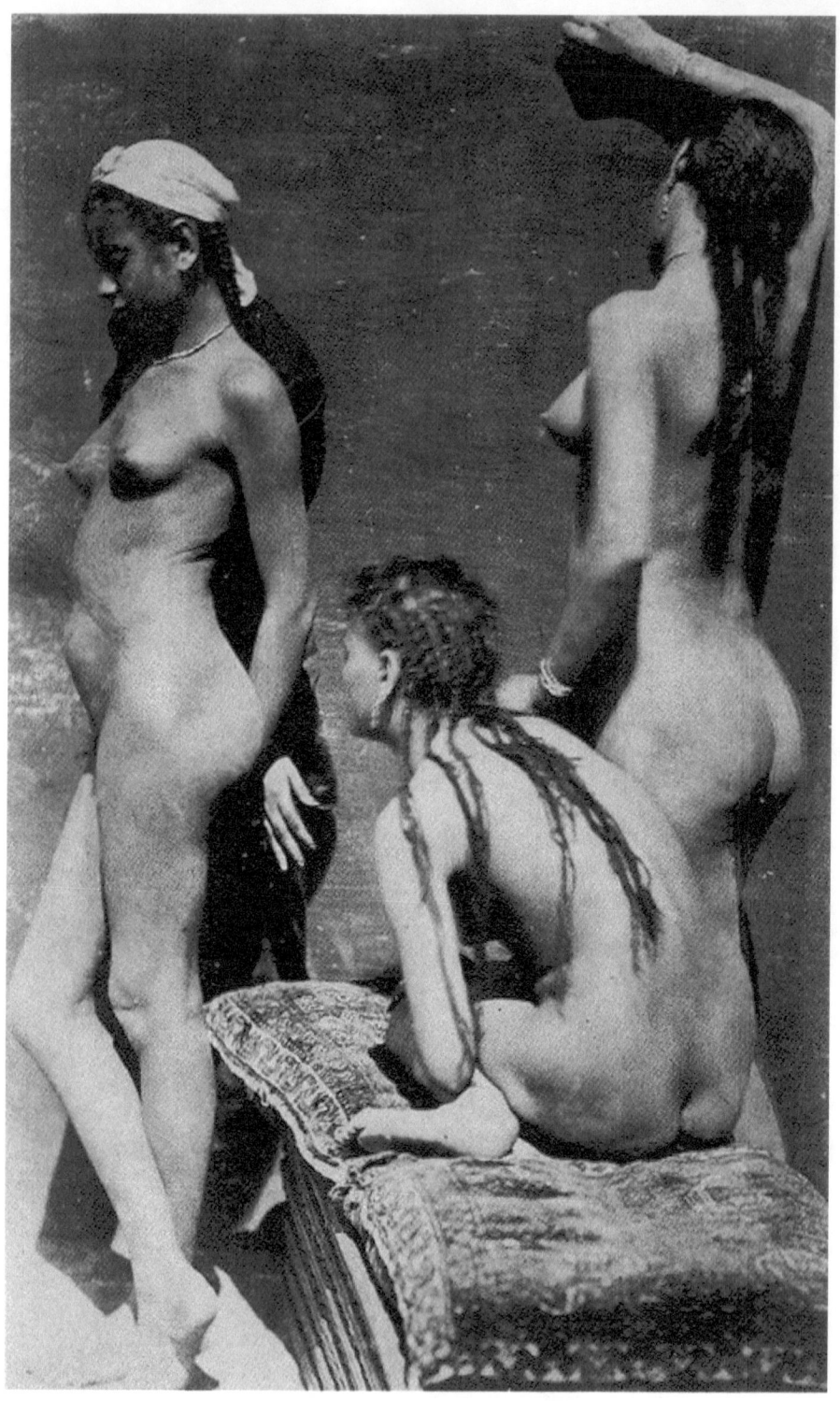

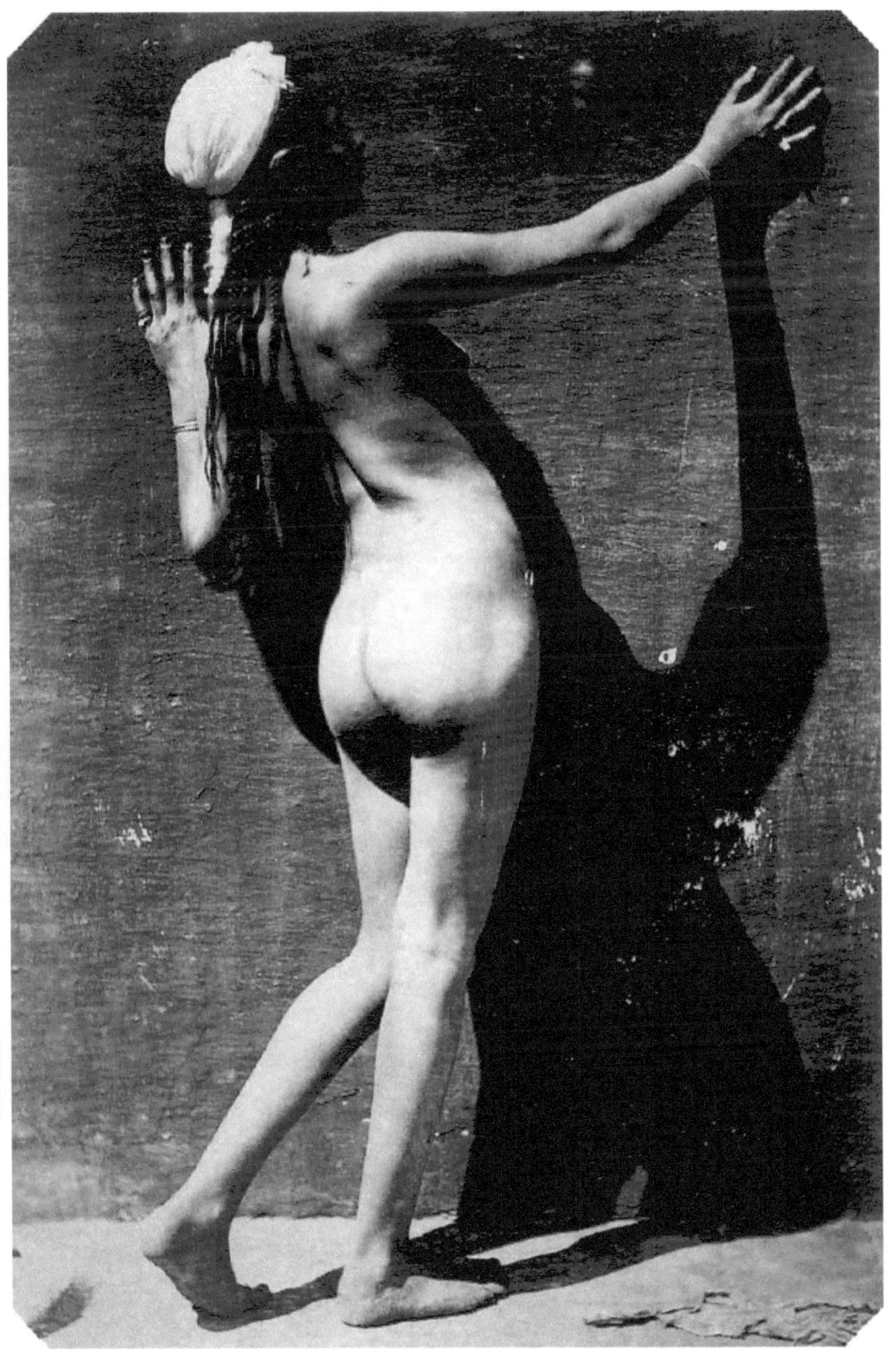

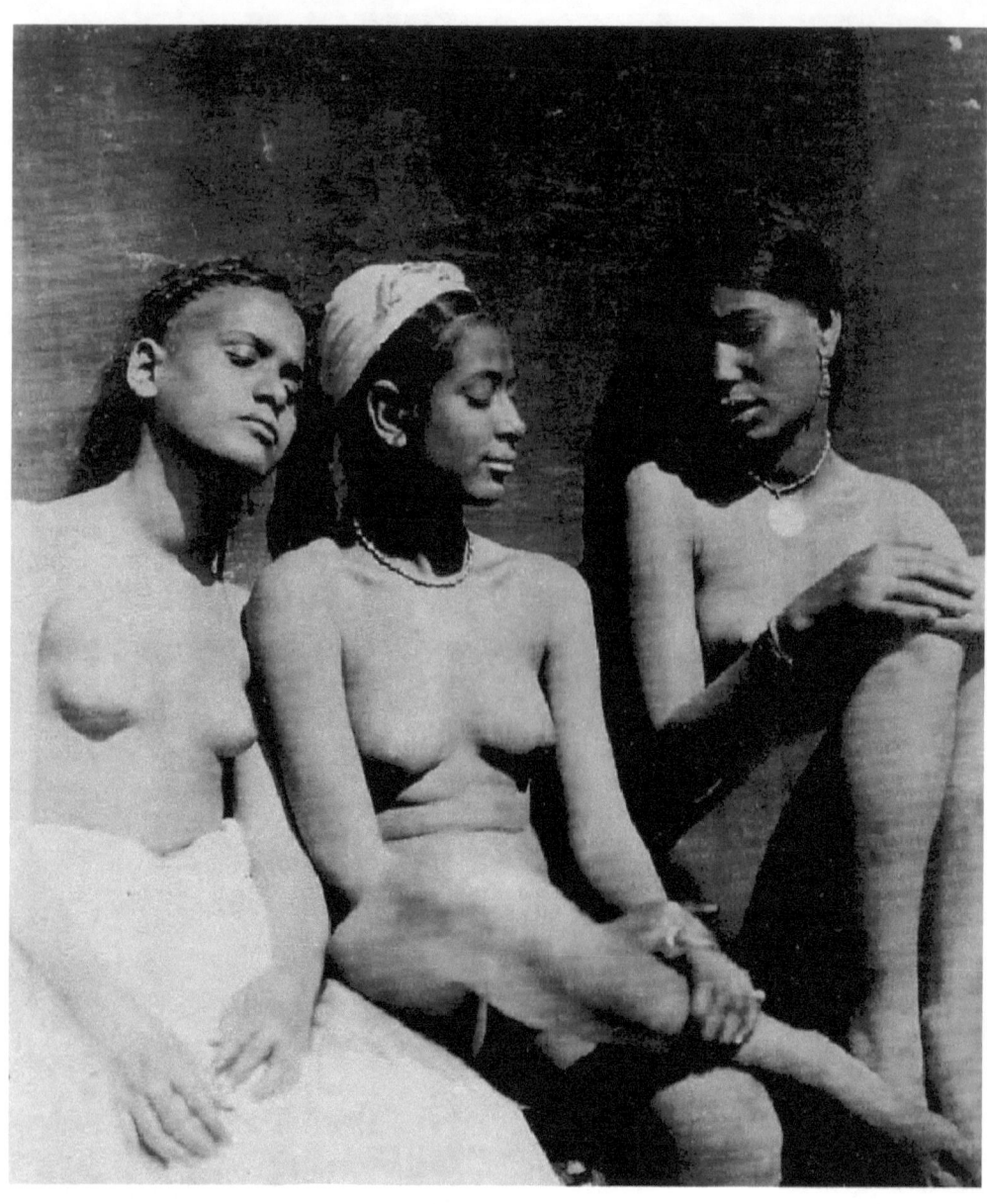

Types du MAROC. - Esclave

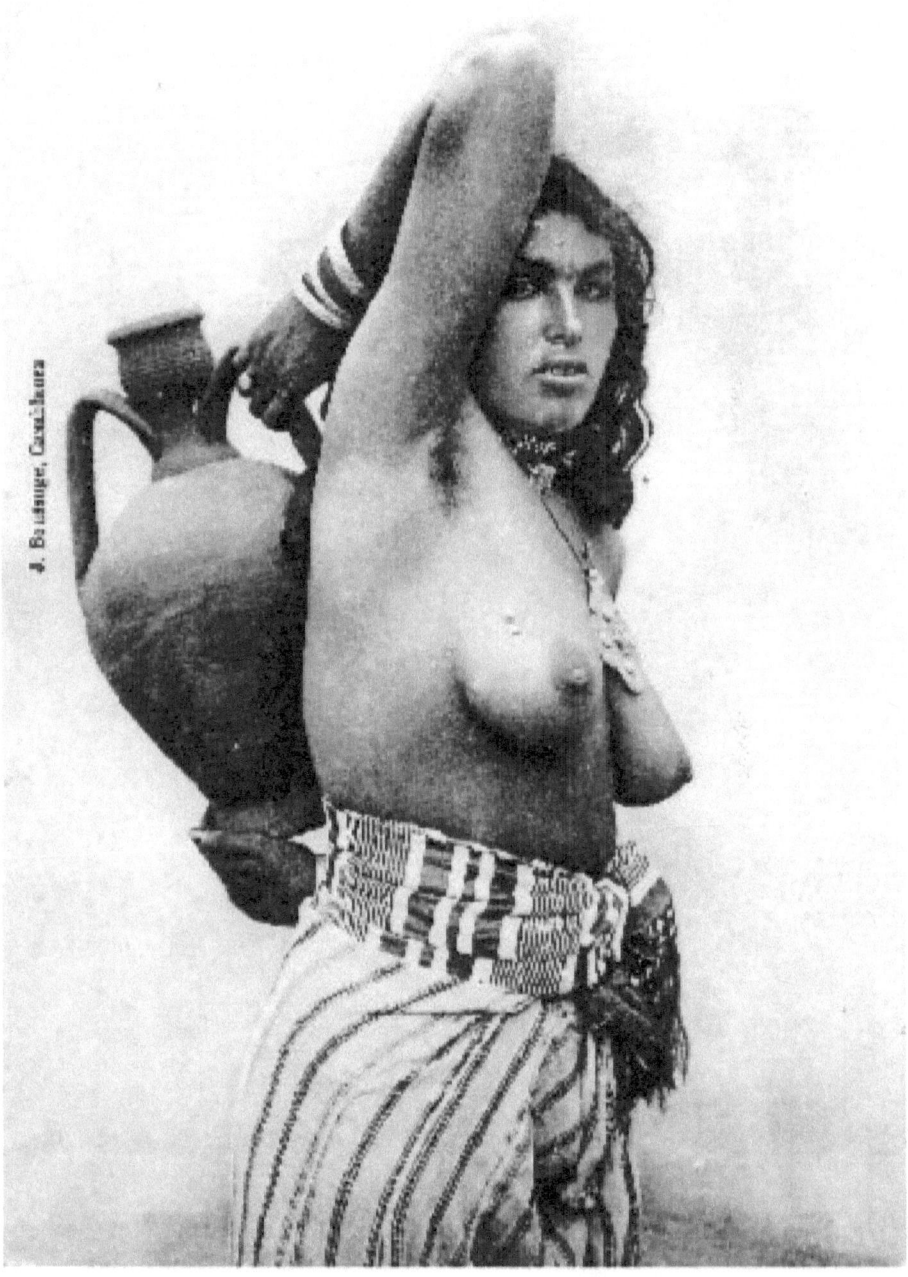

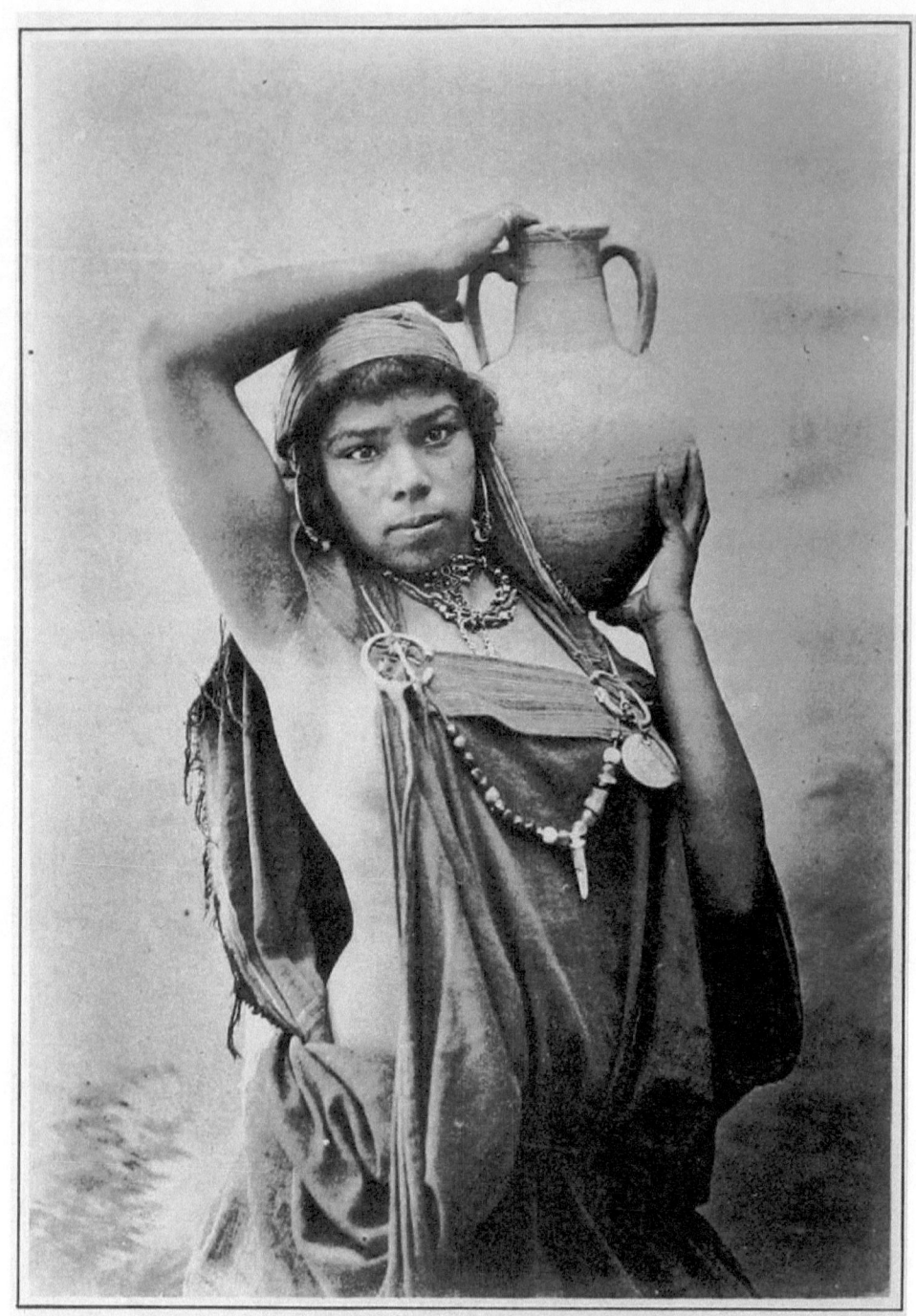

BÉDOUINE REVENANT DE LA CITERNE

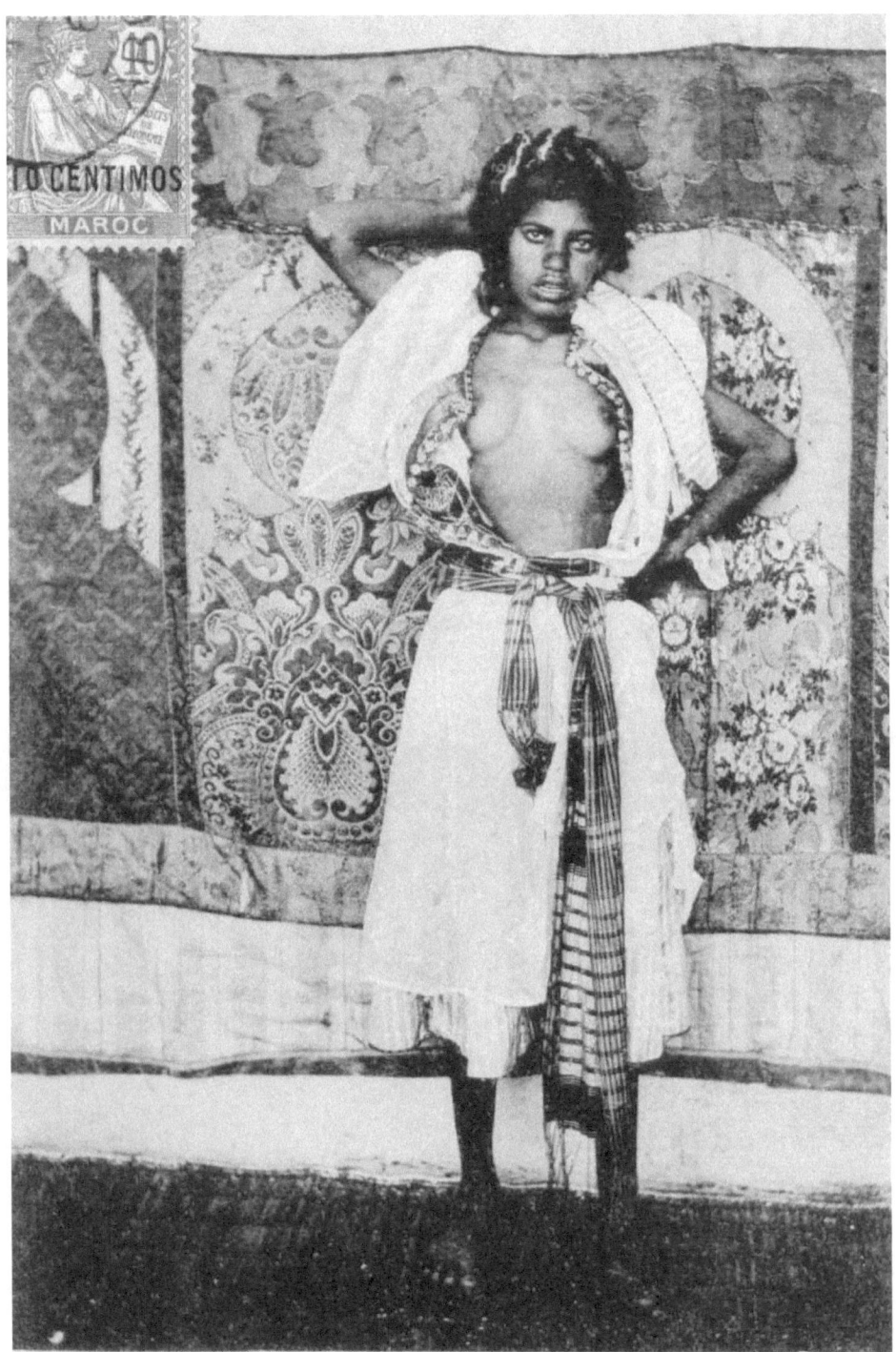

TANGER
Joven Marroquí

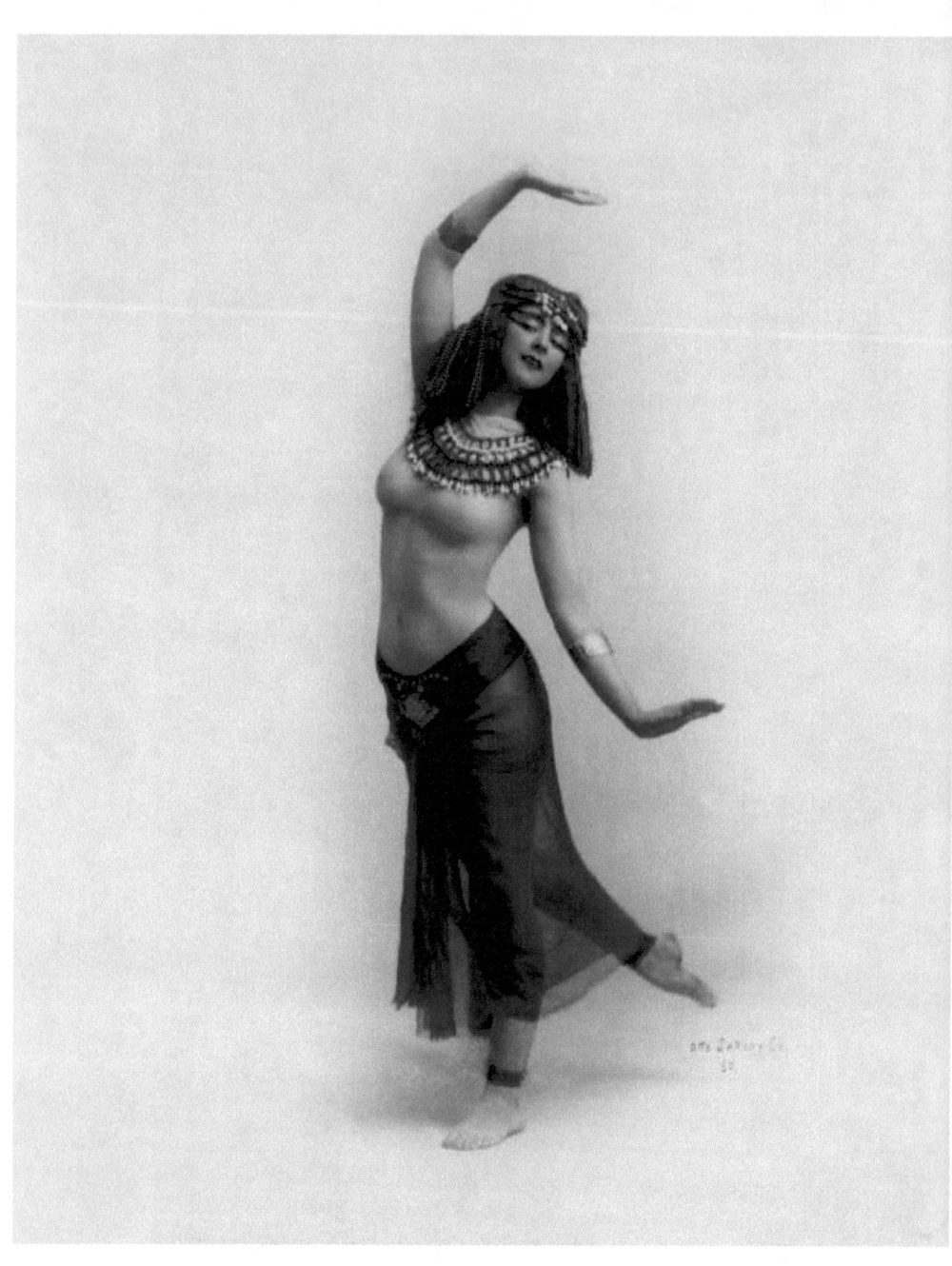

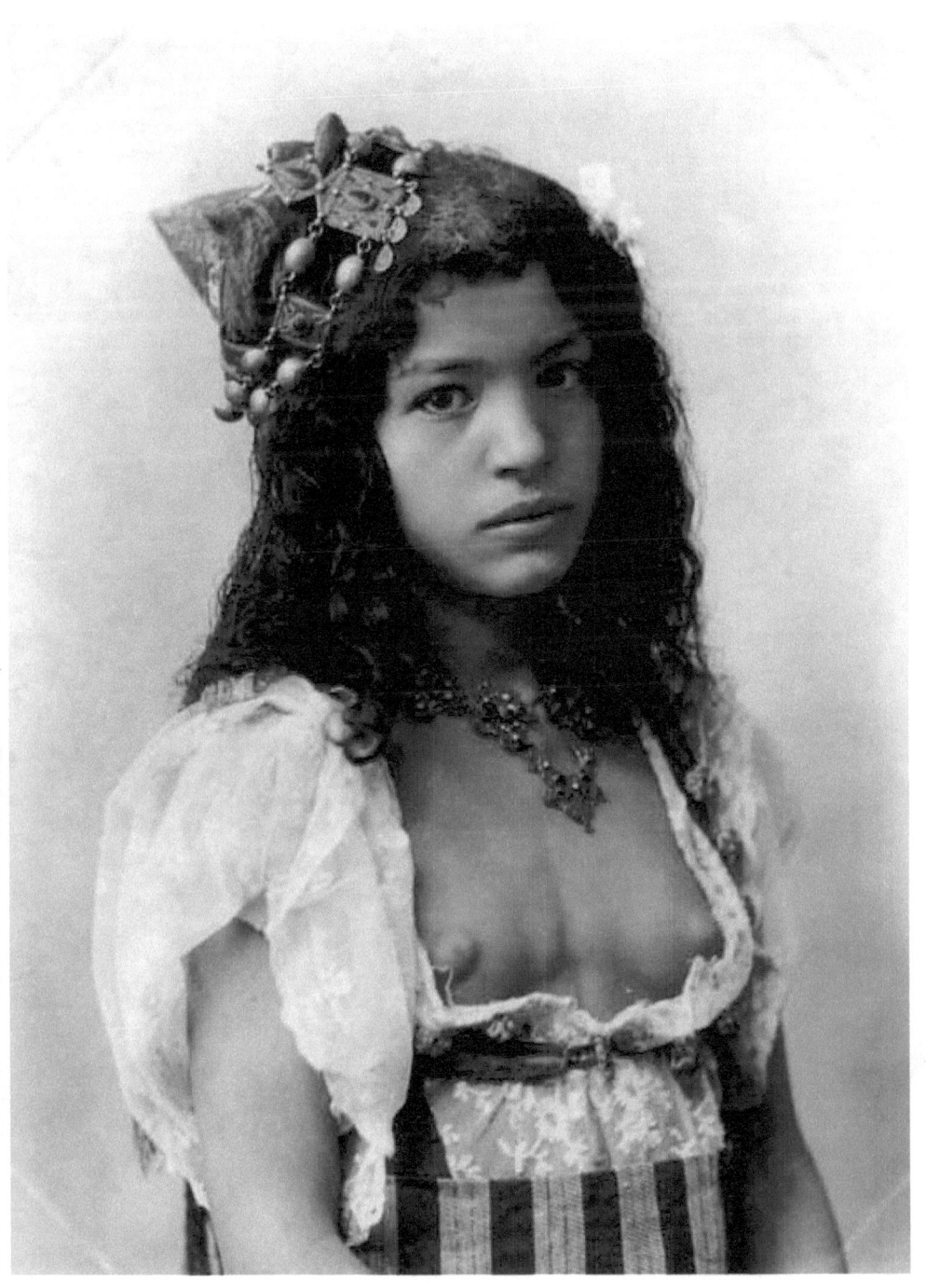

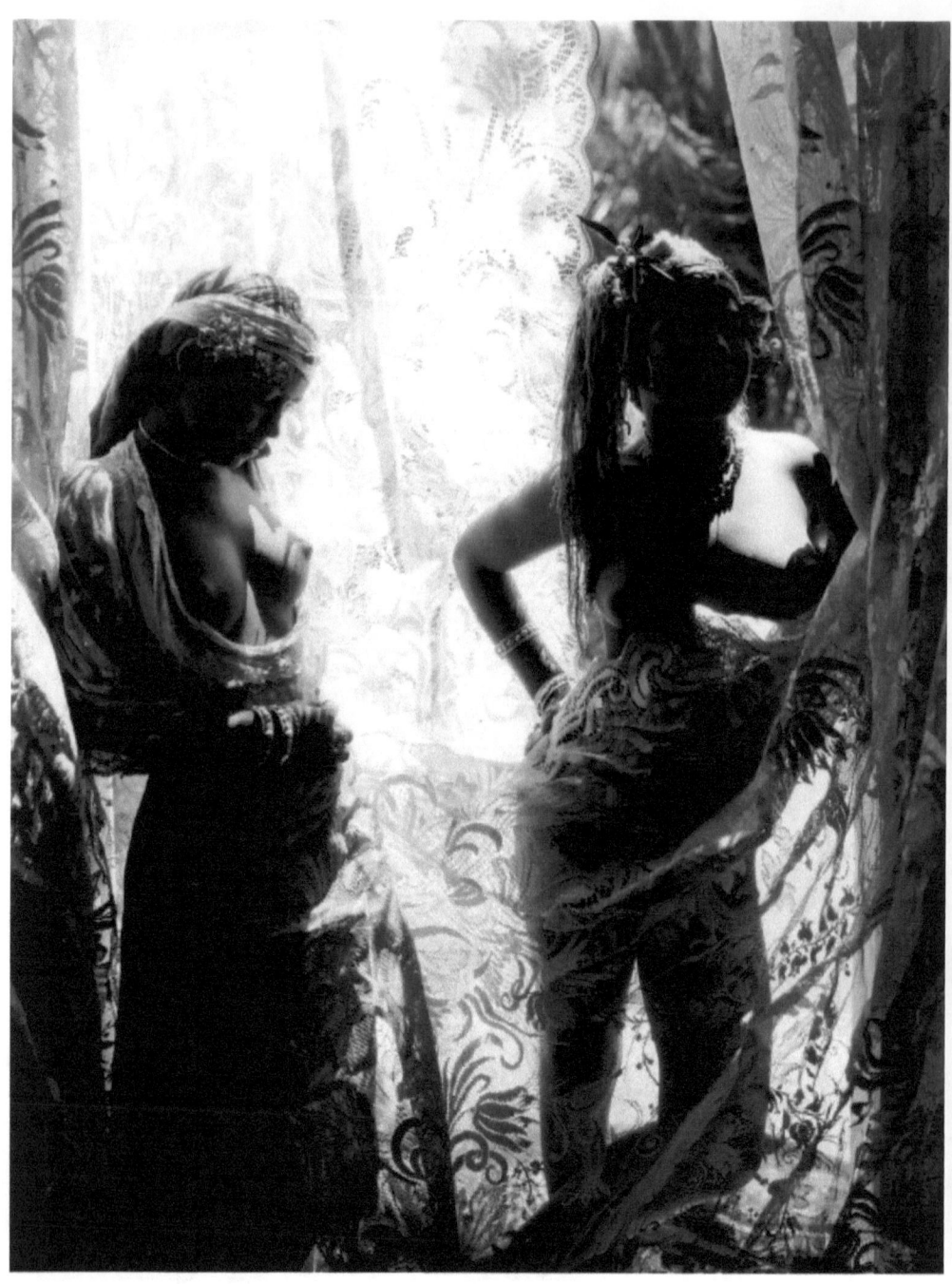

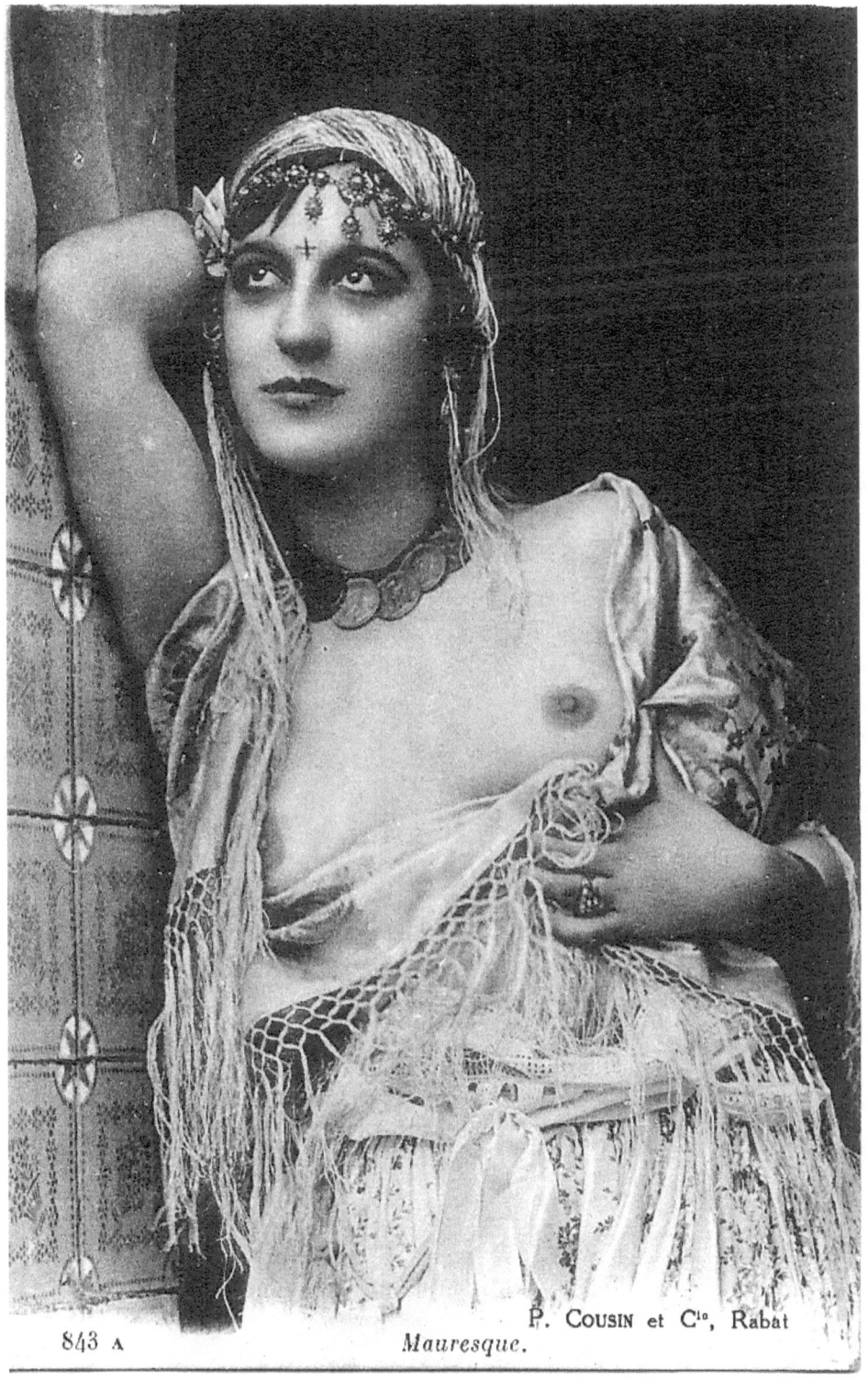
843 A　　　　Mauresque.　　　　P. Cousin et Cie, Rabat

73. - MAROC. - Une Femme à Fez

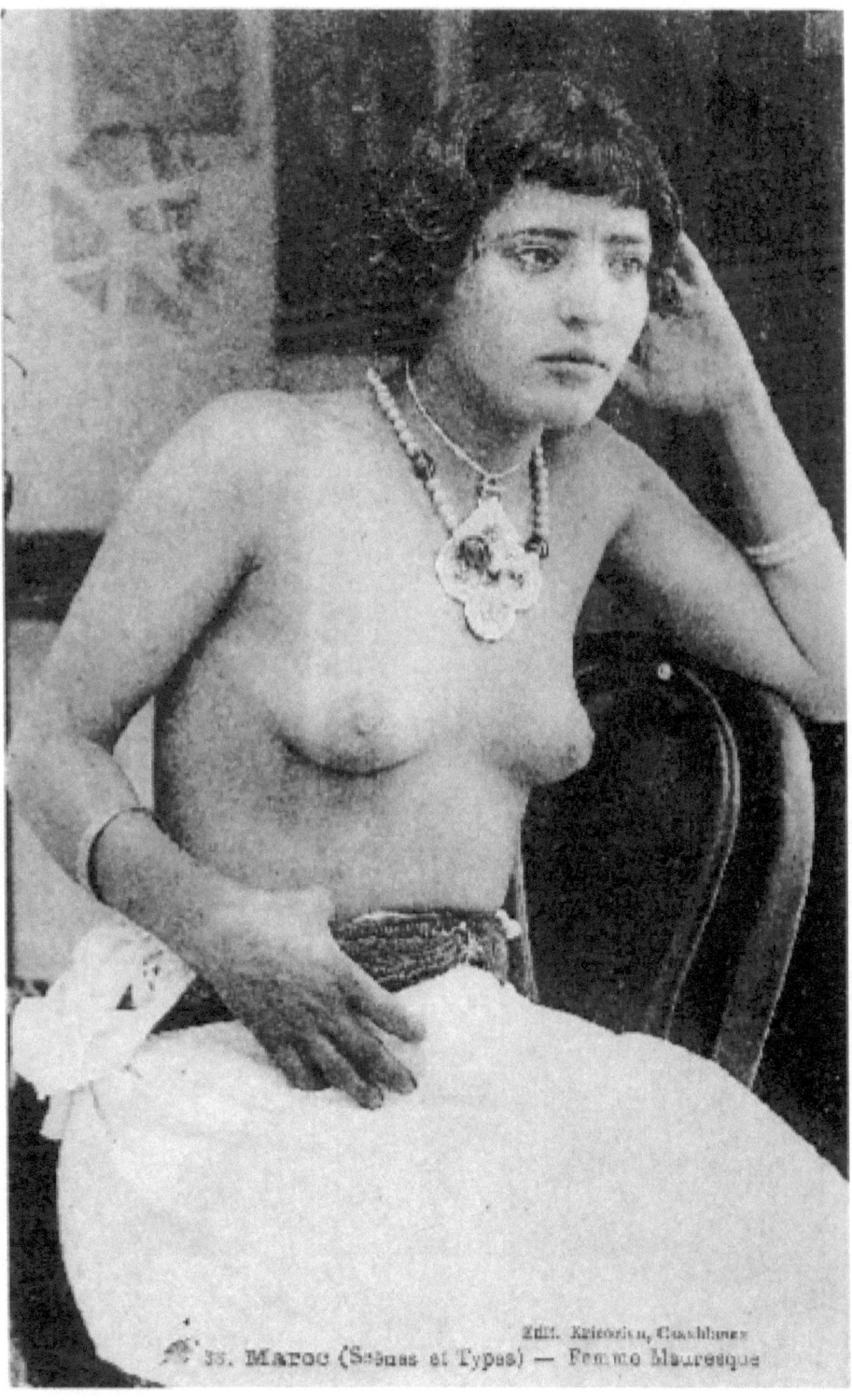

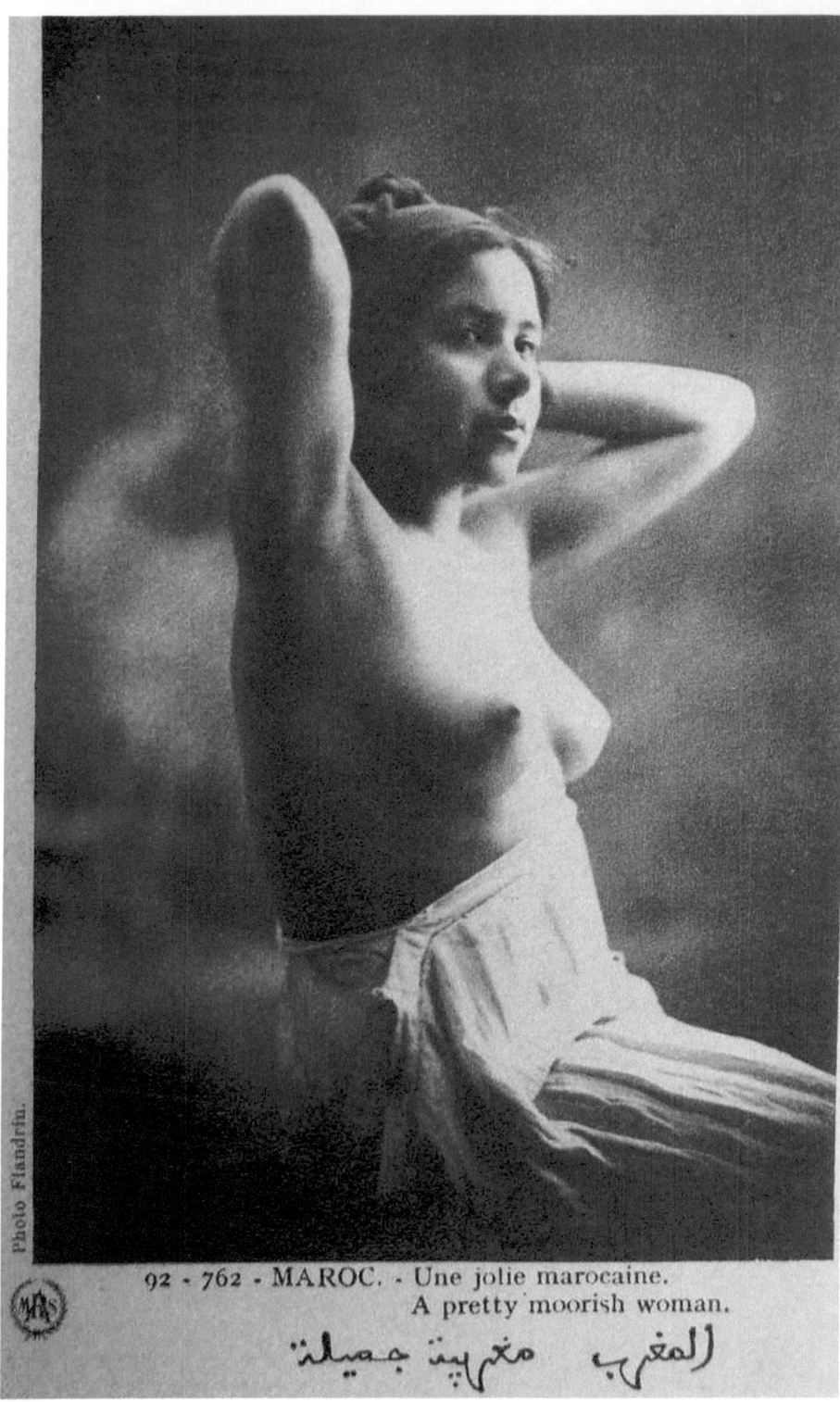

92 - 762 - MAROC. - Une jolie marocaine.
A pretty moorish woman.

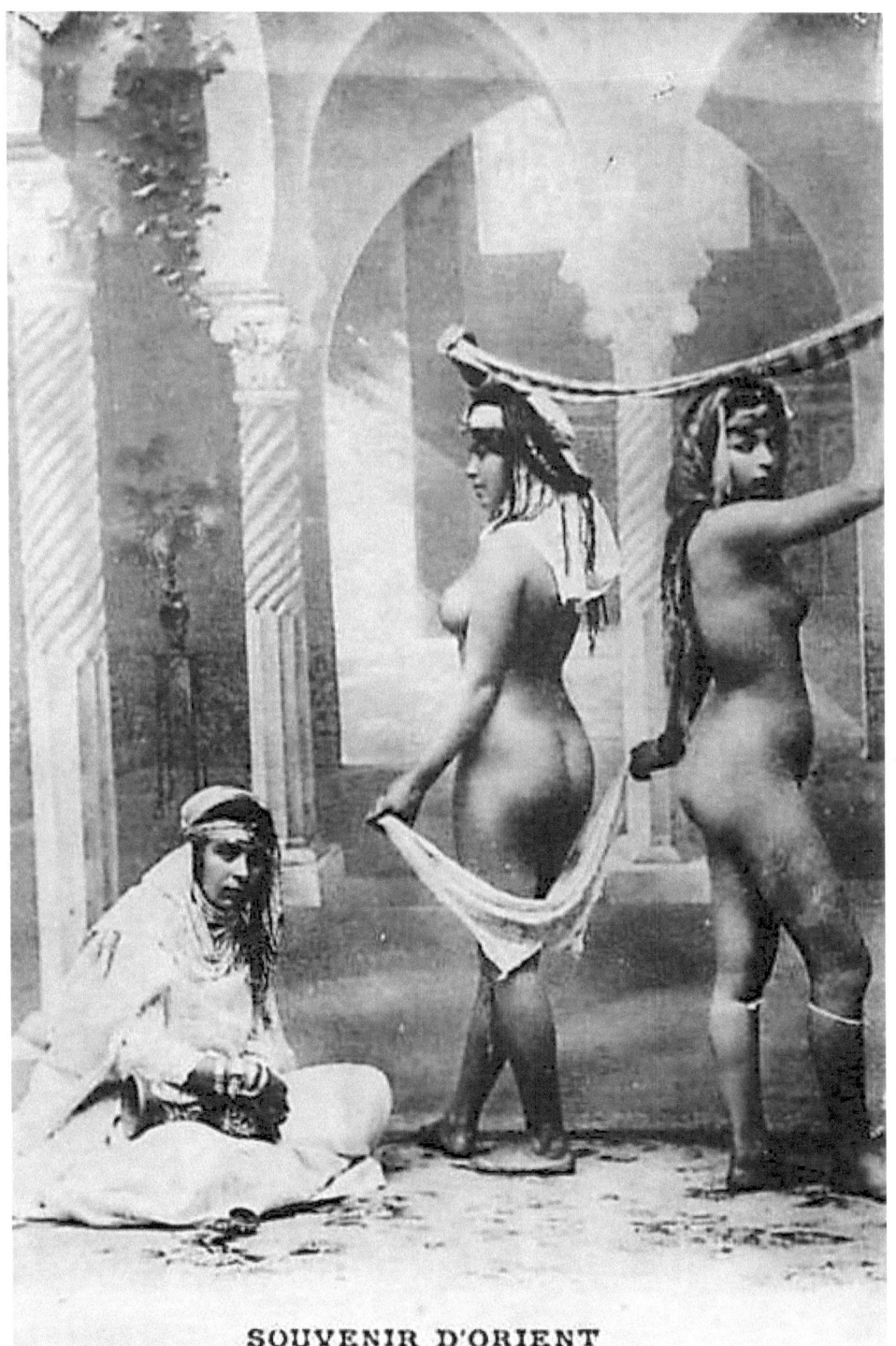

SOUVENIR D'ORIENT
Danse Orientale

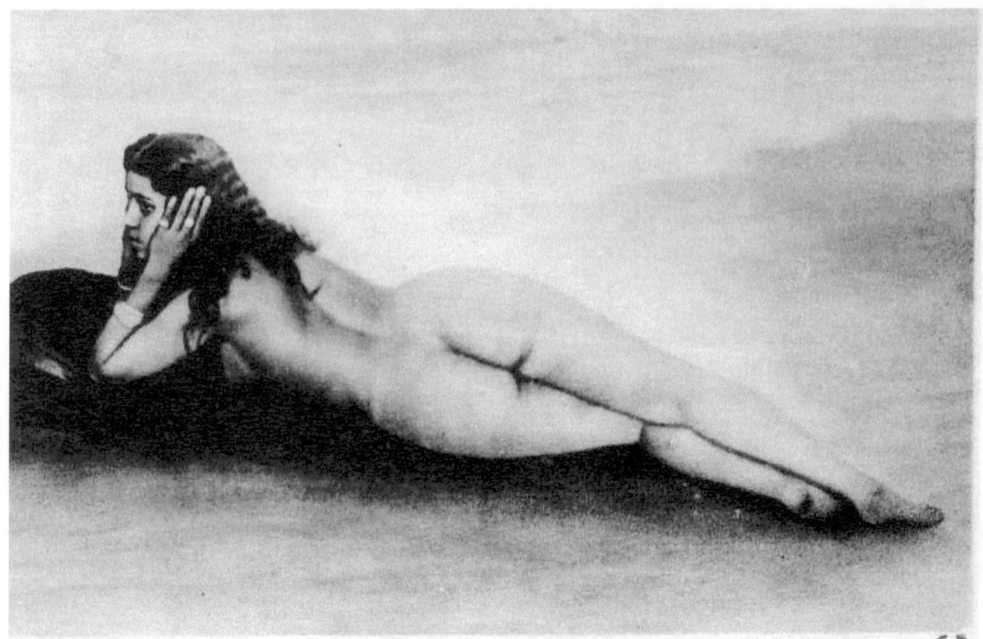

Photo Flandrin · 797. - MAROC. — La favorite après le bain.

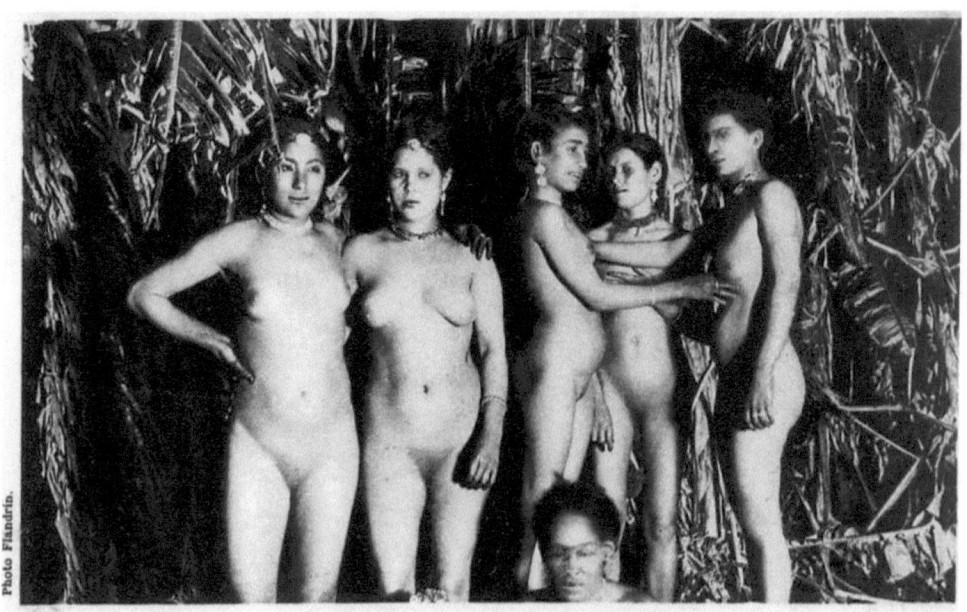

606. — ESCLAVES DANS LES BANANIERS.

Photo Flandrin 713. MAROC — Le Sourire de Yamina !

Photo Flandria 712. MAROC
Au Quartier réservé - Une femme du Sud

Photo Flandrin 681. MAROC — La danse du ventre

Photo Flandrin 680. Femme Marocaine

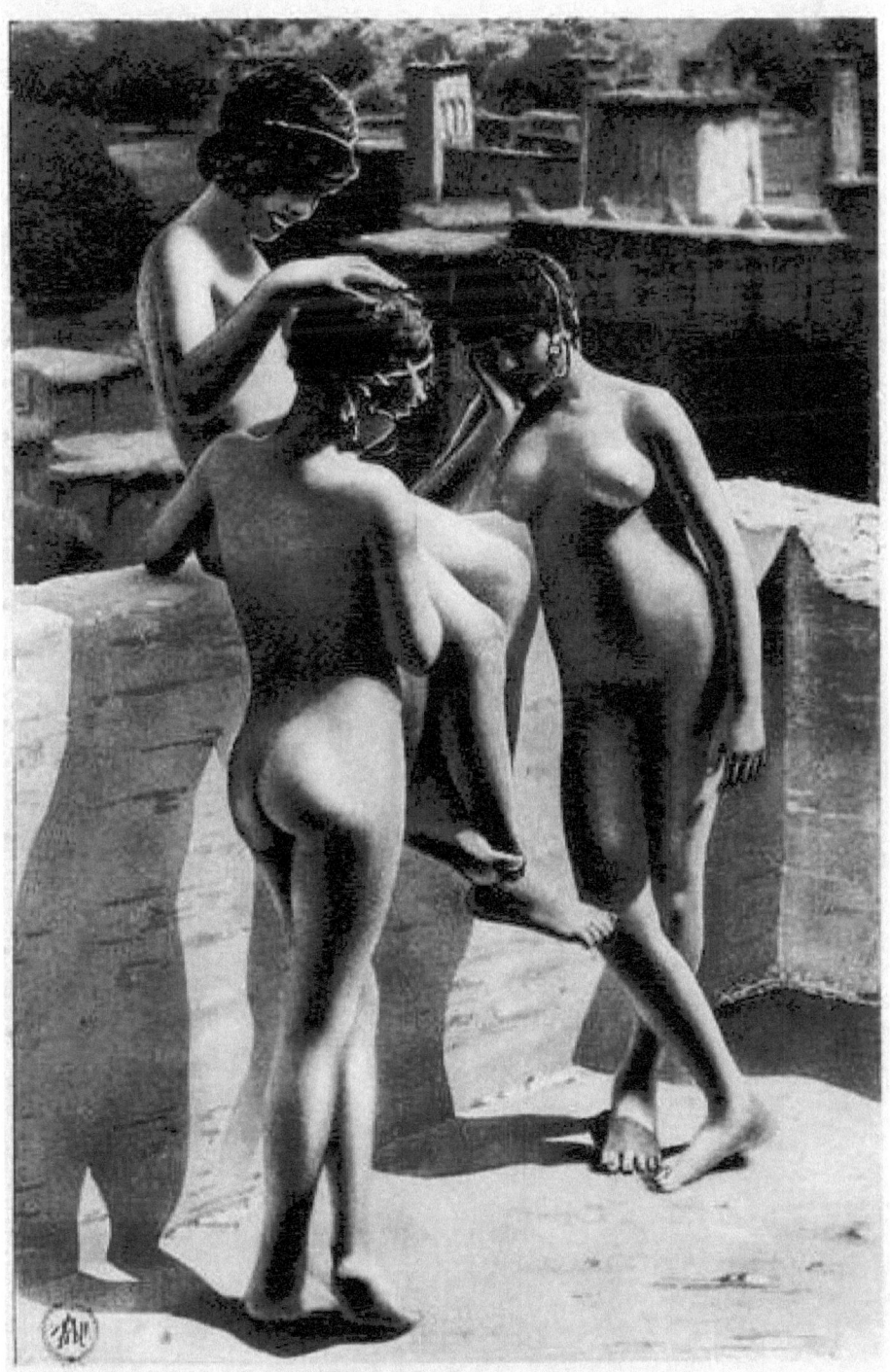

16. — Esclaves sur la terrasse d'une casbah féodale.

614. — ESCLAVE A LA FONTAINE.

Photo Flandrin 589. - MAROC — Jeune berbère nue.

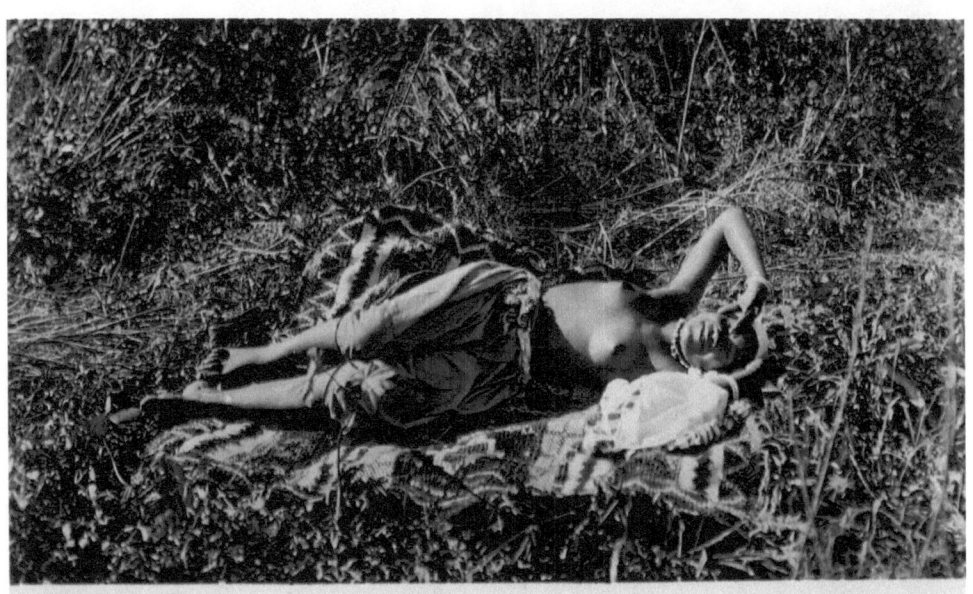

61 - MAROC - Fleur de brousse
Photo Flandrin Reprod. Interd.

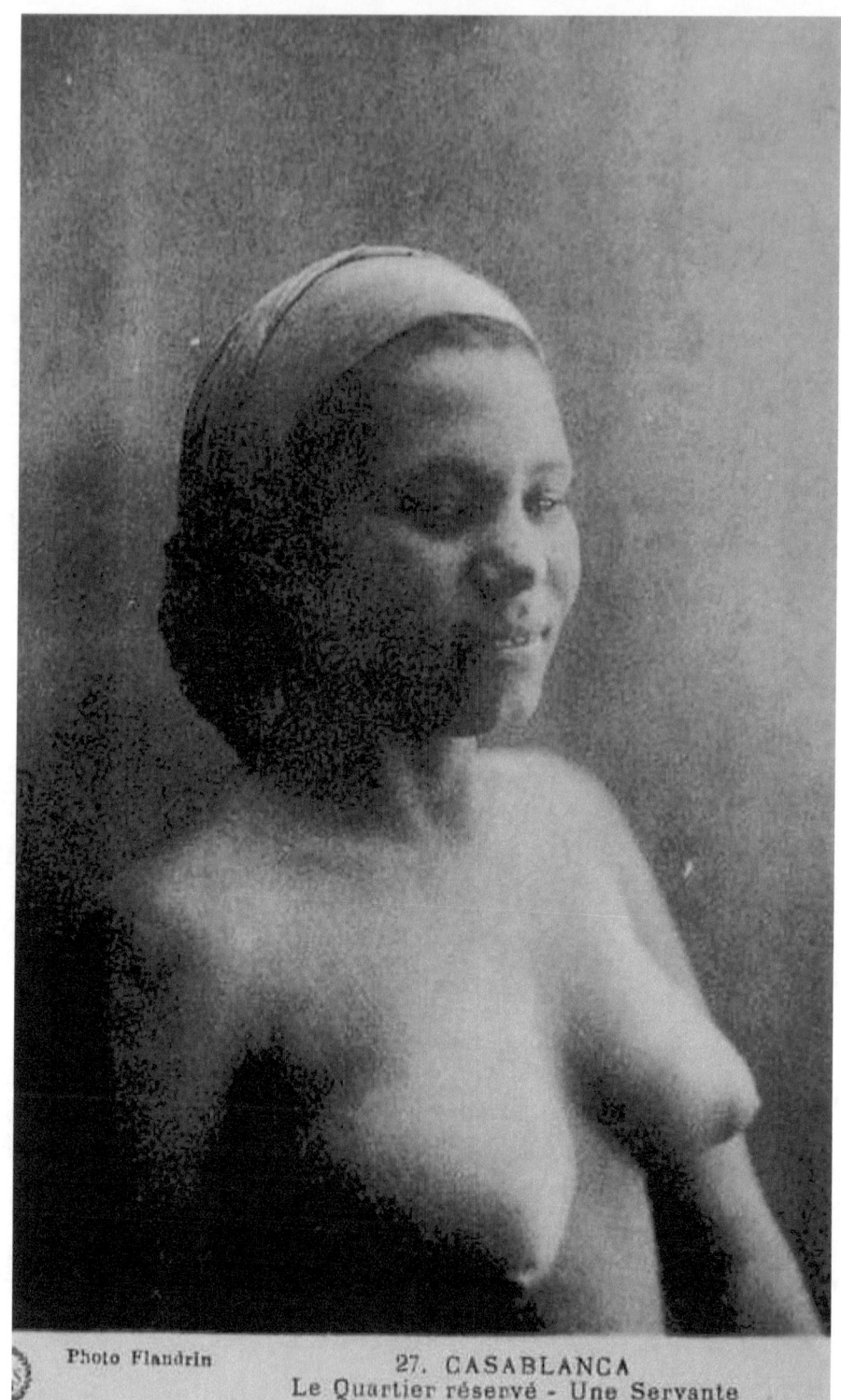
Photo Flandrin — 27. CASABLANCA
Le Quartier réservé - Une Servante

Photo Flandrin 26. CASABLANCA
Au Quartier réservé - Une hétaïre de luxe

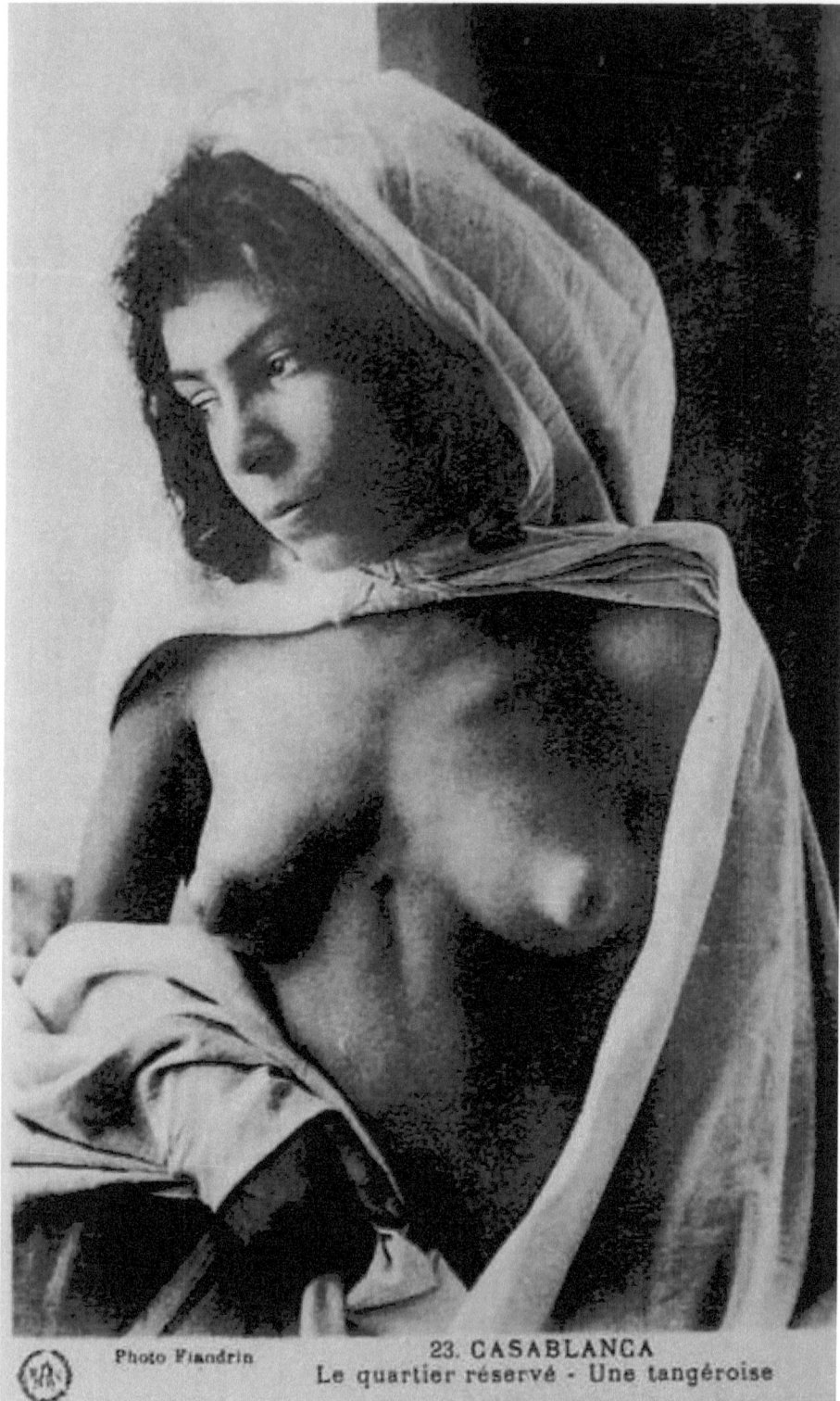
23. CASABLANCA — Le quartier réservé - Une tangéroise
Photo Flandrin

Photo Flandrin 20. CASABLANCA
Le Quartier réservé - Une jolie Mauresque

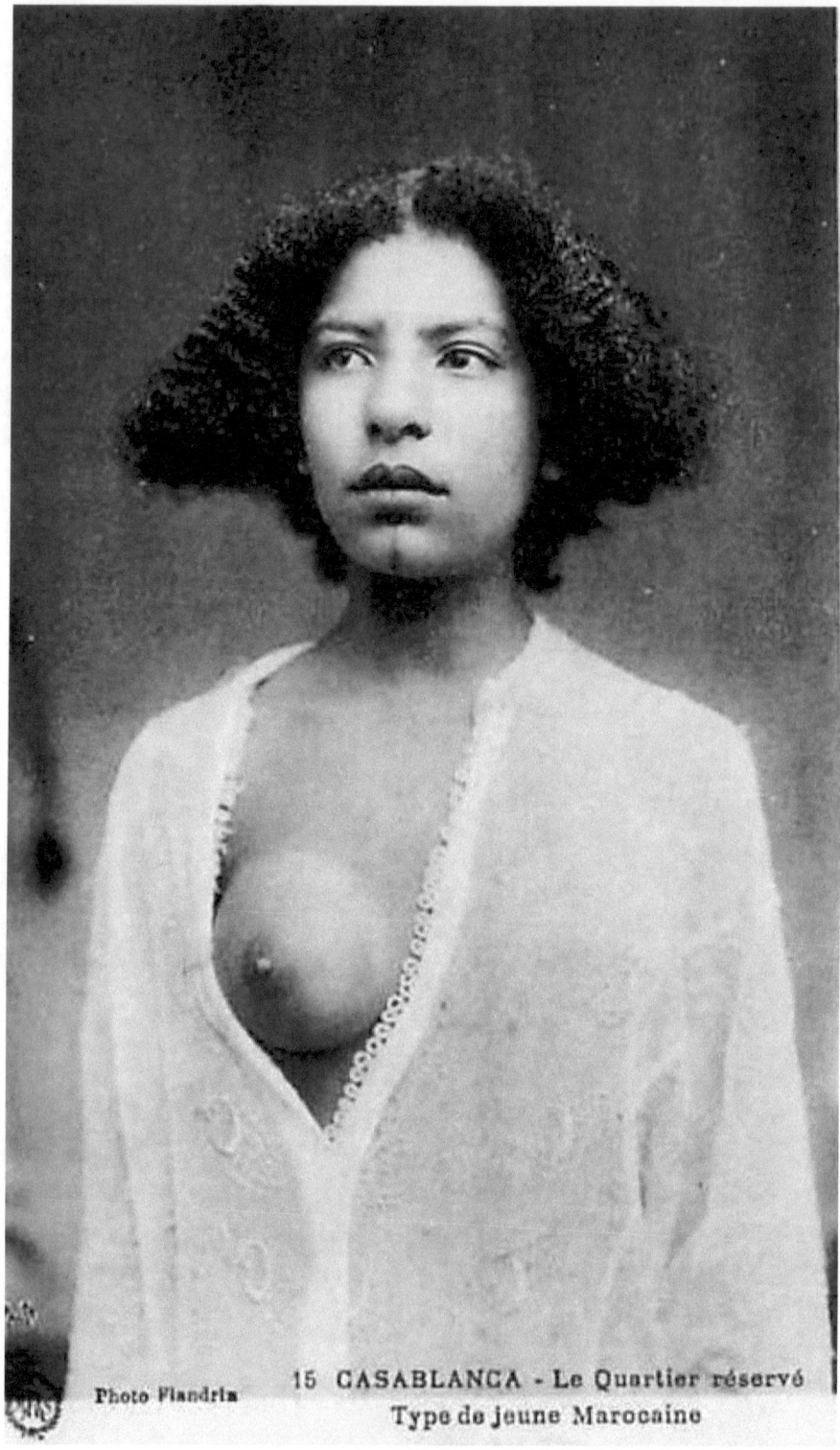

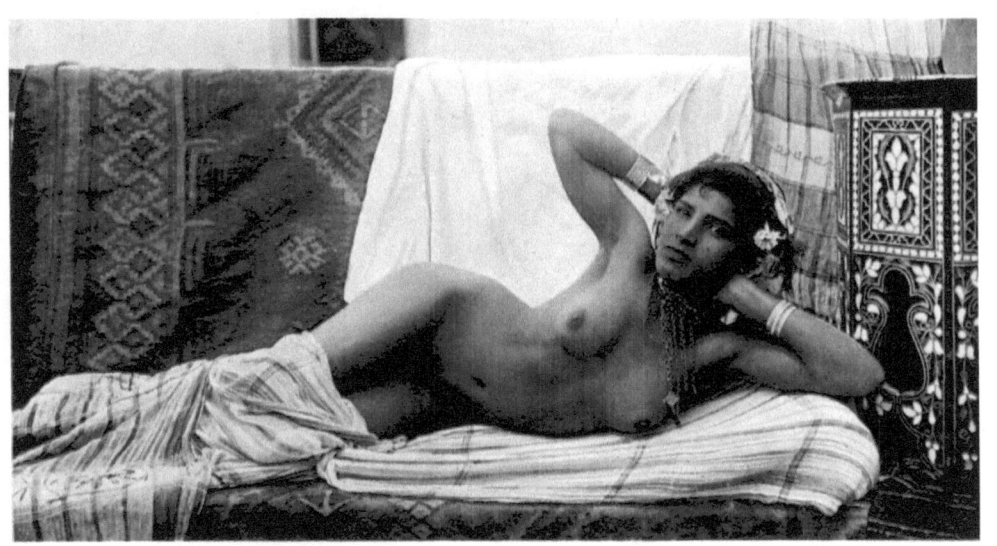

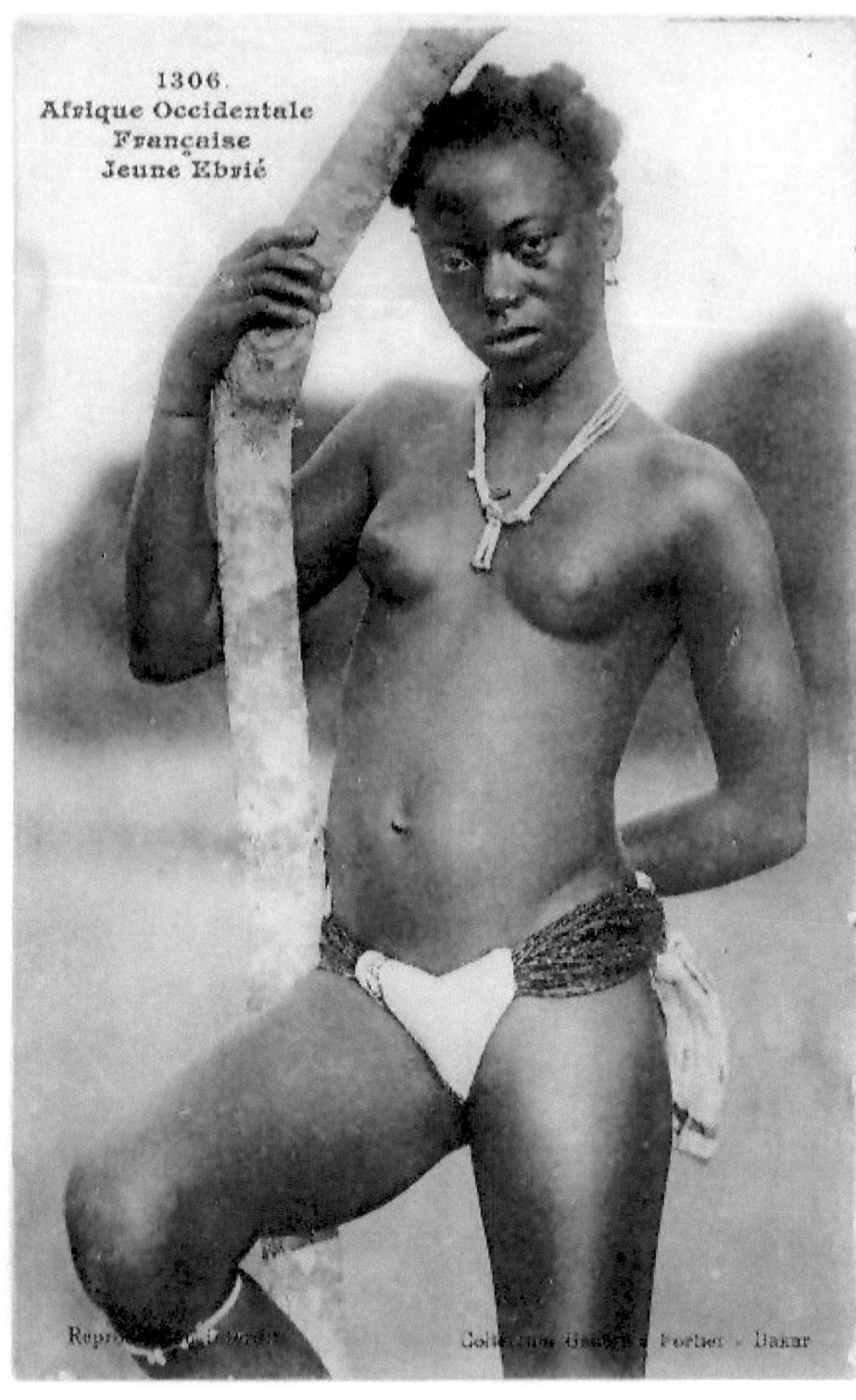

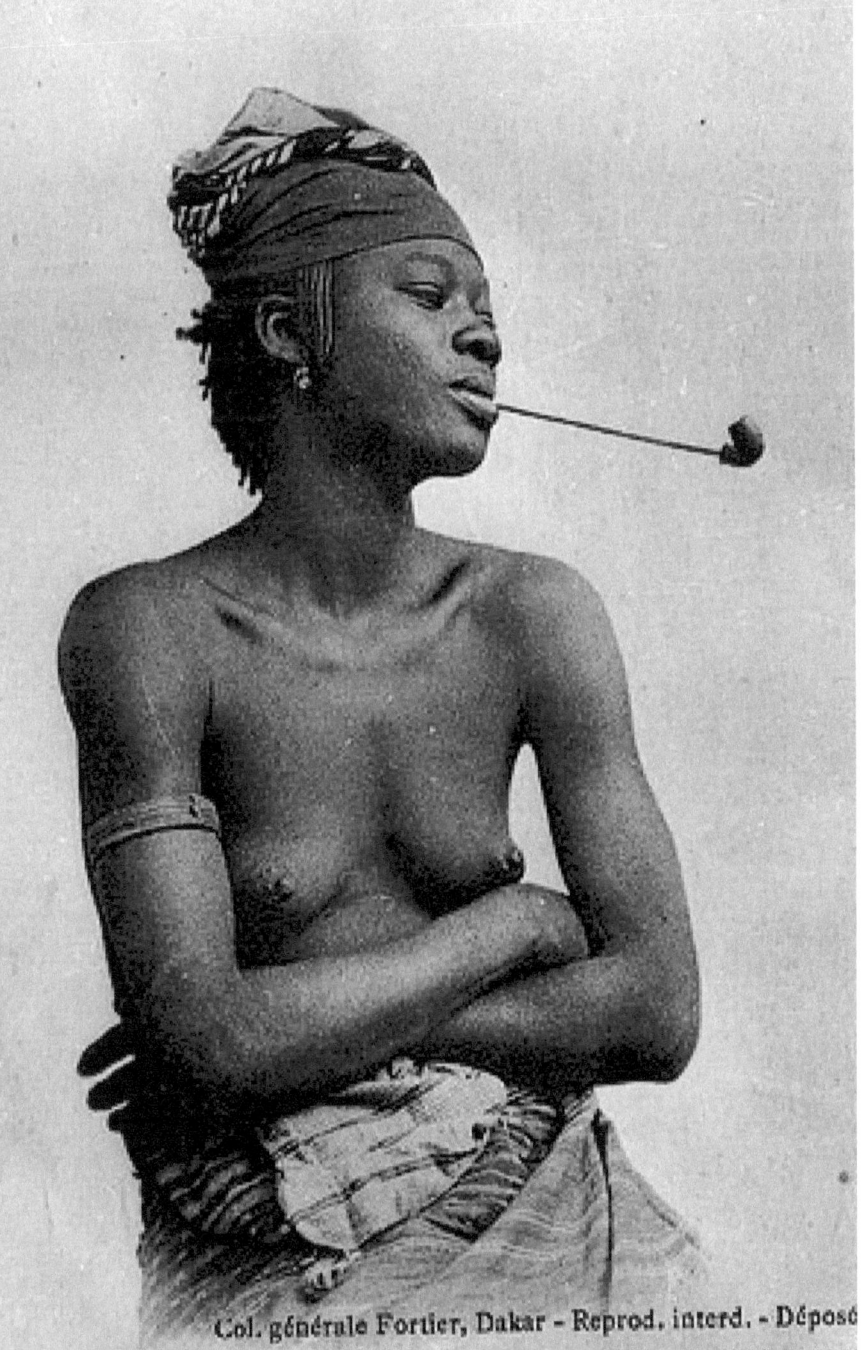

1065. Afrique Occidentale - SÉNÉGAL — Femme "Ouolof"

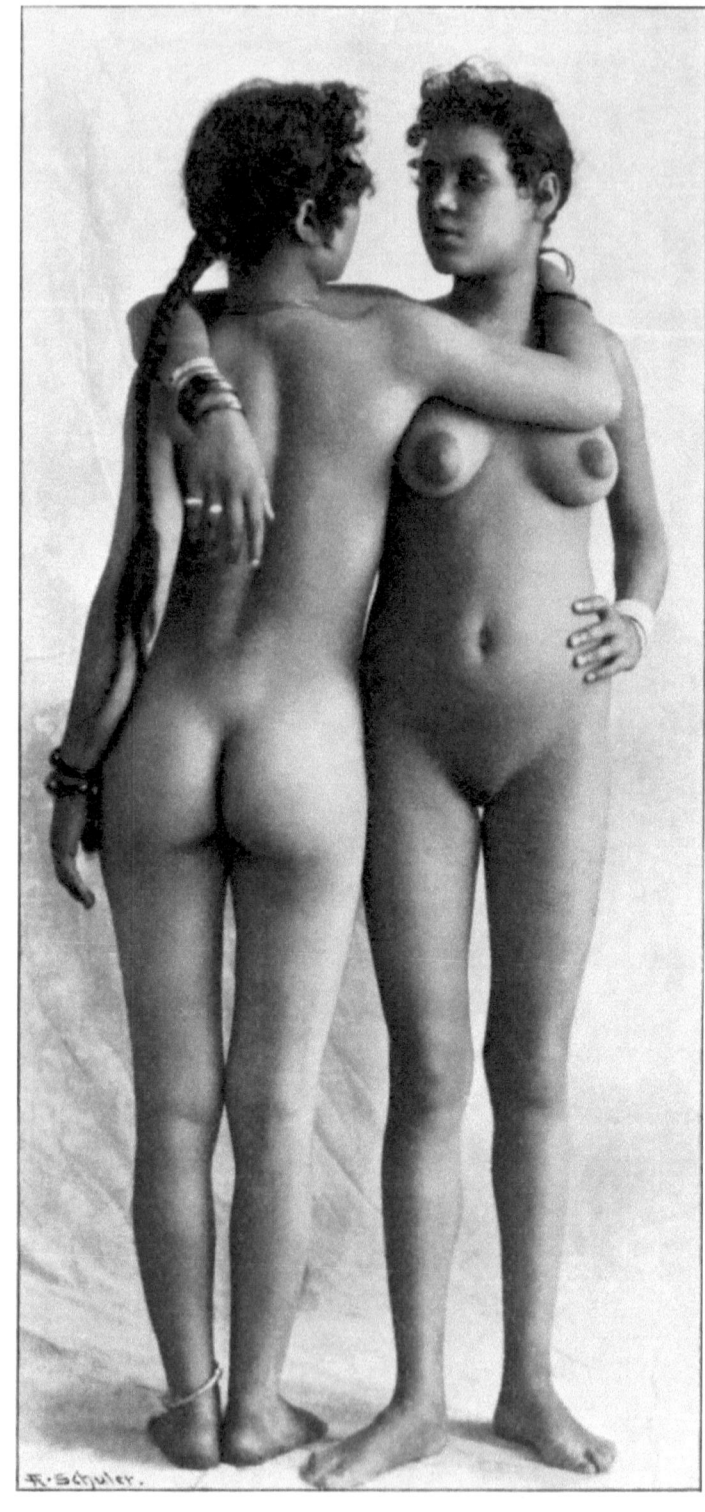

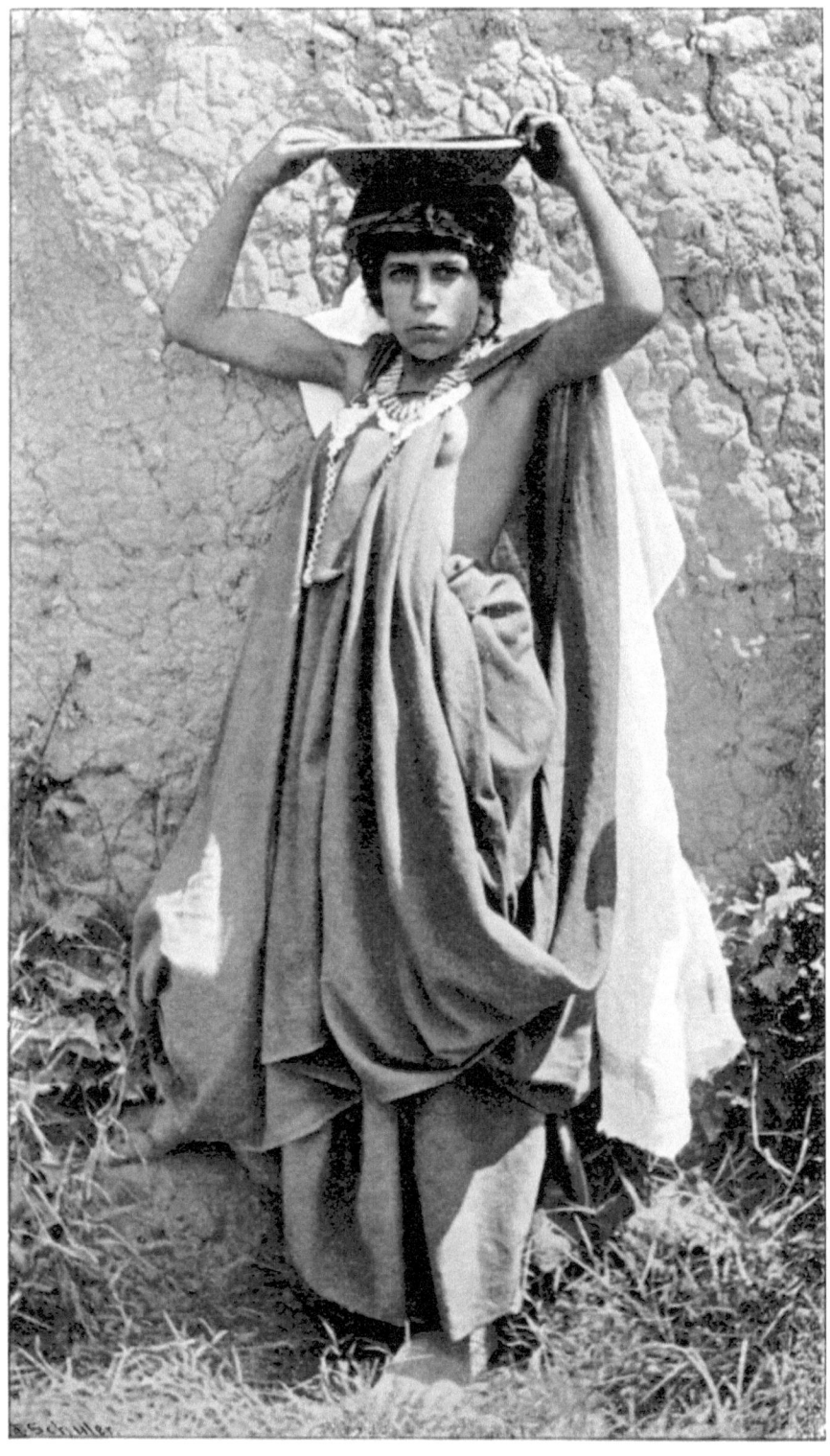

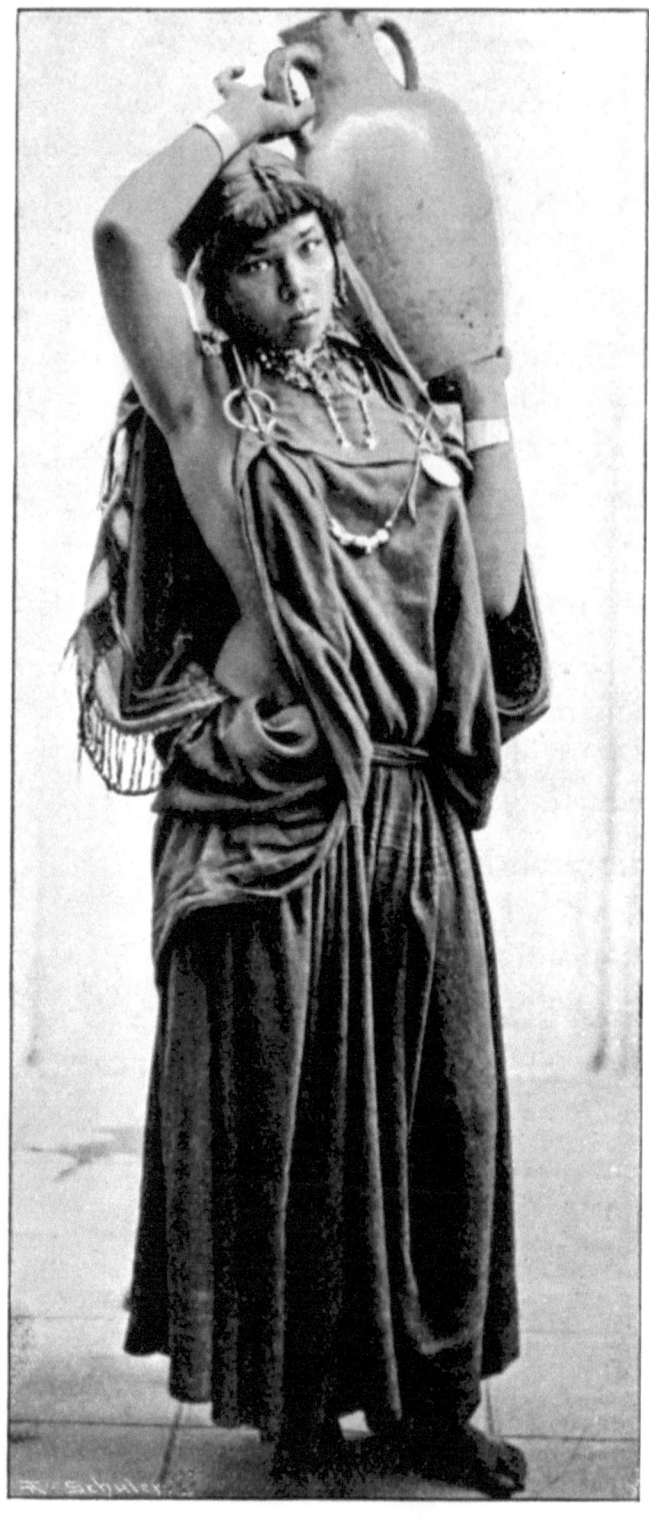

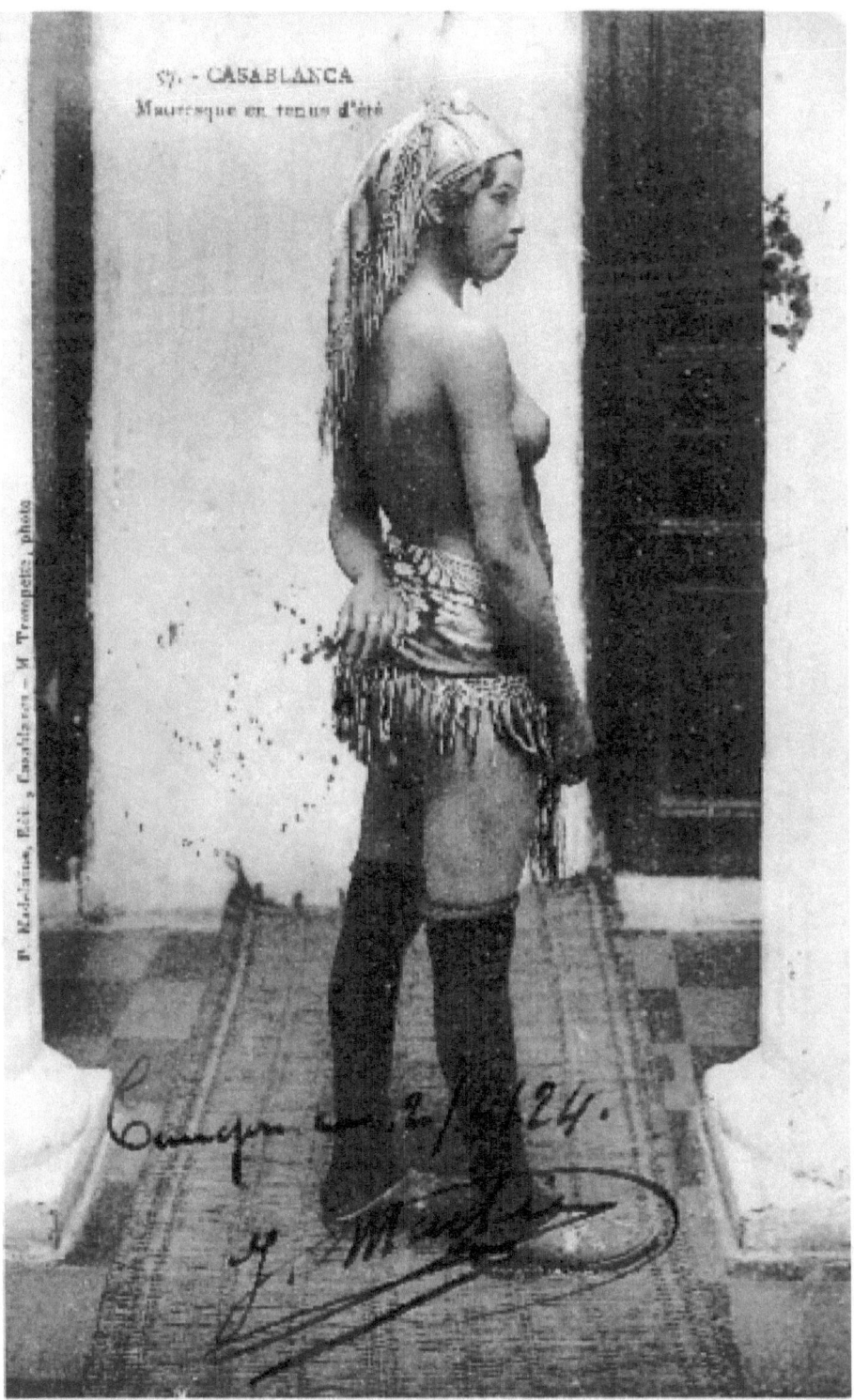

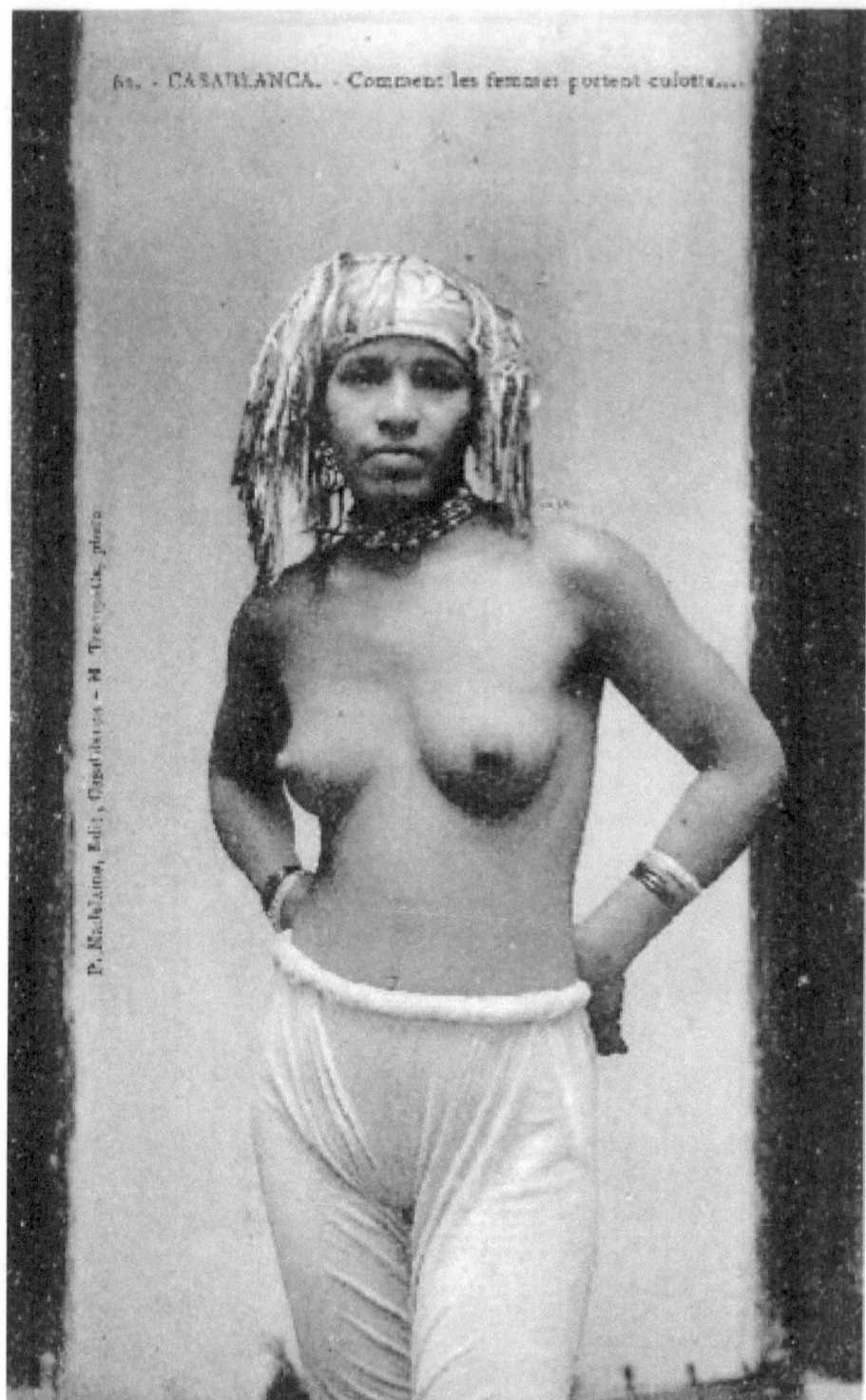

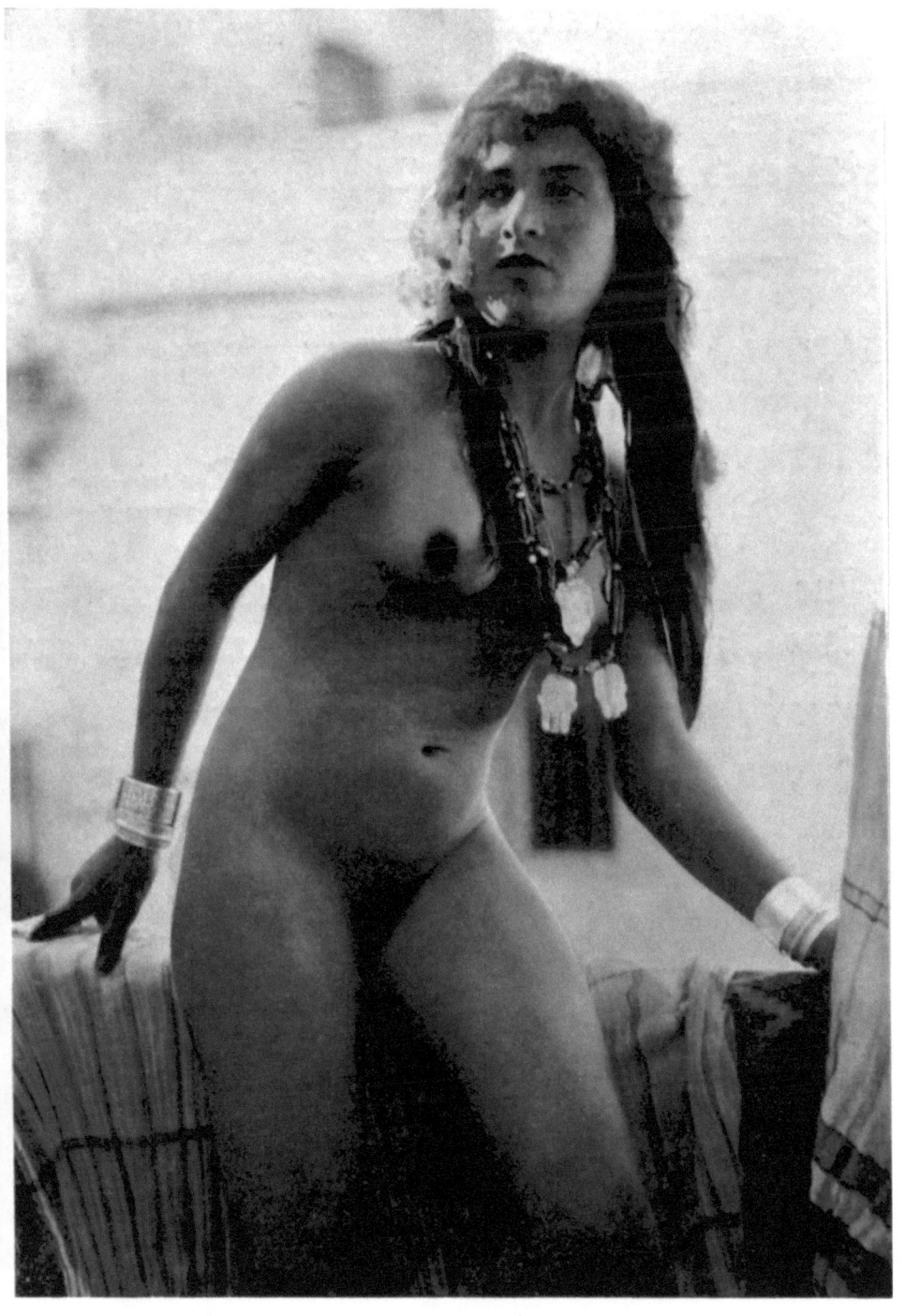

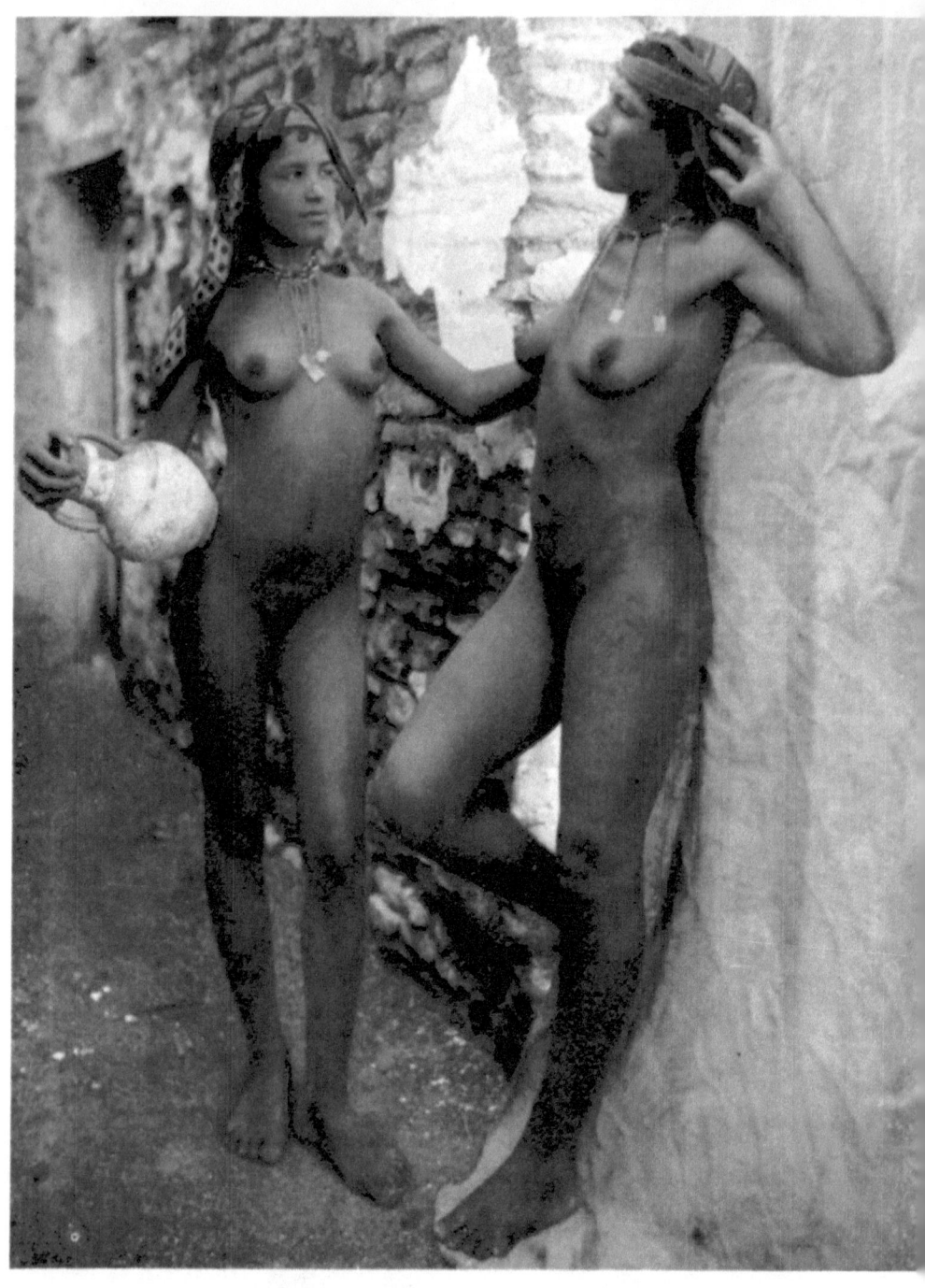

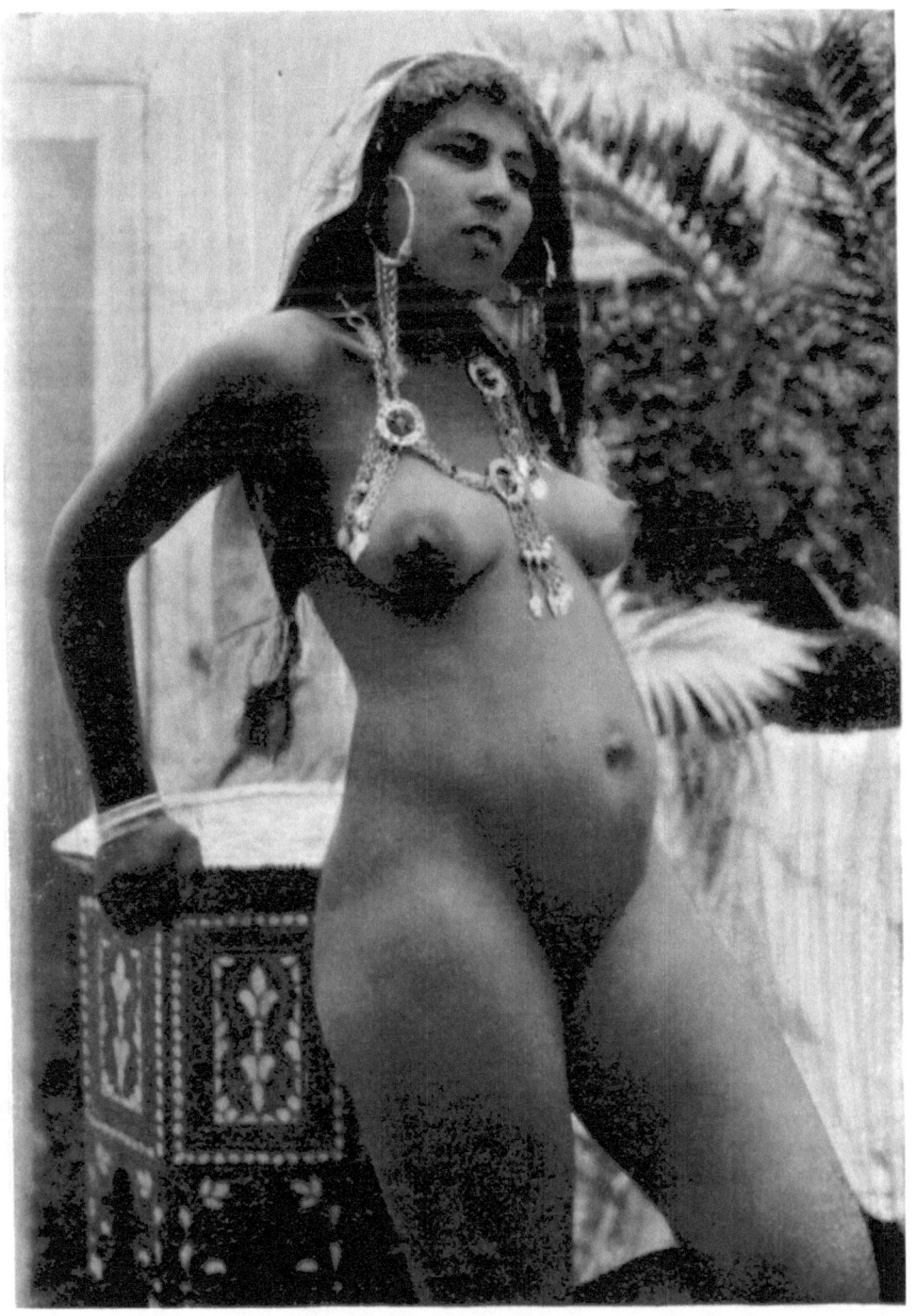

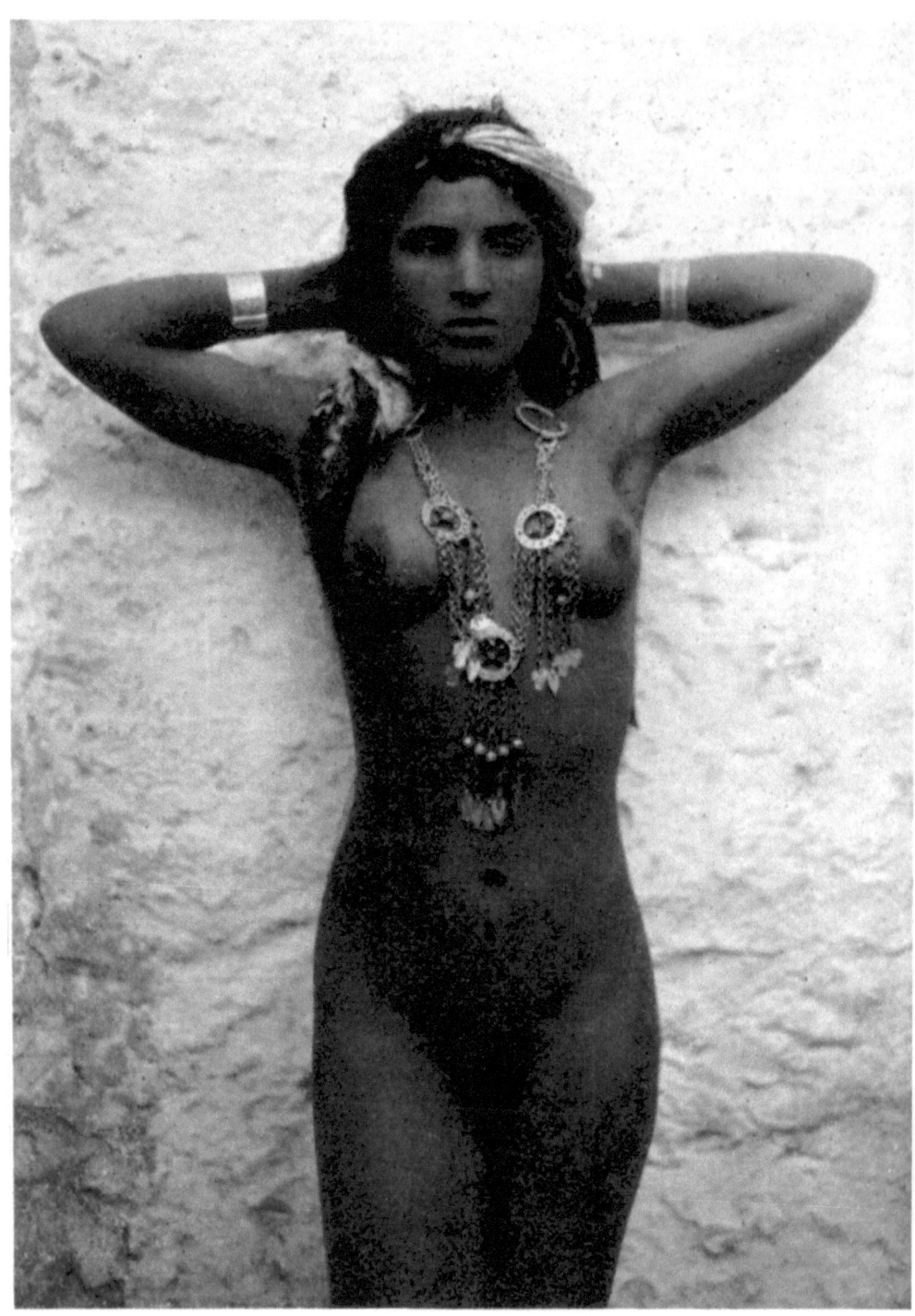

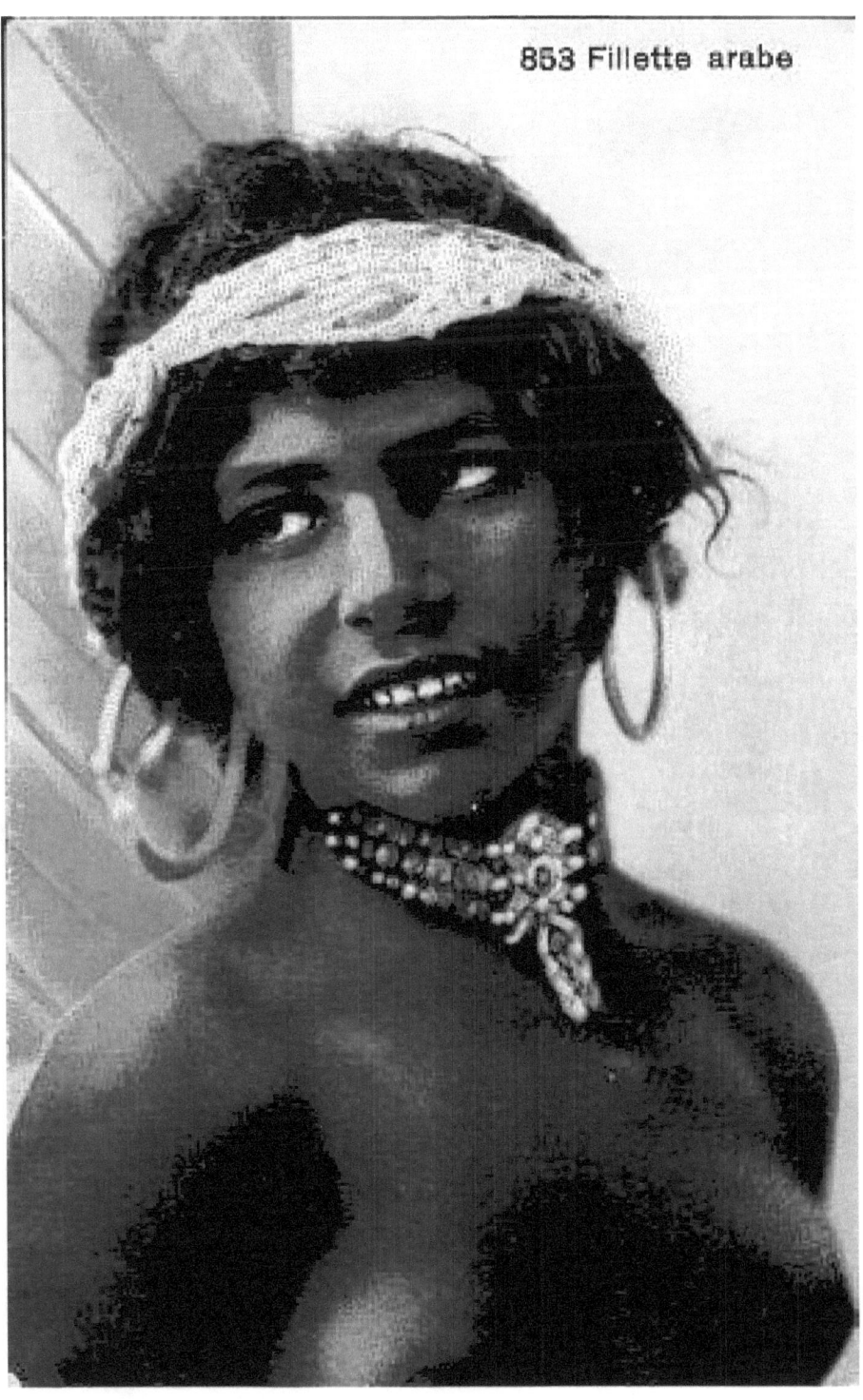

853 Fillette arabe

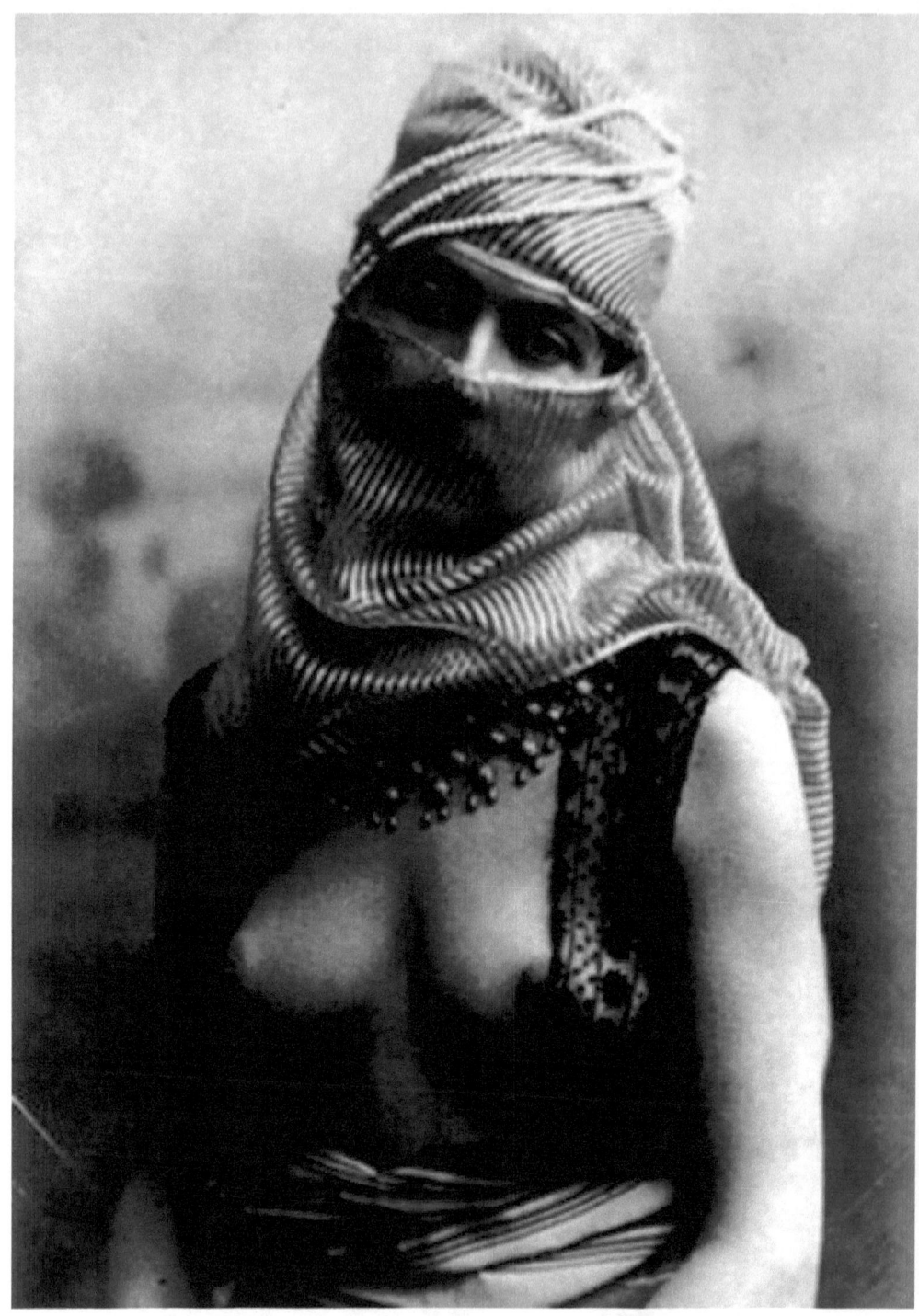

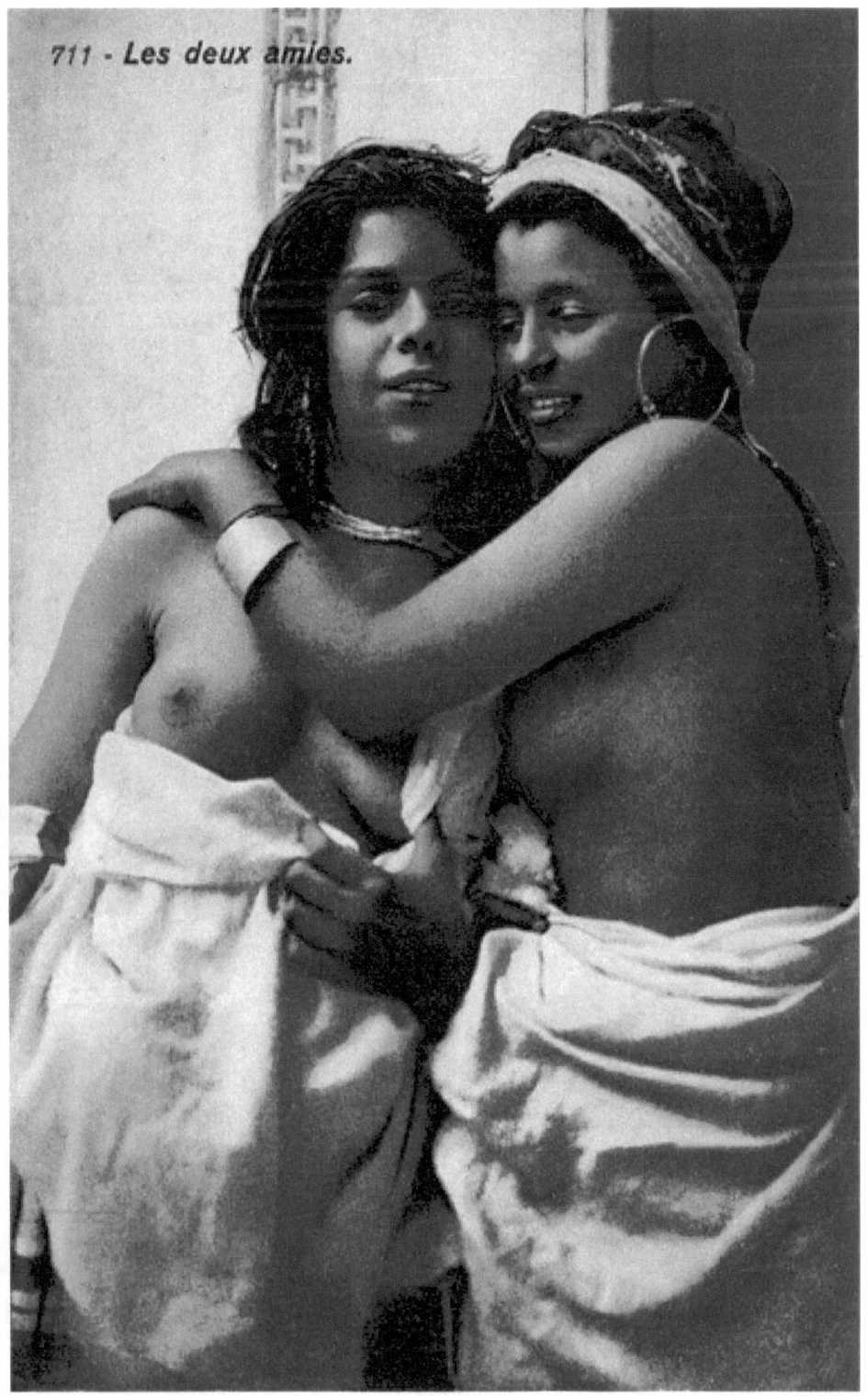

711 - Les deux amies.

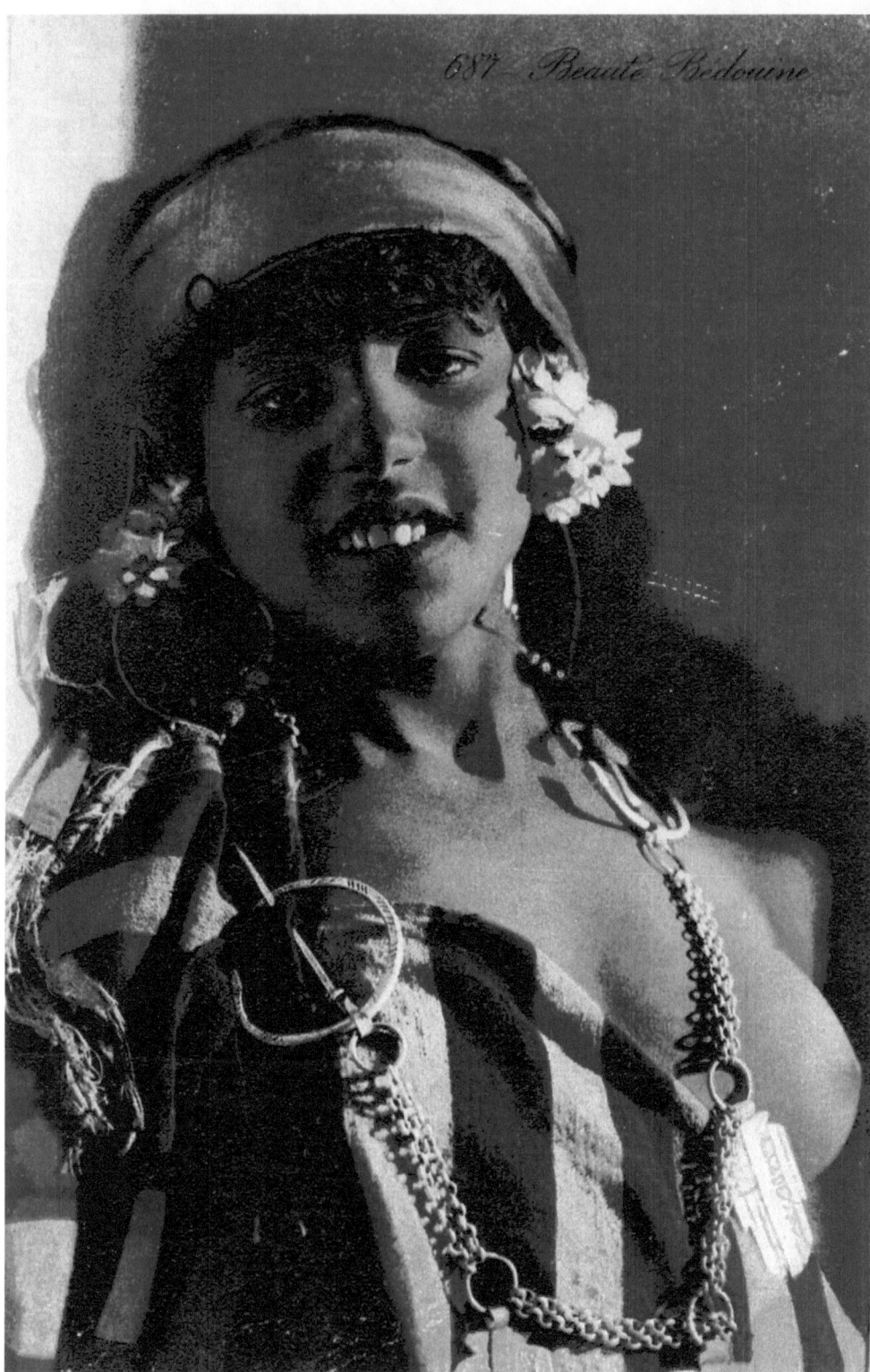

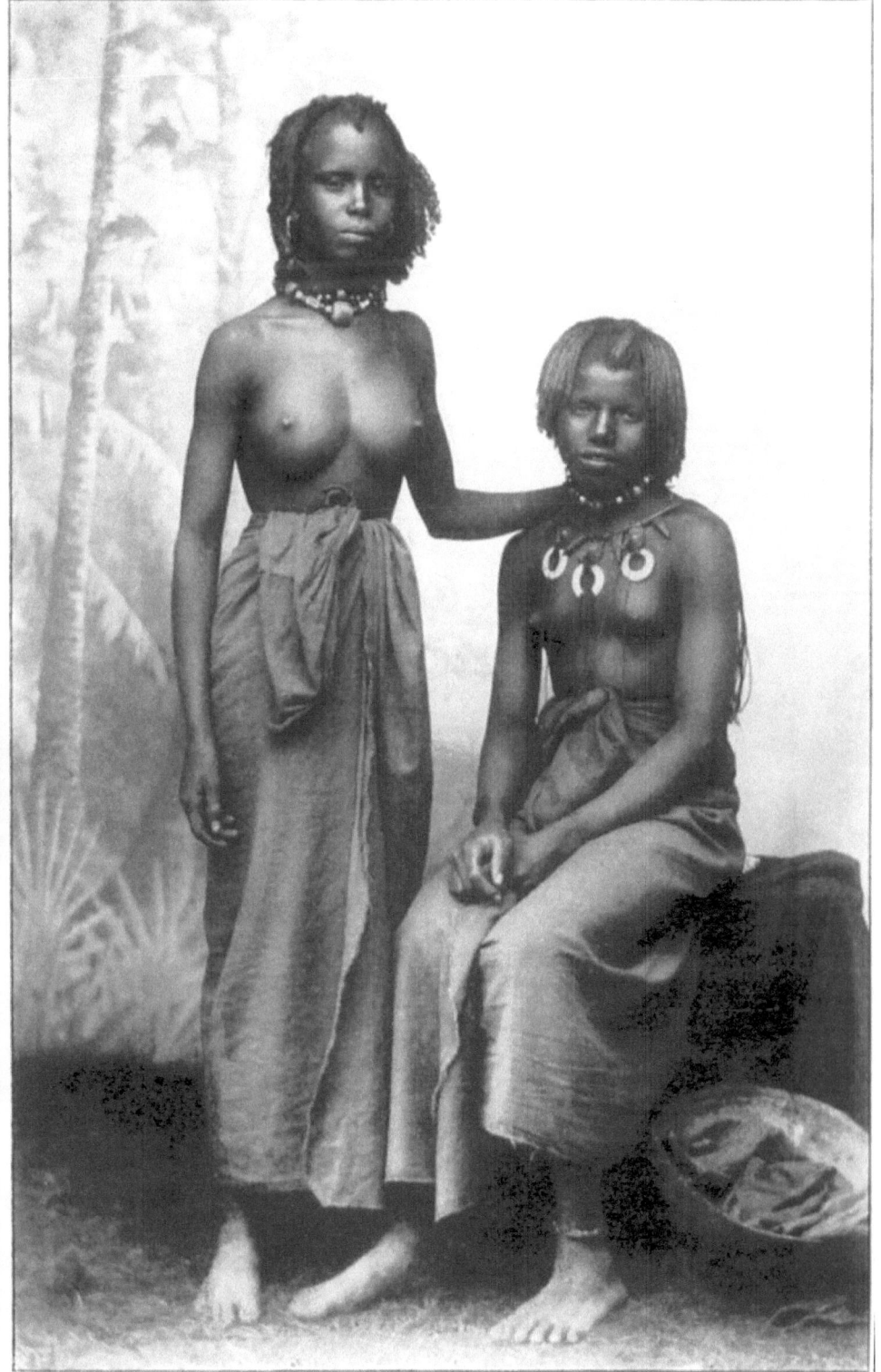

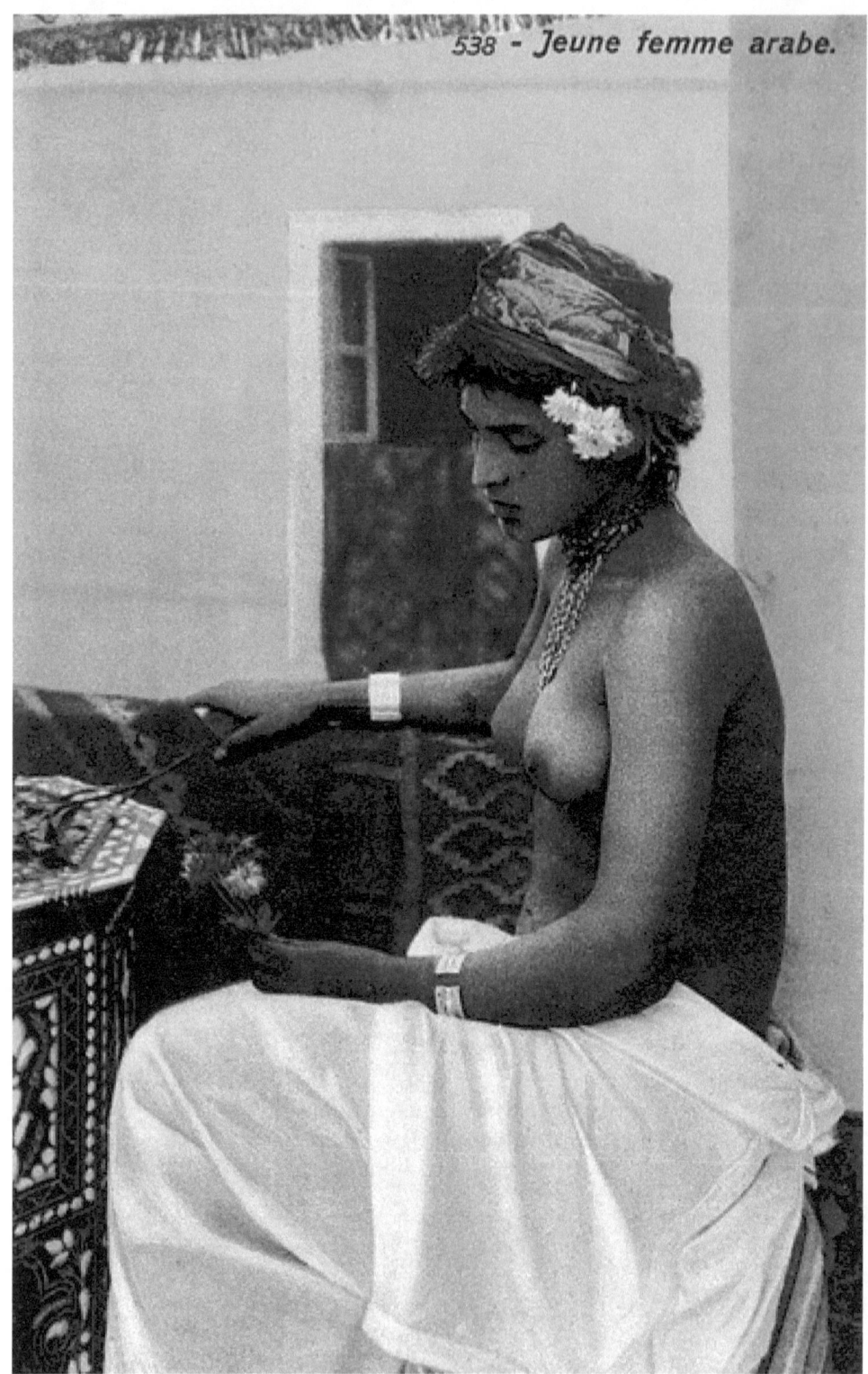
538 - Jeune femme arabe.

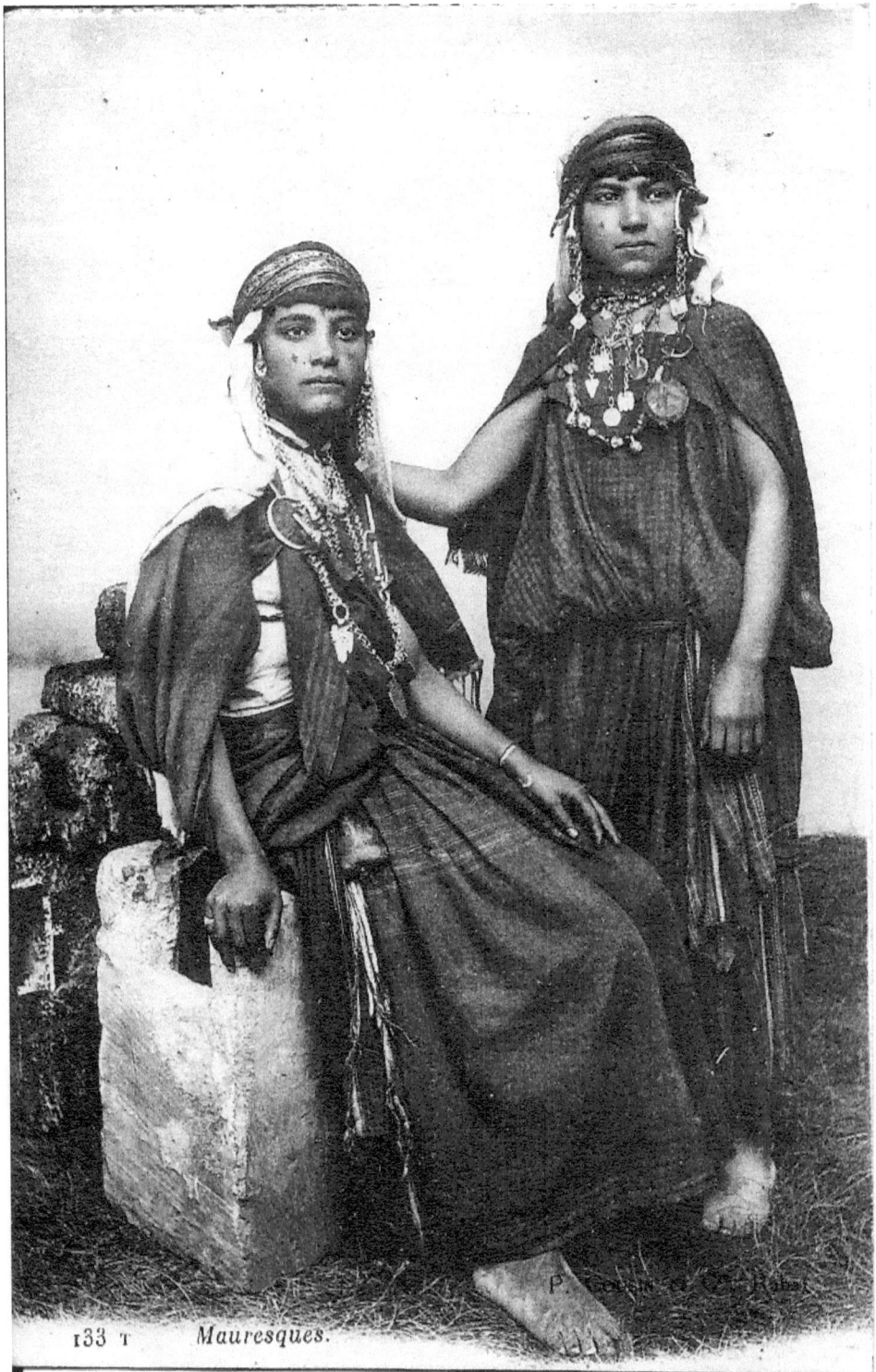
133 T Mauresques.

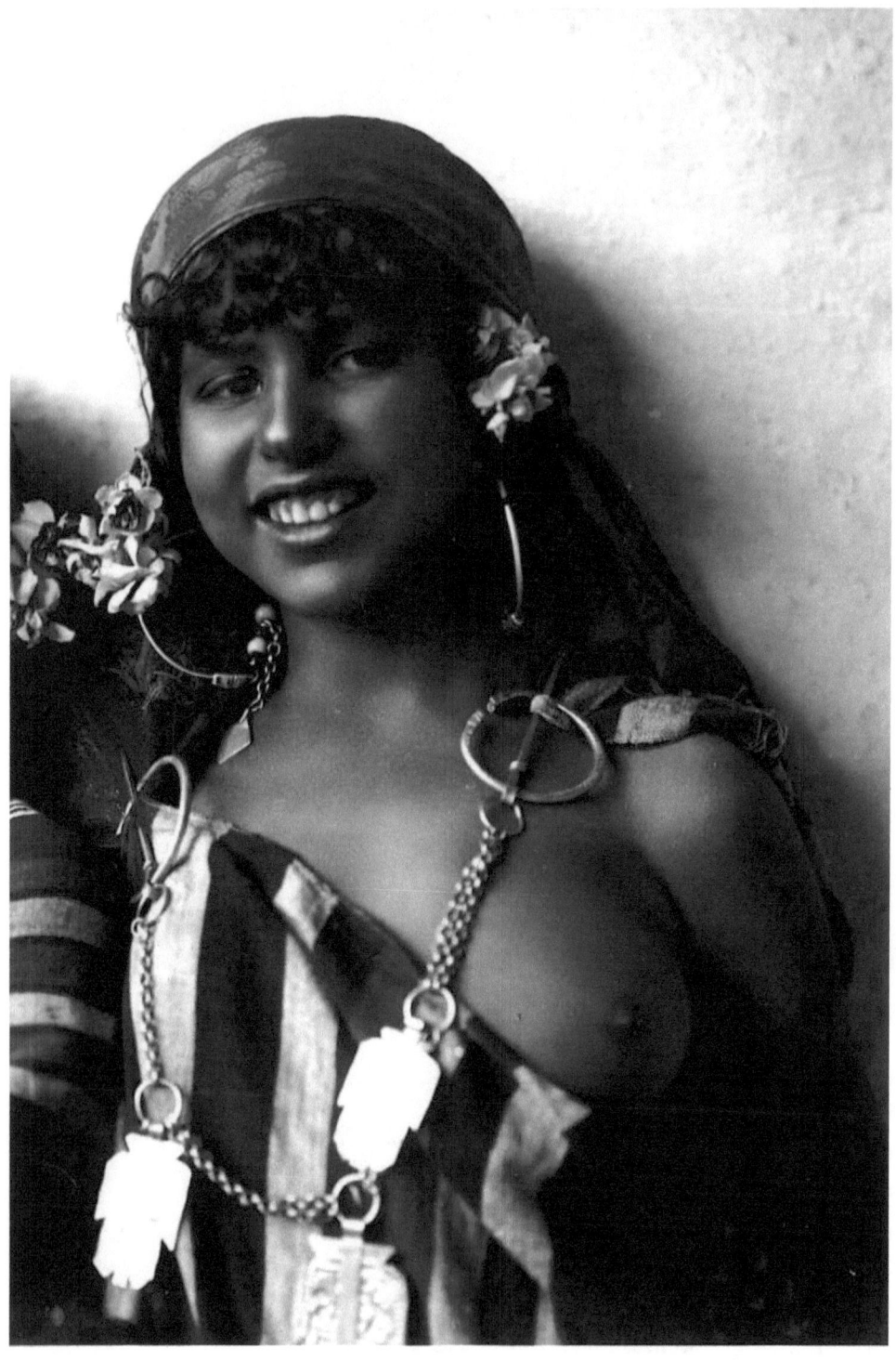

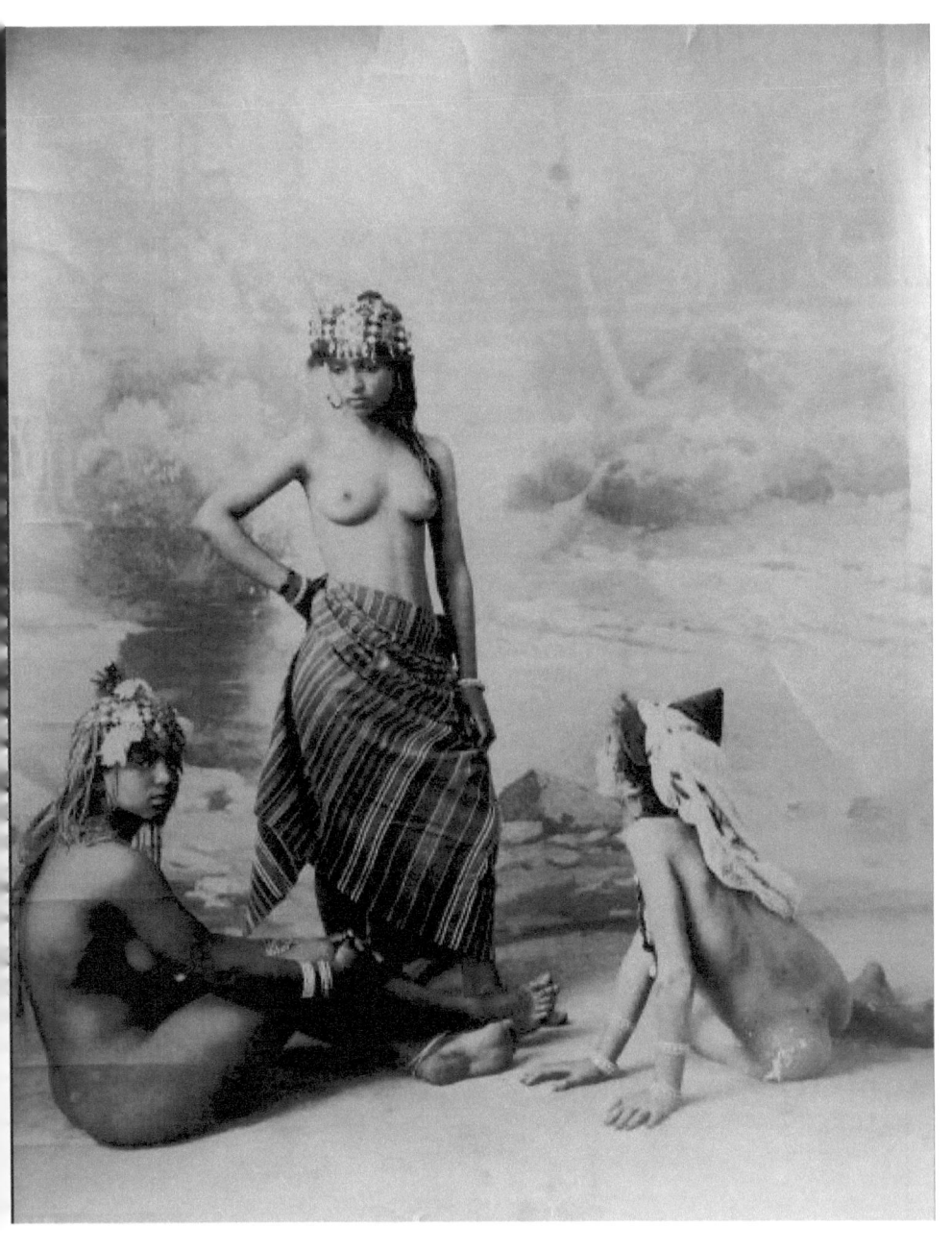

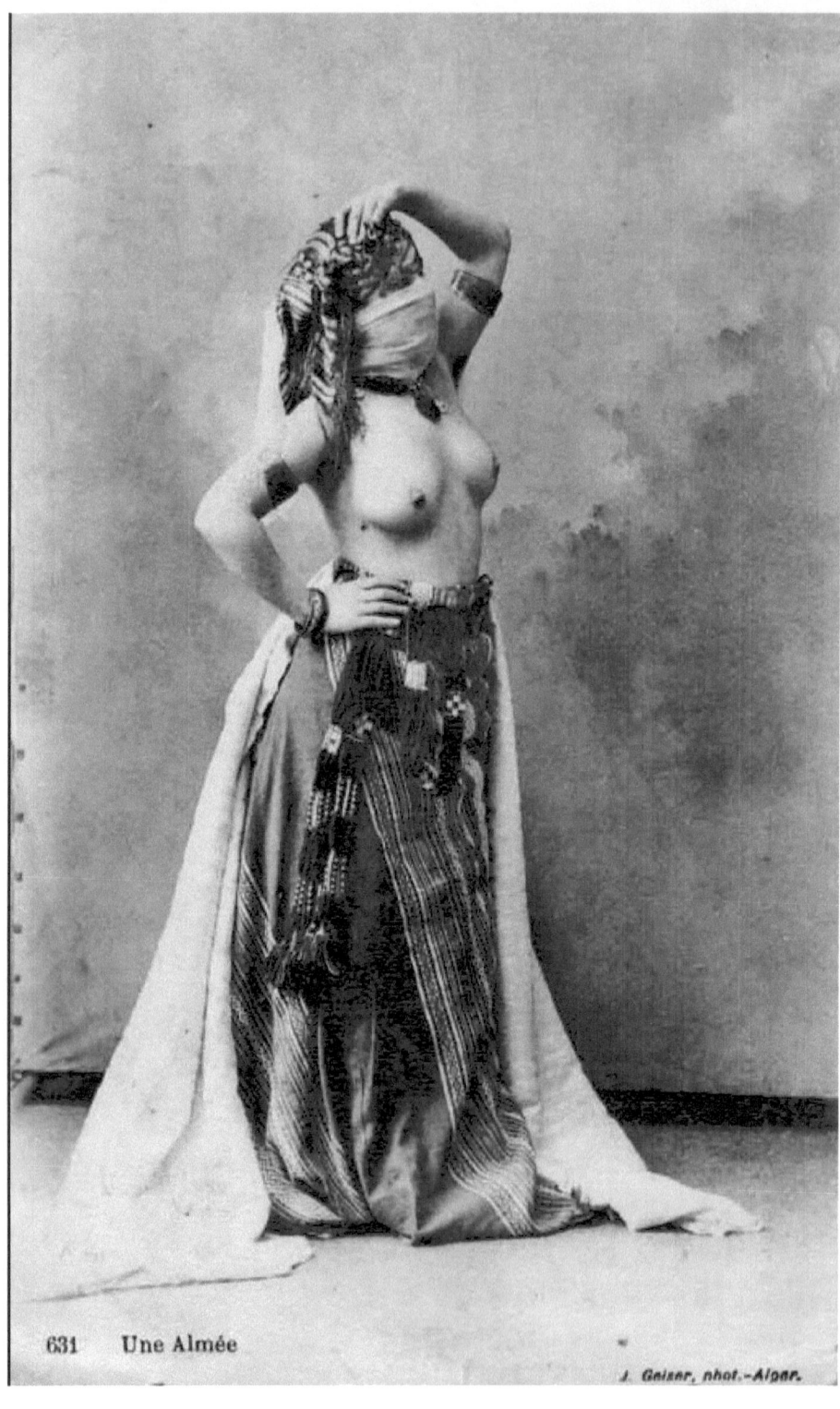

631 Une Almée

J. Geiser, phot.-Alger.

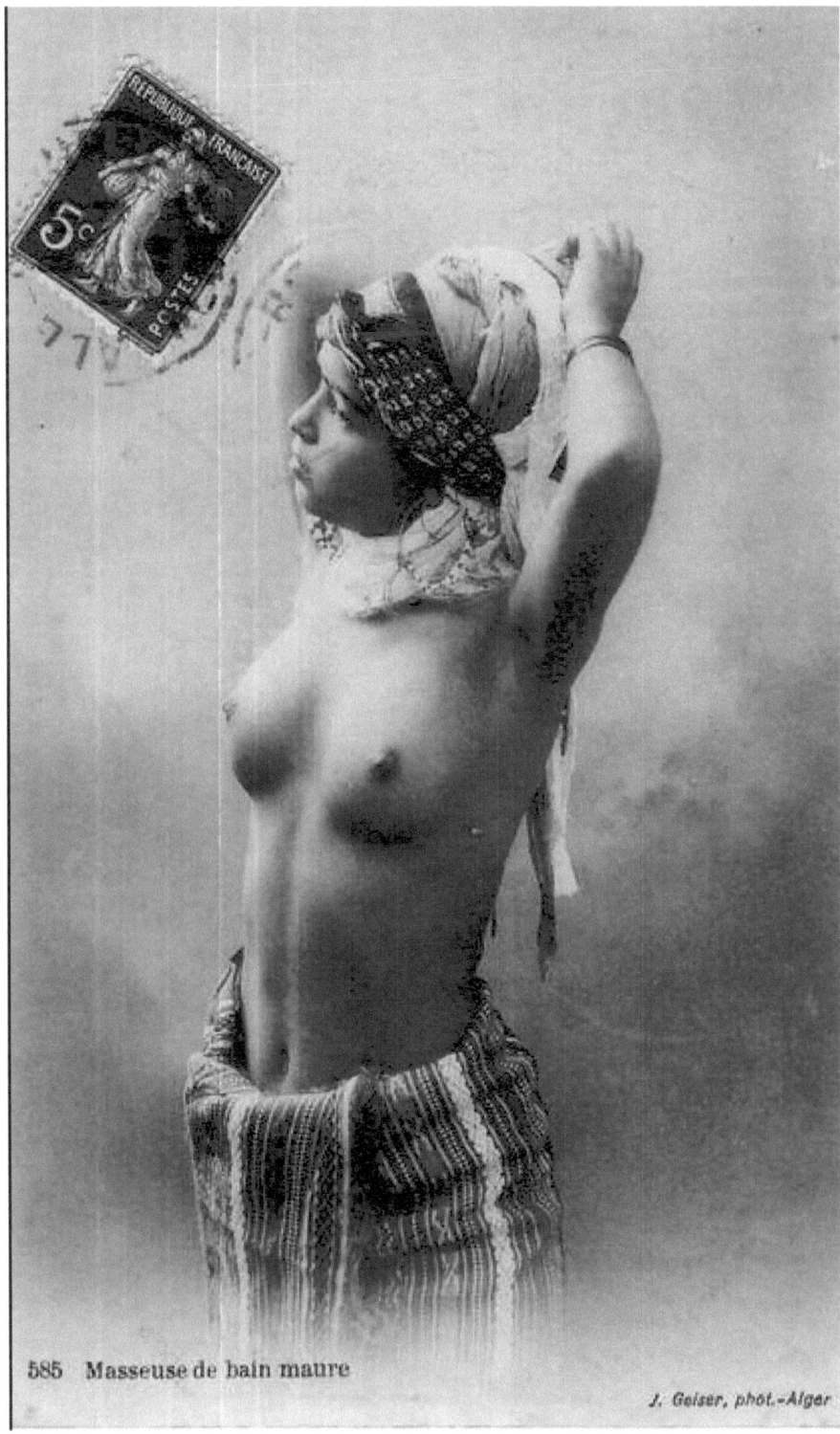

585 Masseuse de bain maure

J. Geiser, phot.-Alger

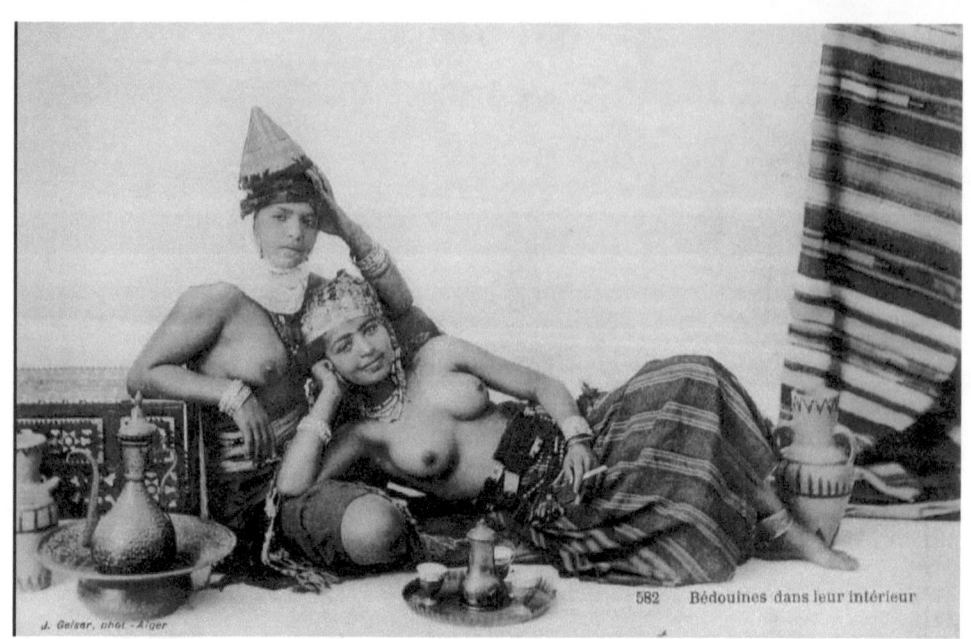

582 Bédouines dans leur intérieur

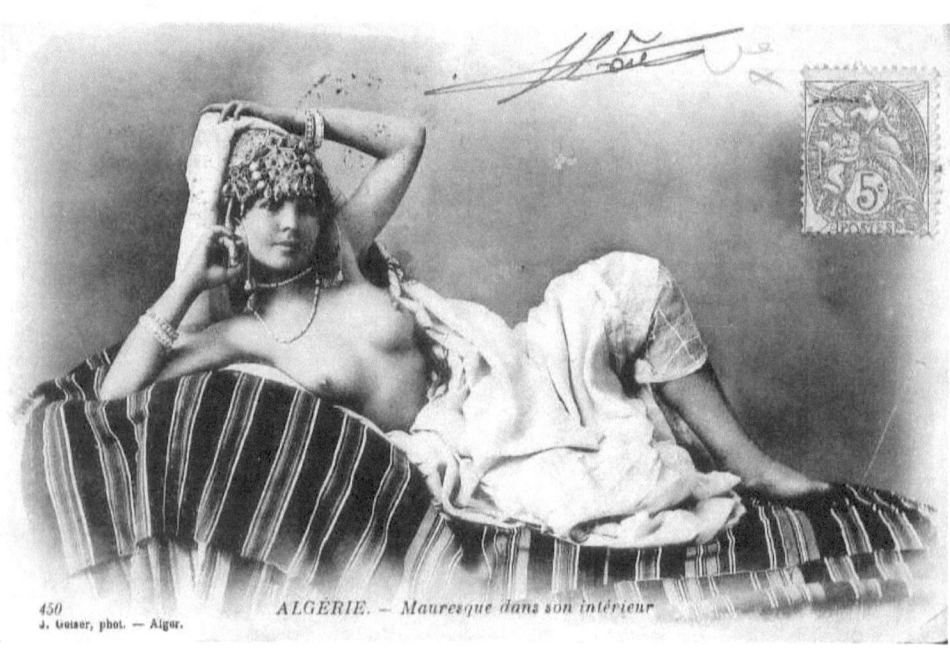

450 ALGÉRIE. — Mauresque dans son intérieur

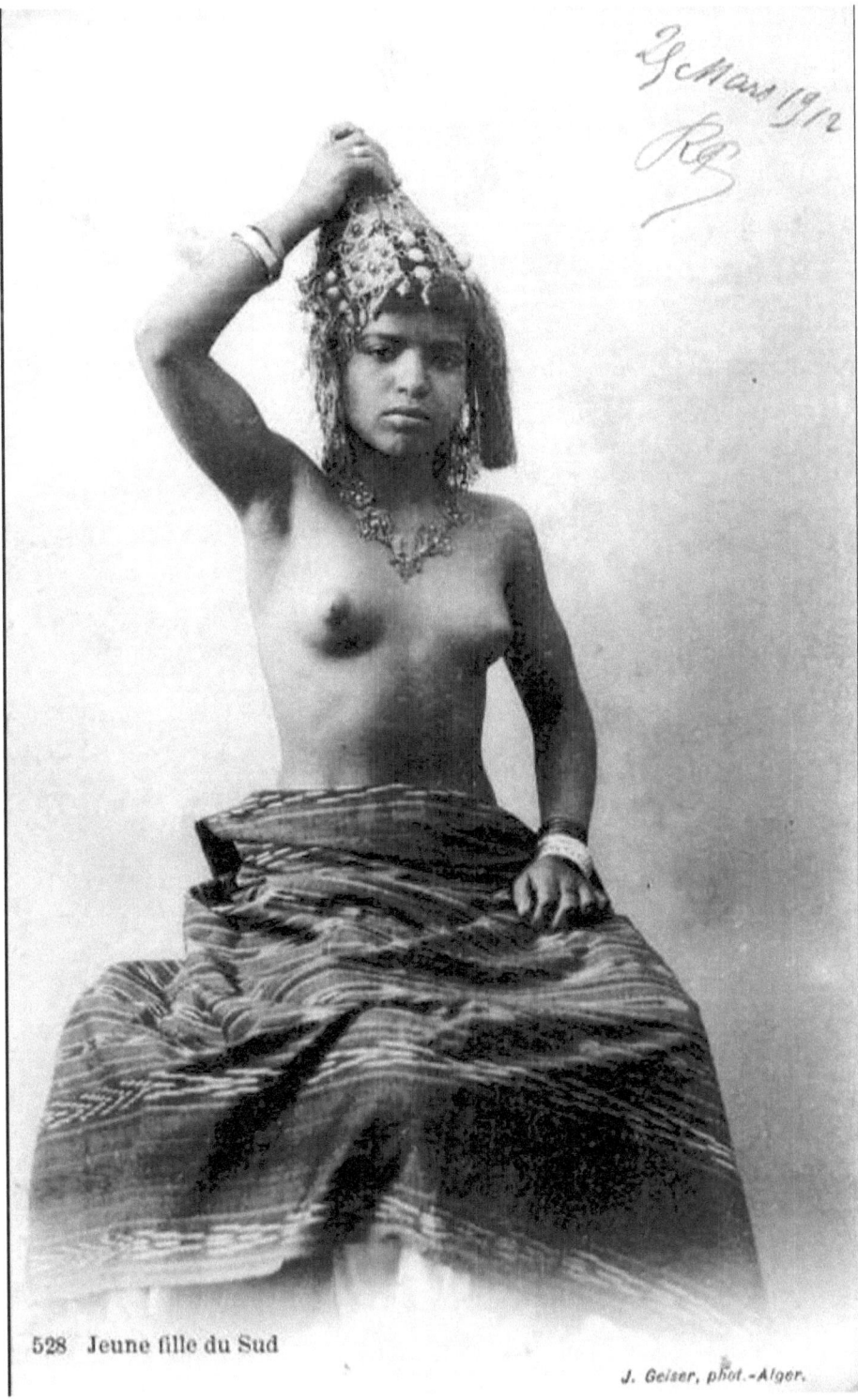

528 Jeune fille du Sud

J. Geiser, phot.-Alger.

faudrais de te voir avant
de quitter Zaza j'ai vu le
d'lieutenant de l'aviation
un bon copain. et comme
tu m'avais
dit que
tu voulais si tu
venir au y tiens
Maroc_ je te
et je mettrai
crois qu'il en relation
pourrait avec lui.
te faire
venir en Je t'em
remontant brasse
avec un cinq
type cent fois
 Marly

523 Jeune mauresque

J. Geiser, phot. — Alger.

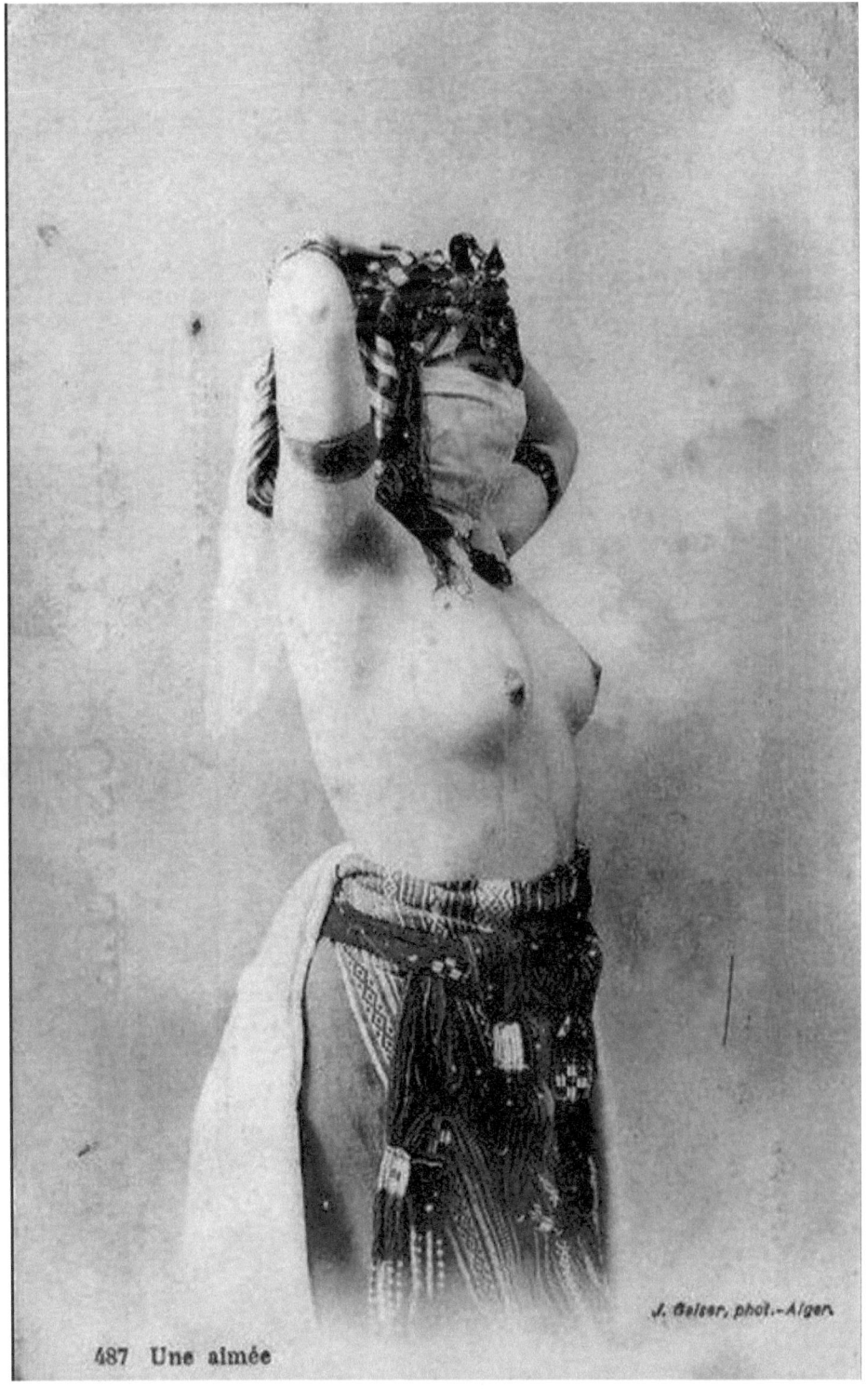

487 Une almée

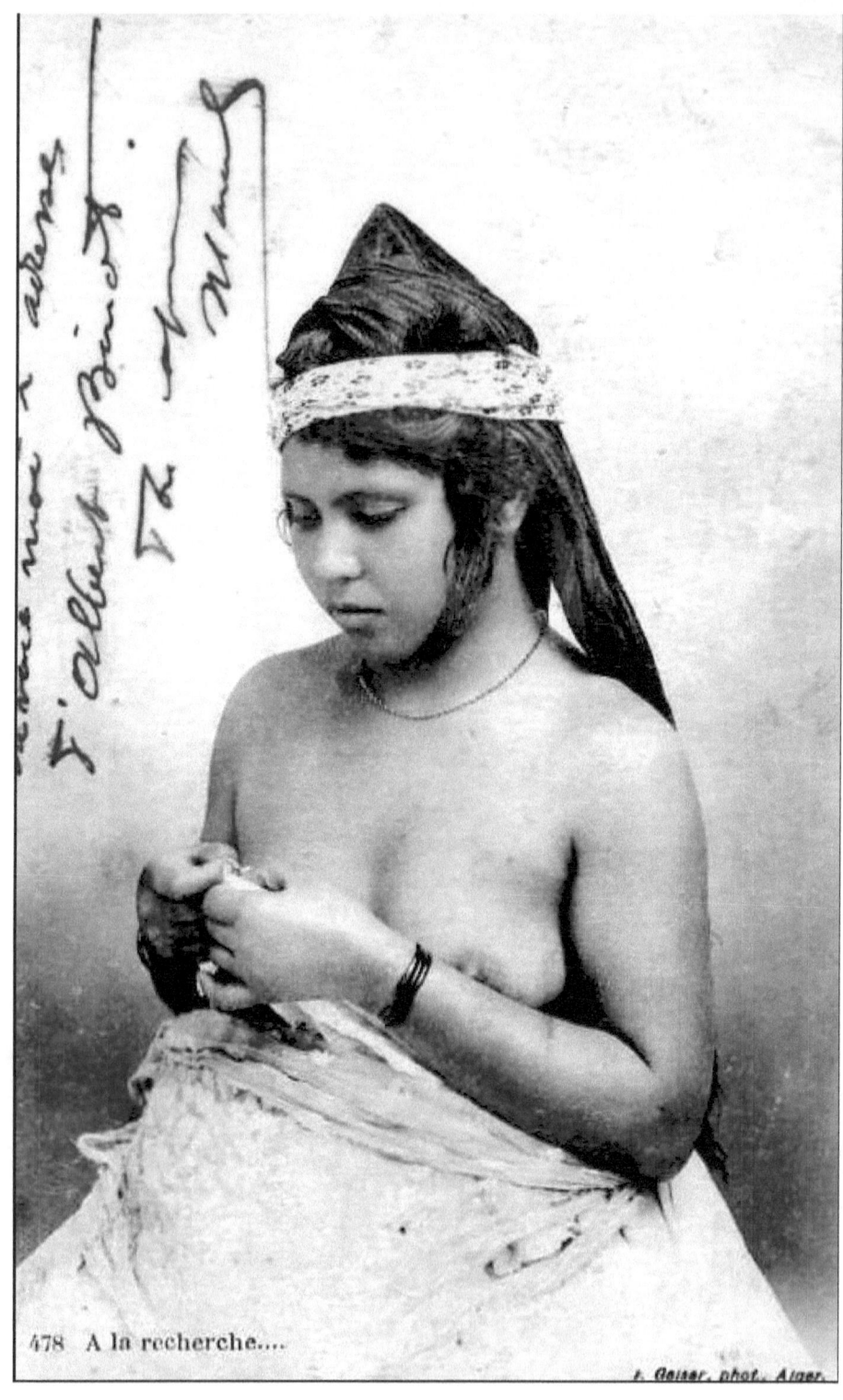
478 A la recherche....

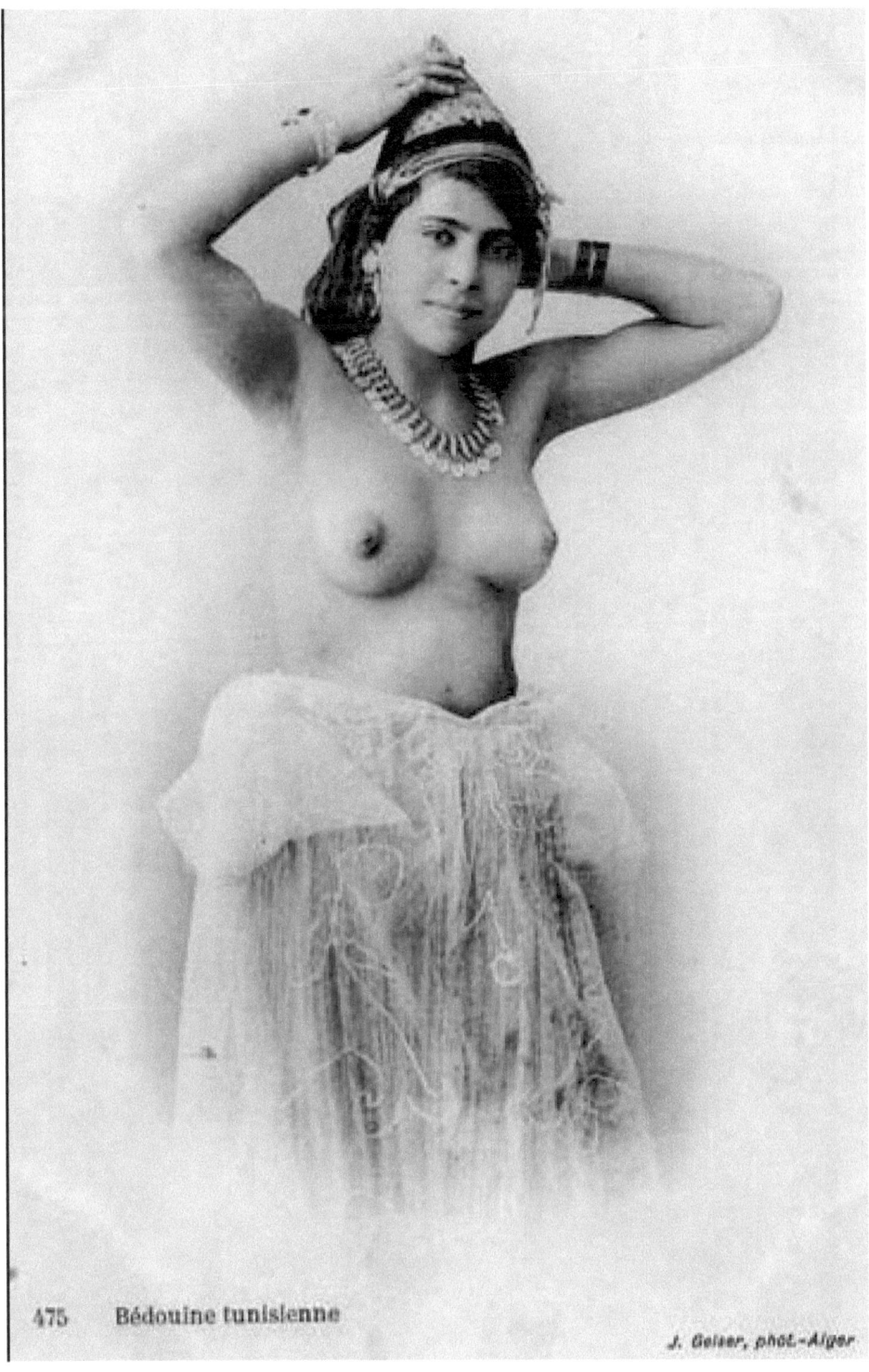

475 Bédouine tunisienne

J. Geiser, phot.-Alger

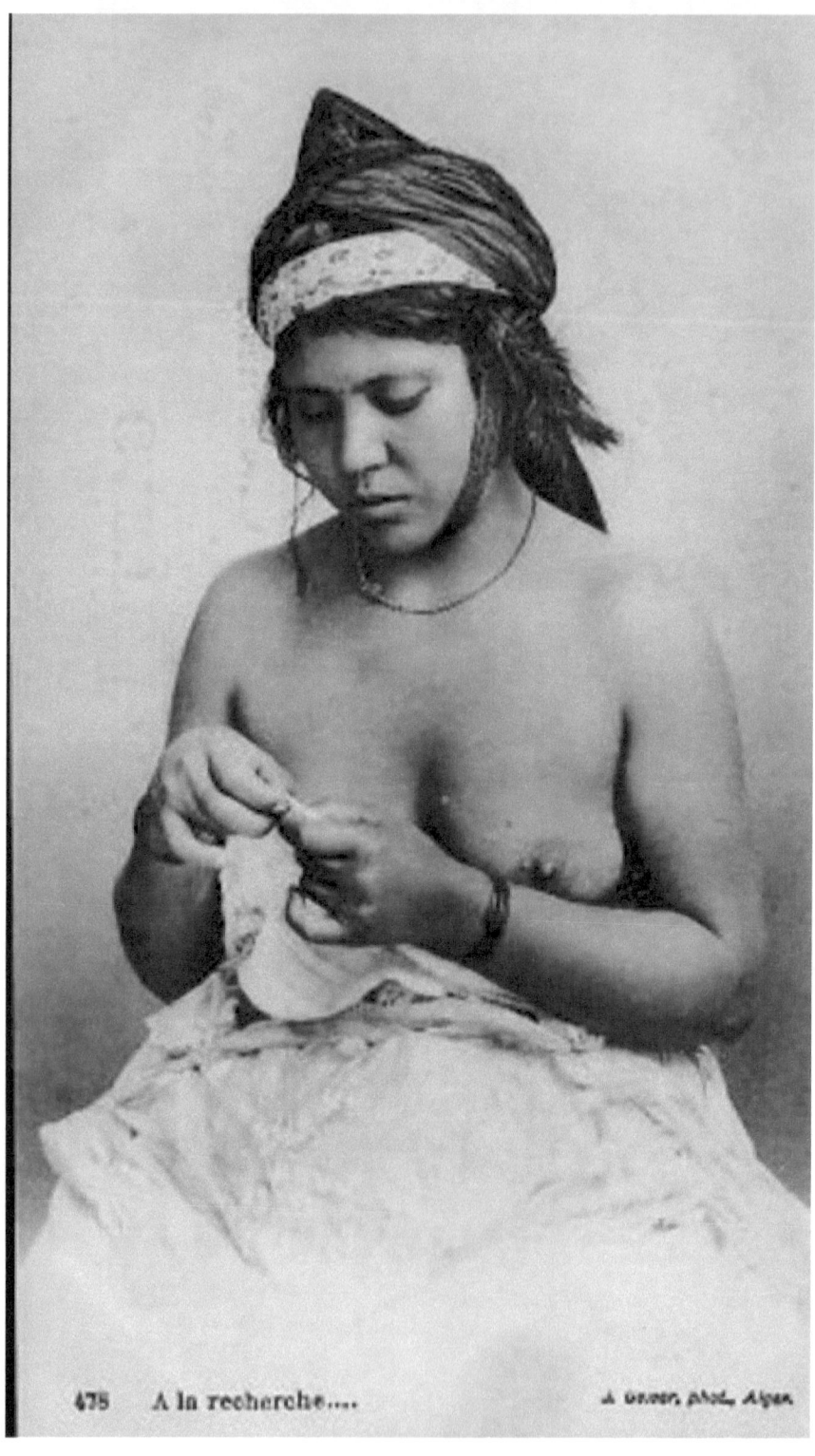

475 A la recherche.... A. Geiser, phot., Alger

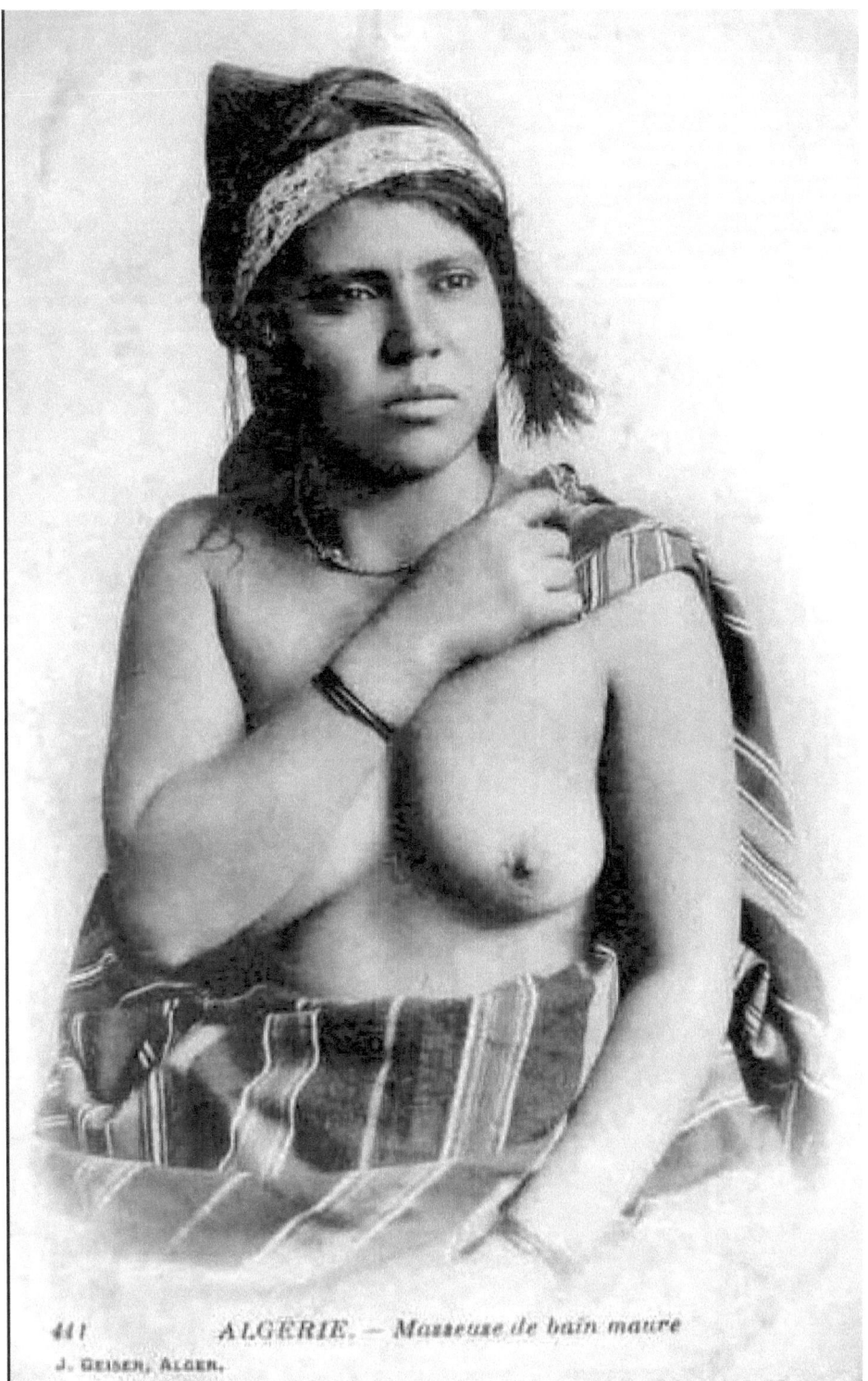

441 ALGÉRIE. — Masseuse de bain maure
J. GEISER, ALGER.

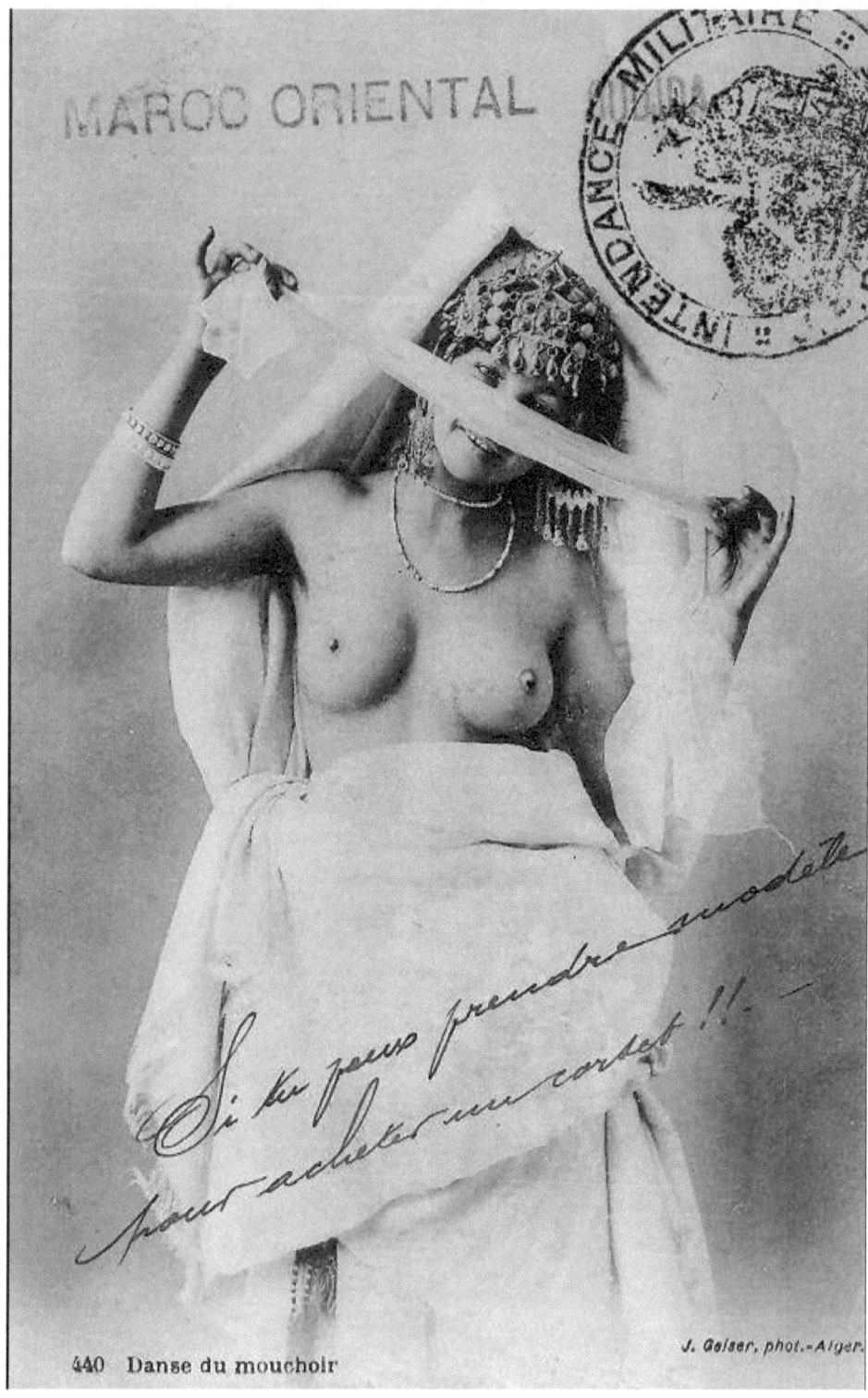

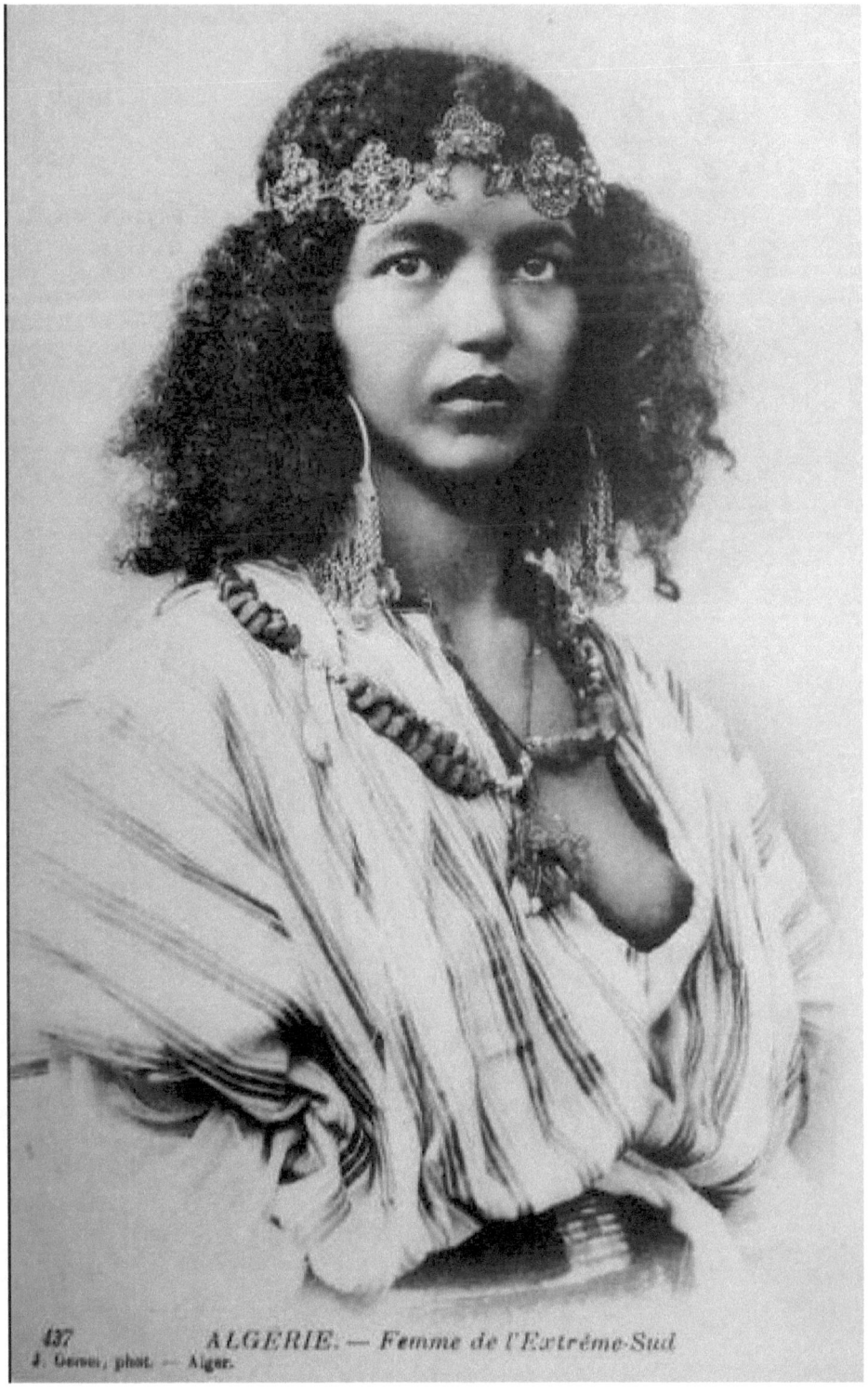

437 ALGERIE. — Femme de l'Extrême-Sud
J. Geiser, phot. — Alger.

431 Mauresque dans son intérieur J. Geiser, phot. — Alger

374 Mauresque dans son intérieur J. Geiser, phot.-Alger

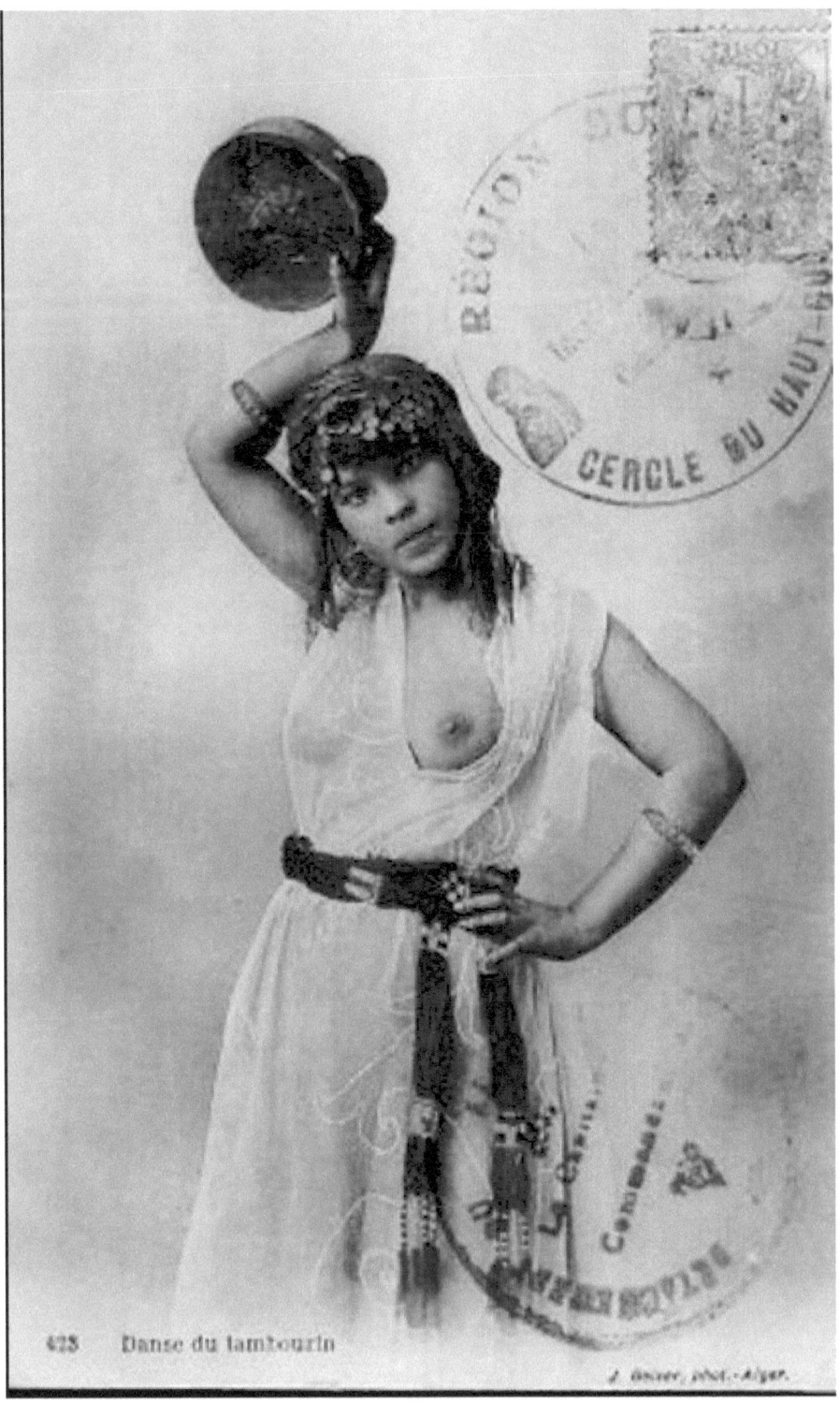

423 Danse du tambourin

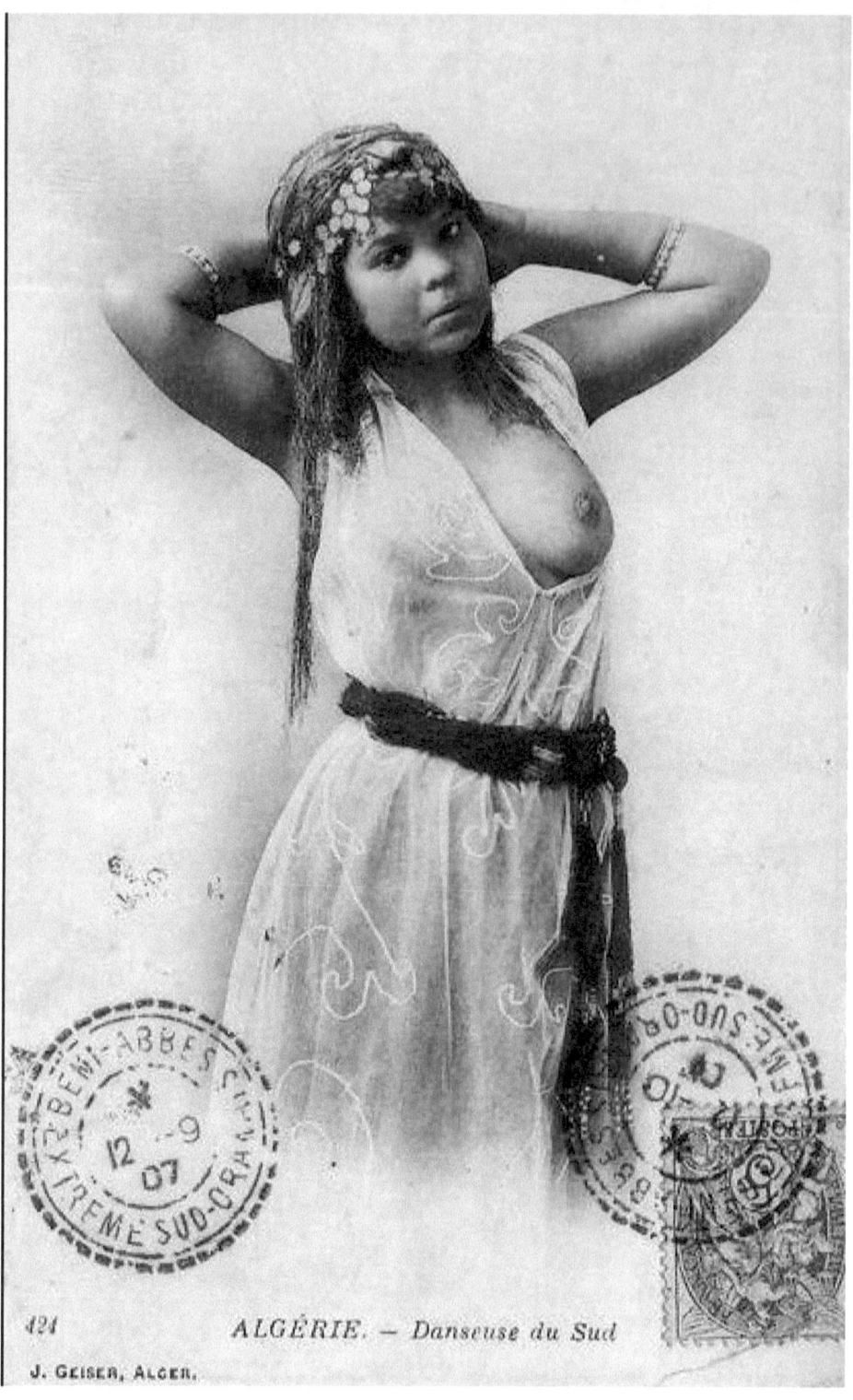

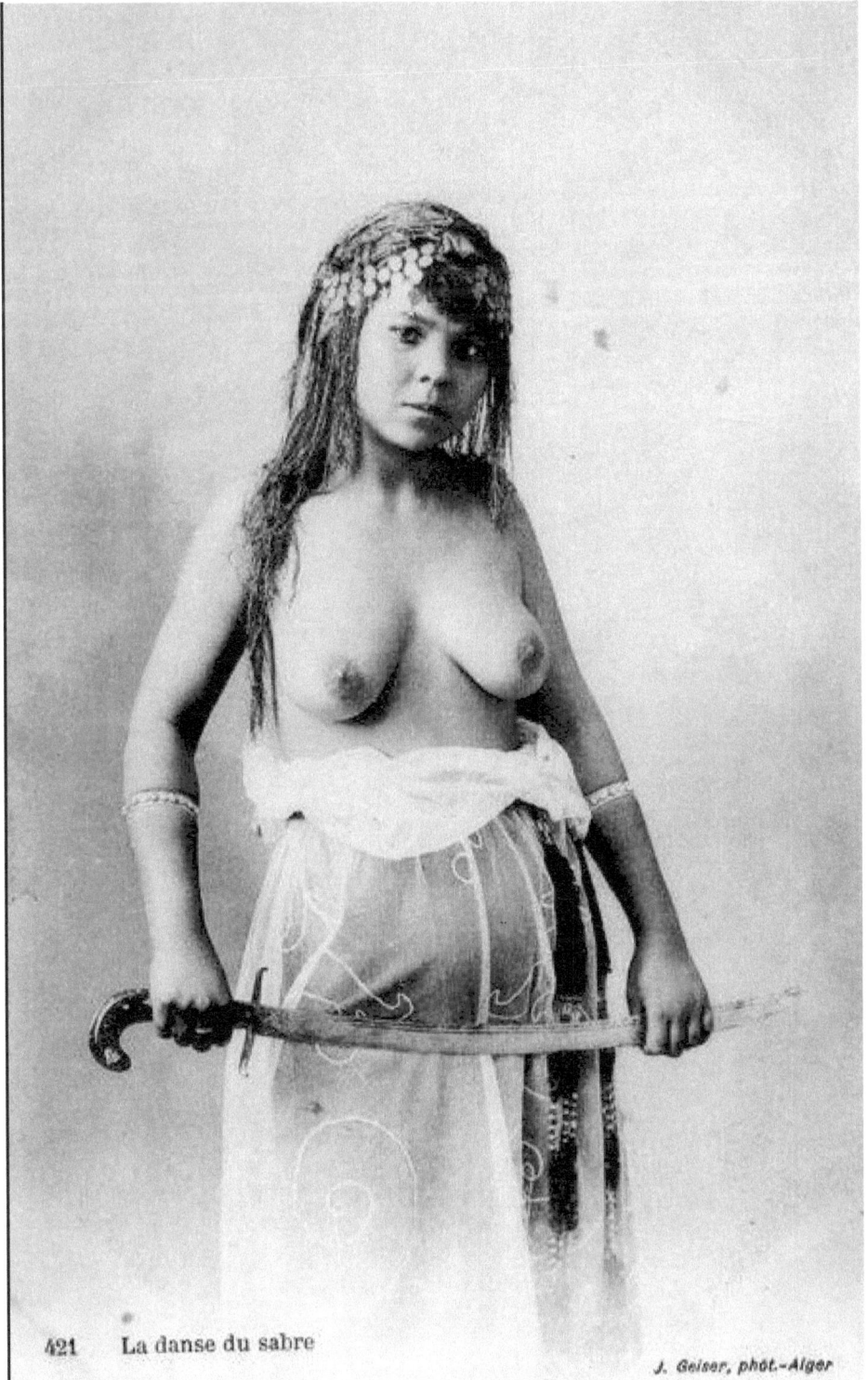

421 La danse du sabre

J. Geiser, phot.-Alger

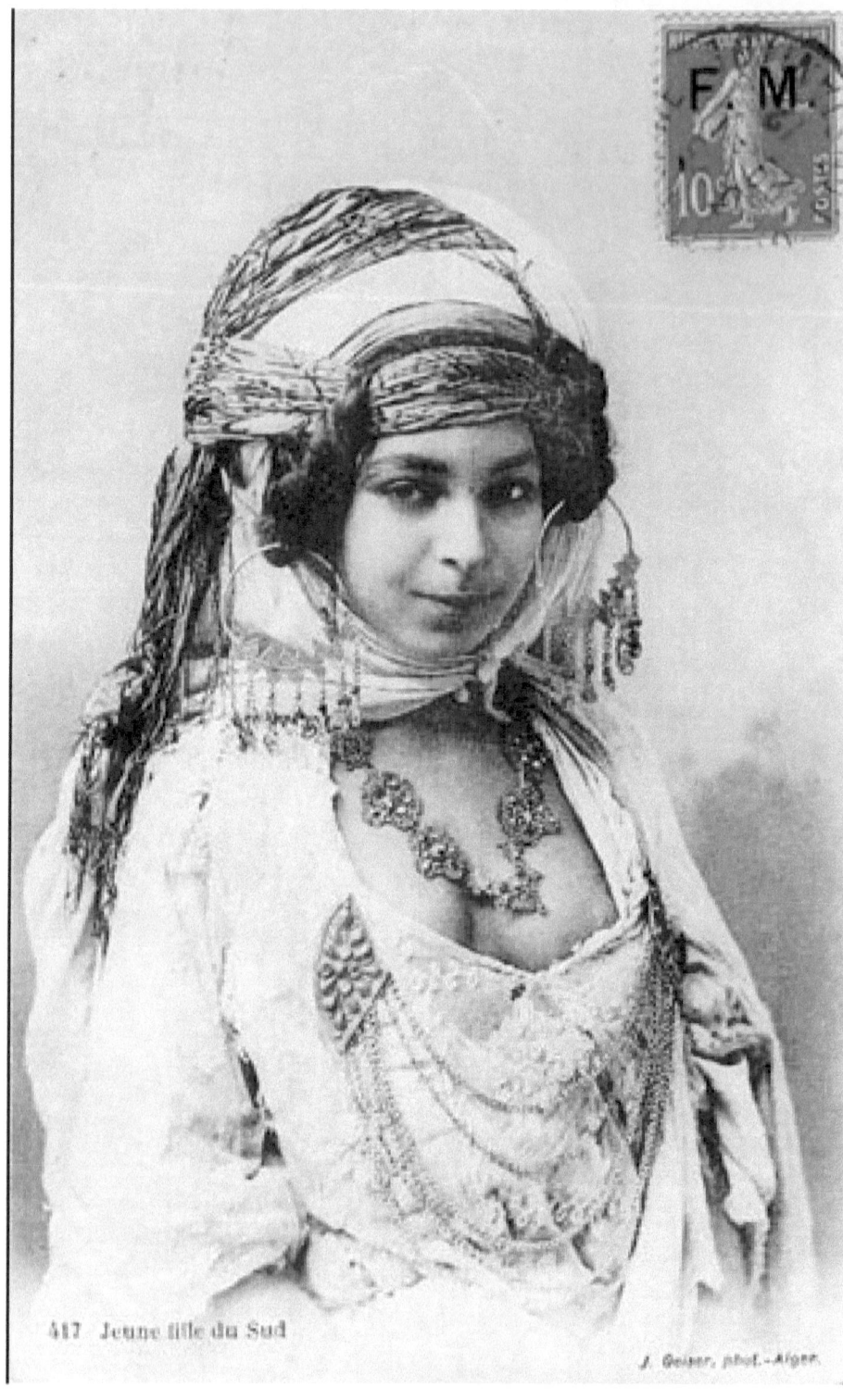

417 Jeune fille du Sud

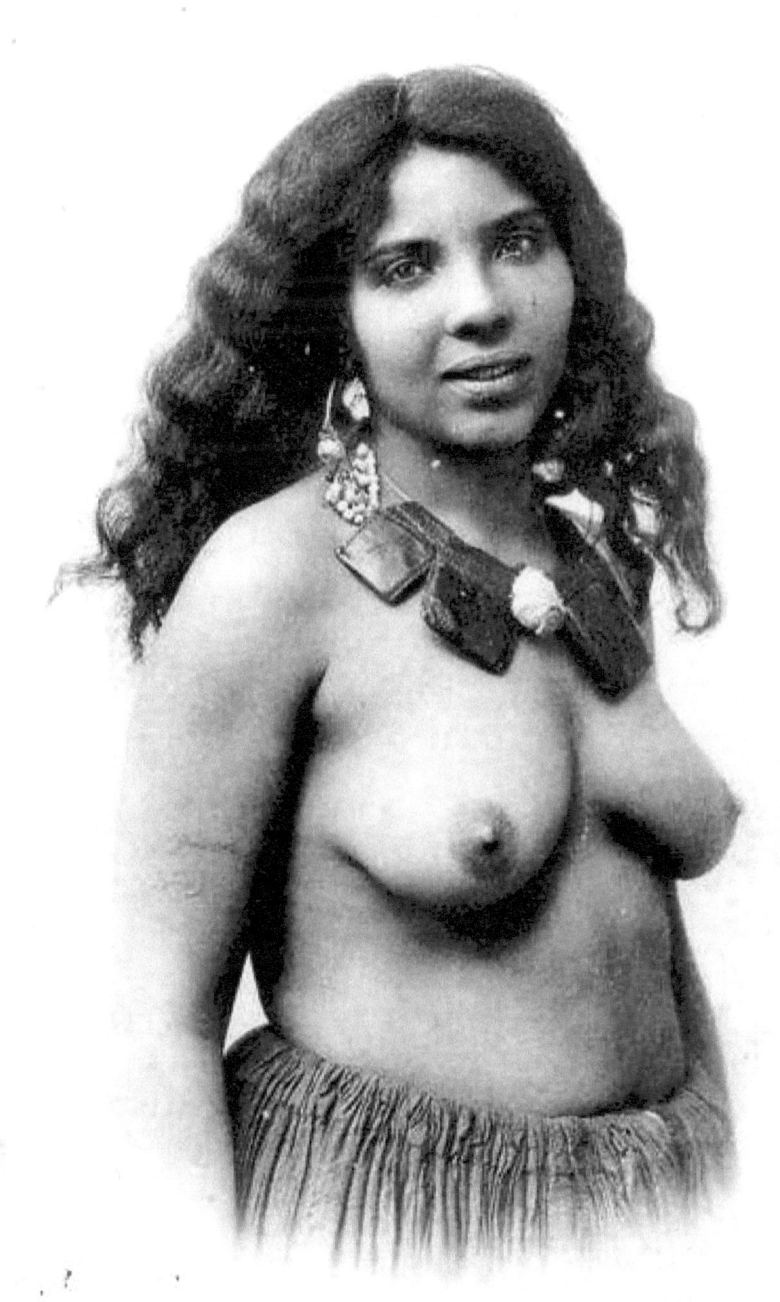

Algérie. — *Masseuse de Bain maure*

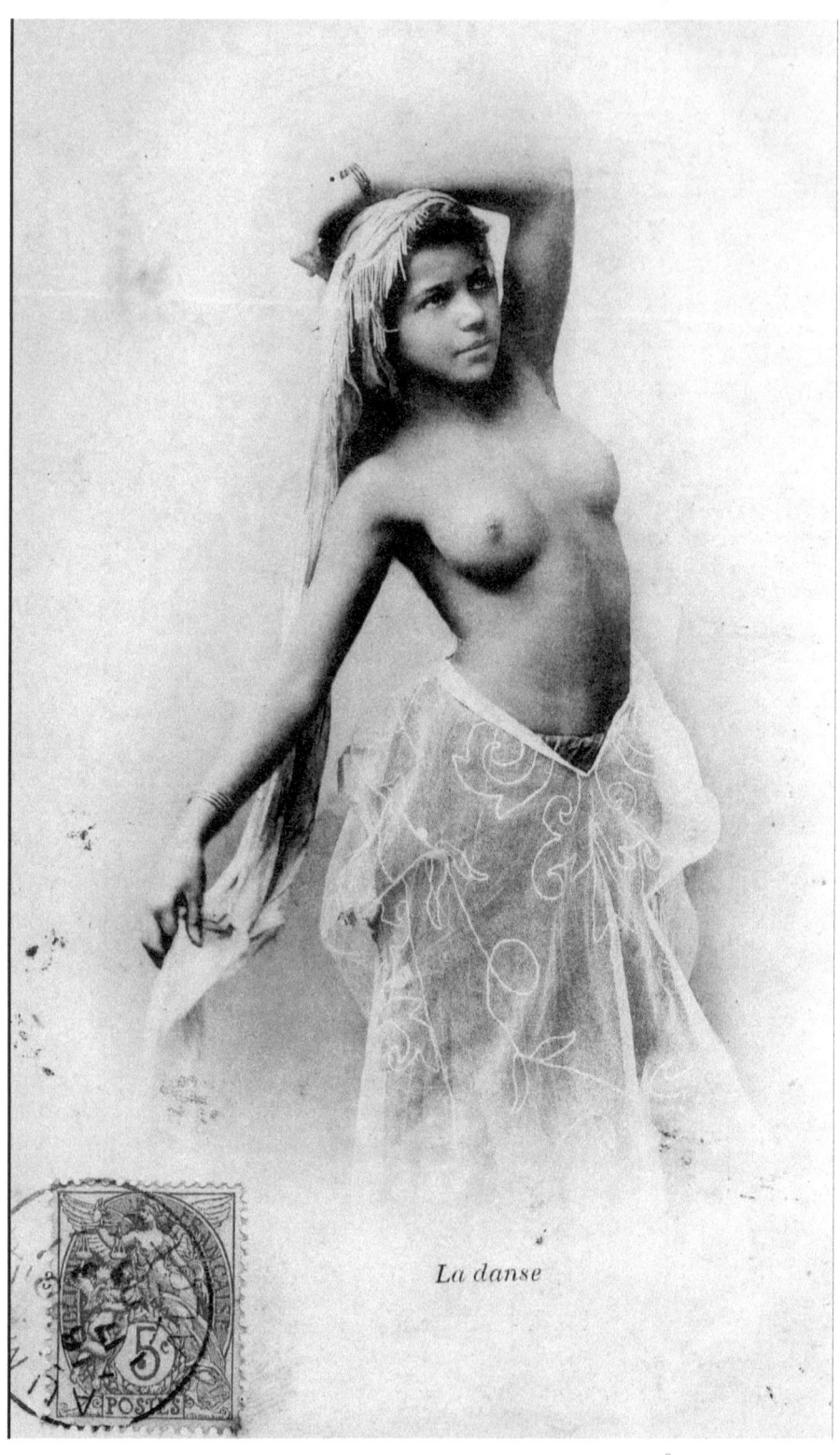

La danse

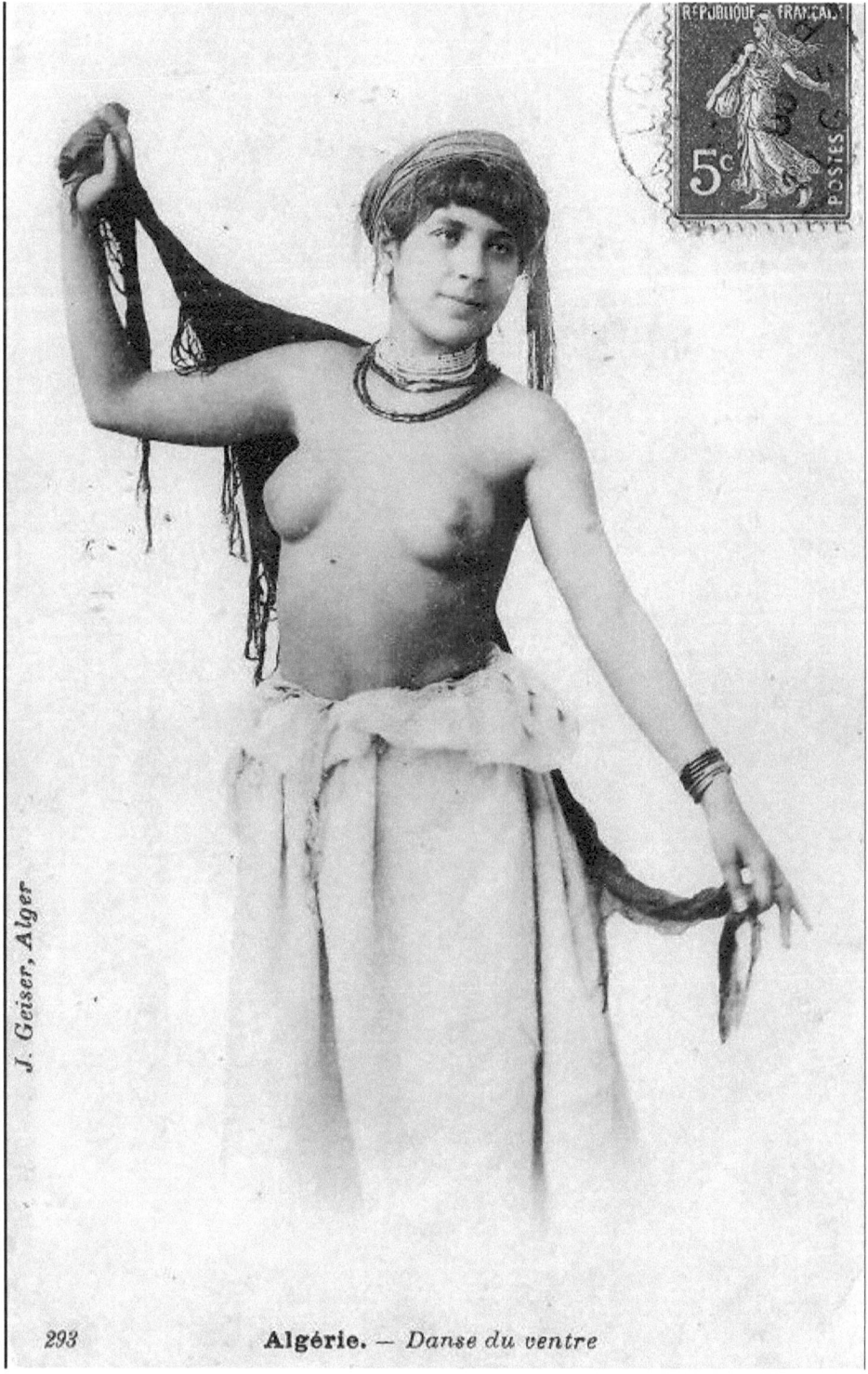

Algérie. — *Danse du ventre*

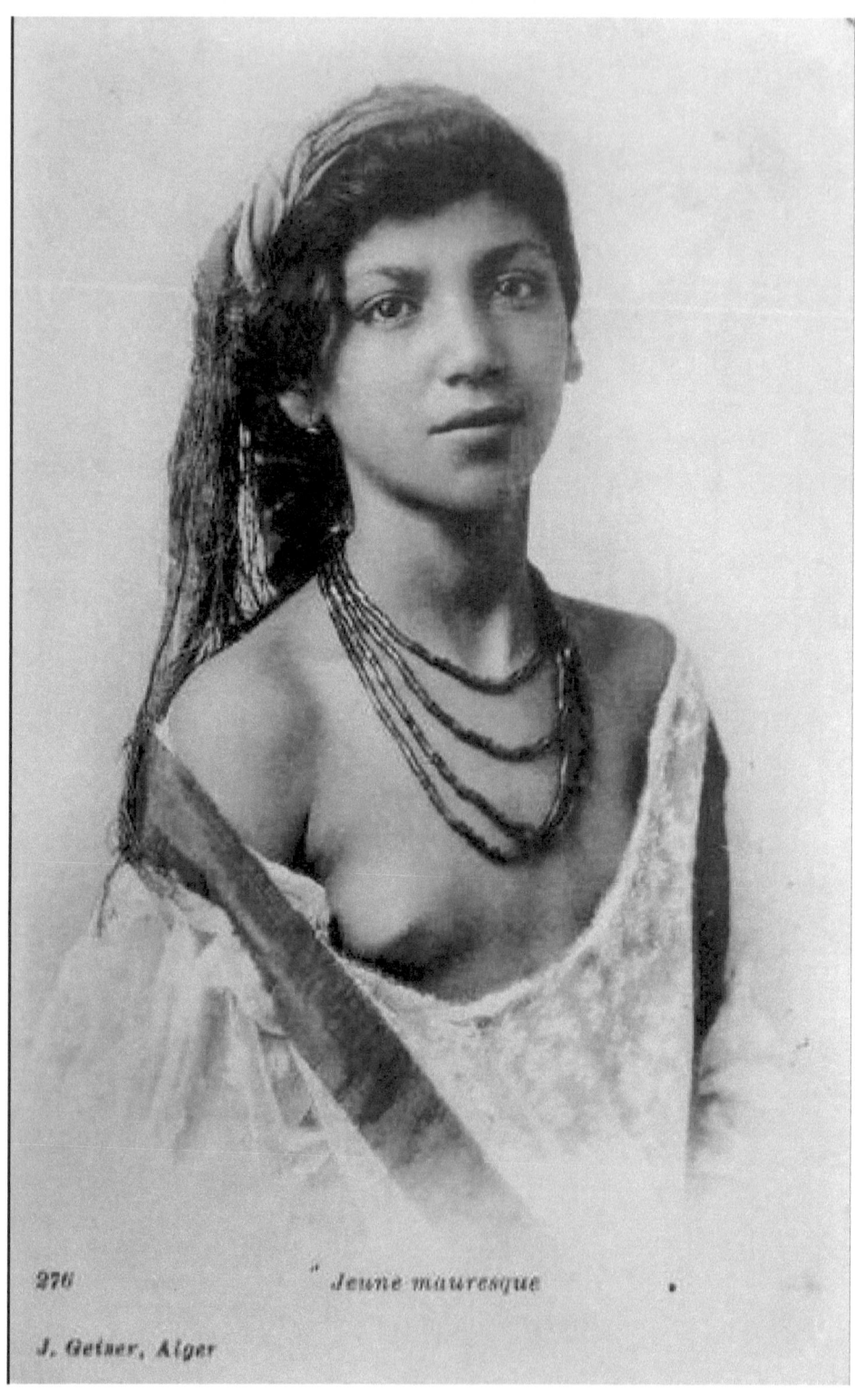

273 Jeune mauresque

J. Geiser, Alger

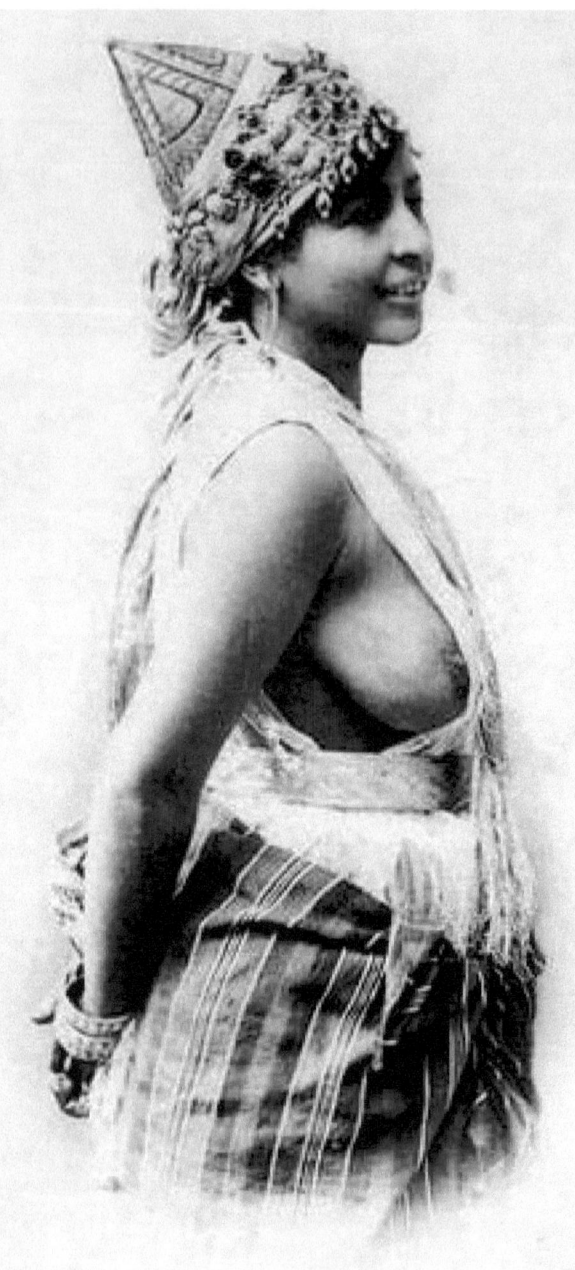

272 Femme du Sud

J. Geiser, phot.-Alger.

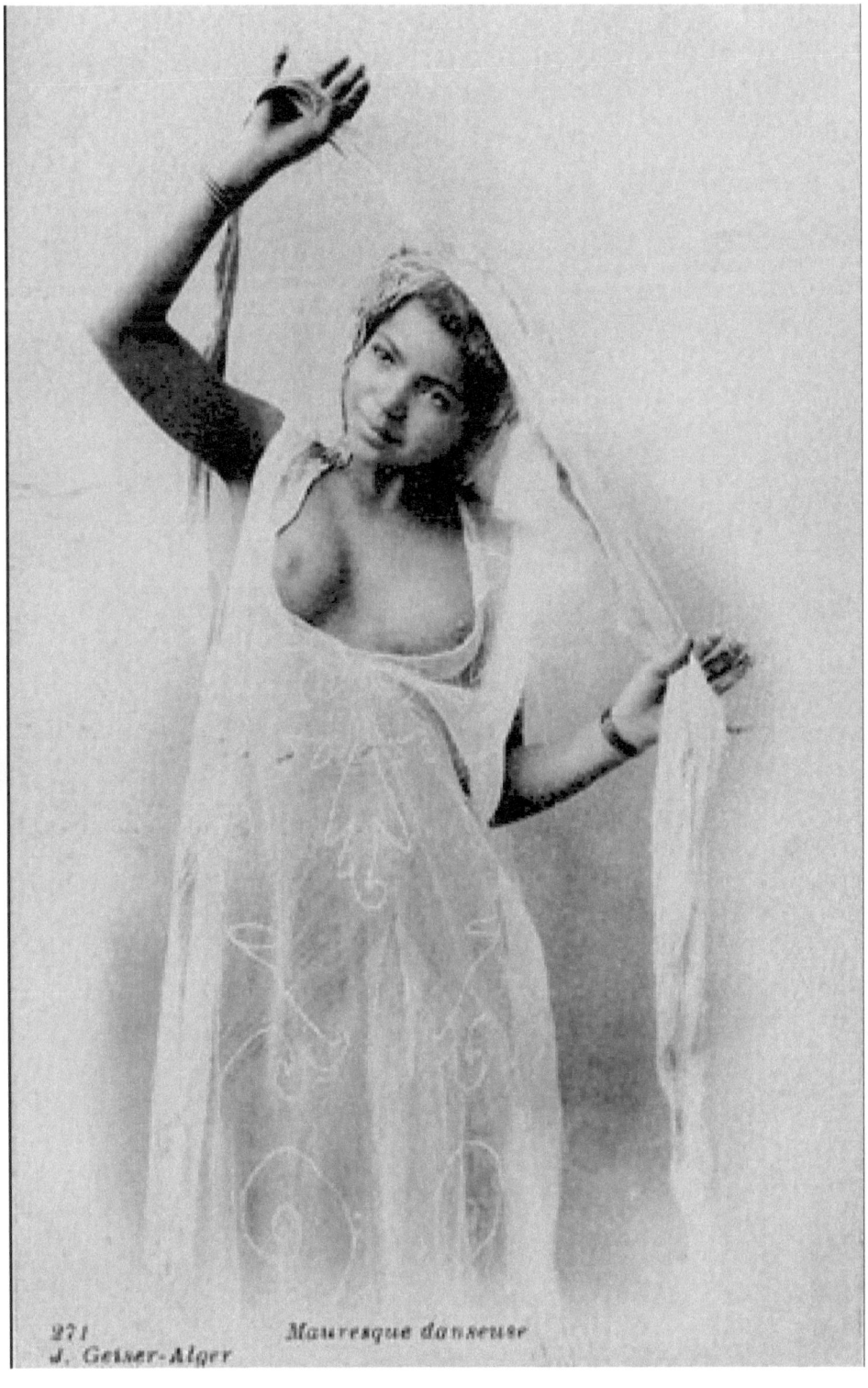

271 Mauresque danseuse
J. Geiser-Alger

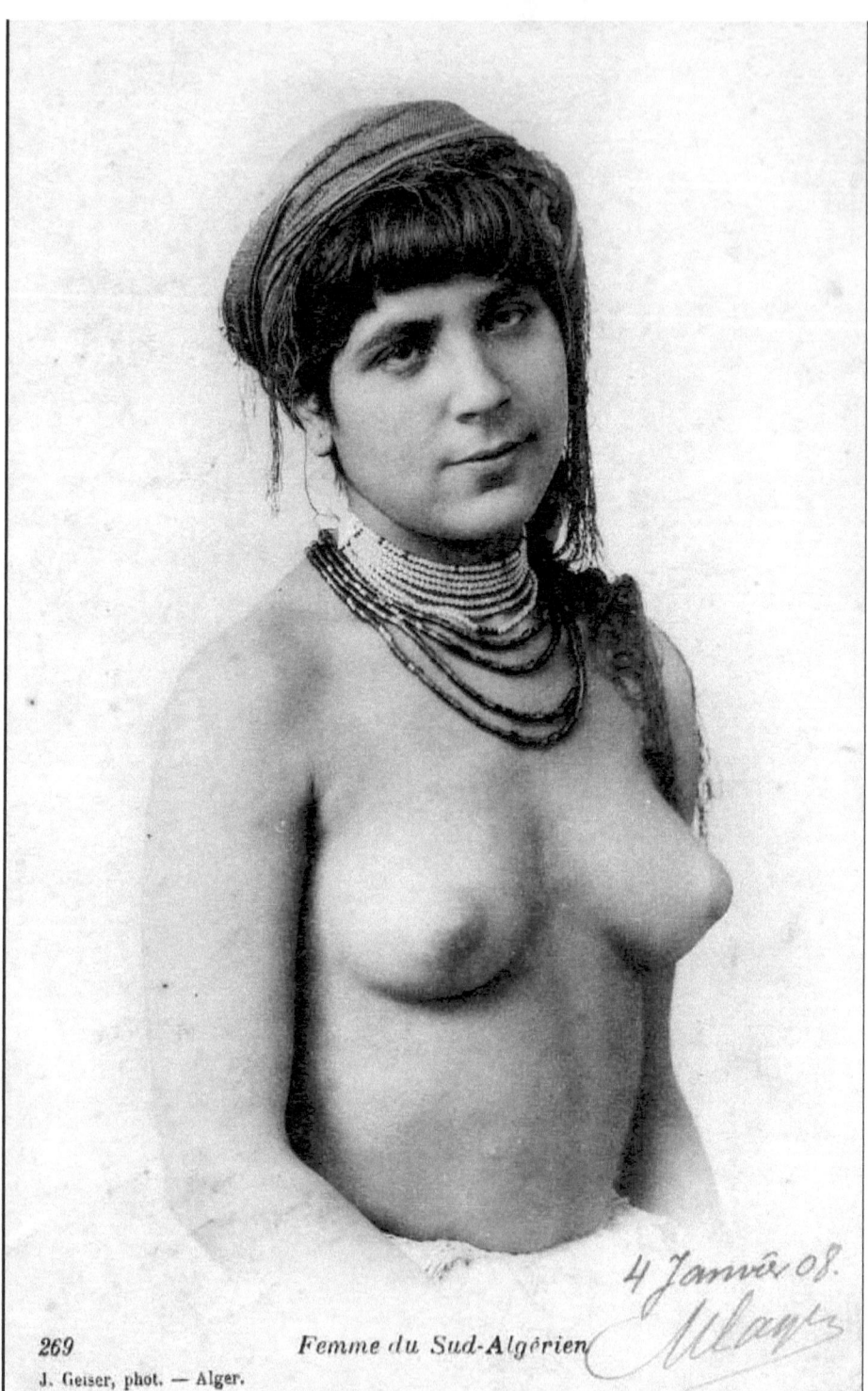

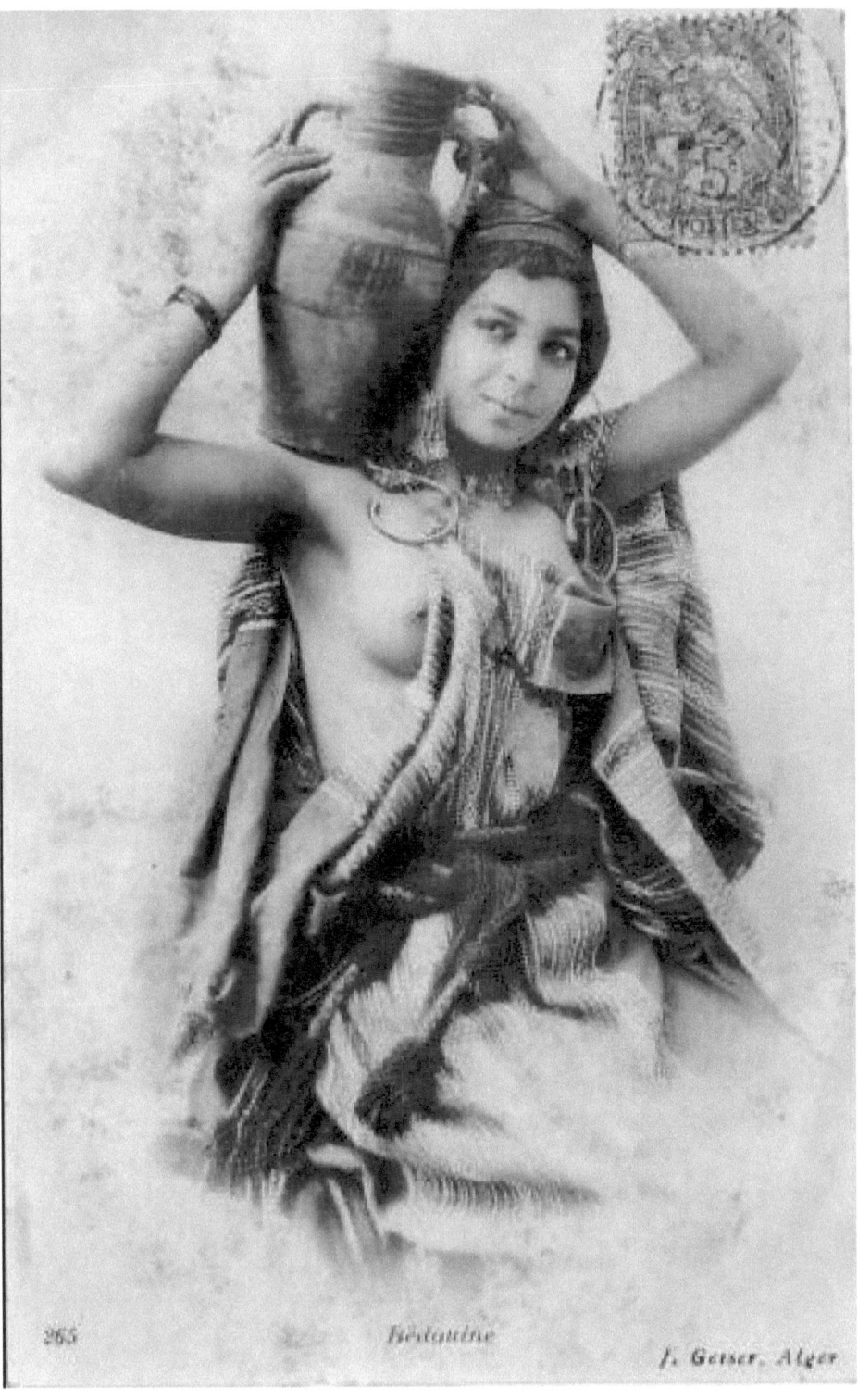

Bédouine

J. Geiser, Alger

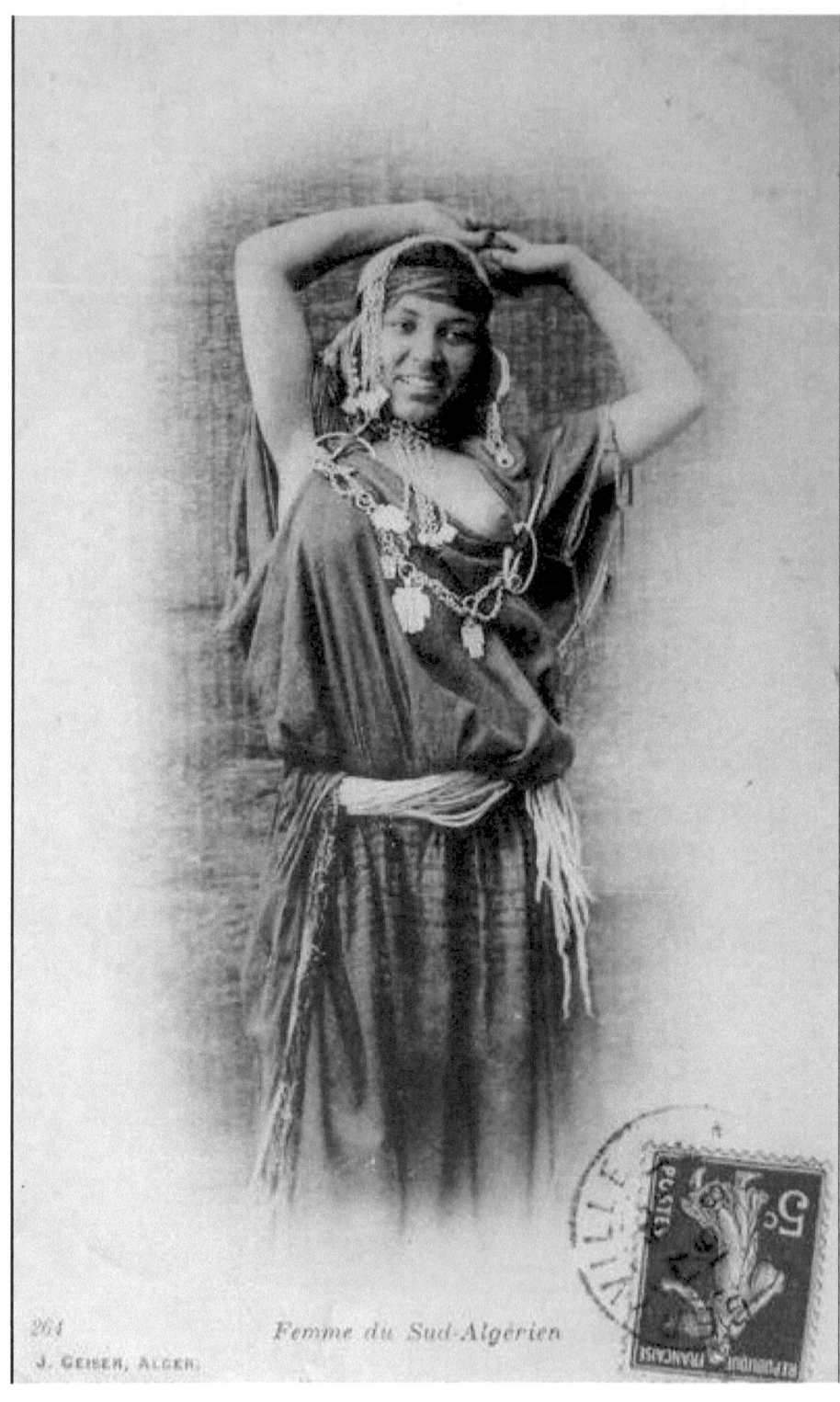
Femme du Sud-Algérien

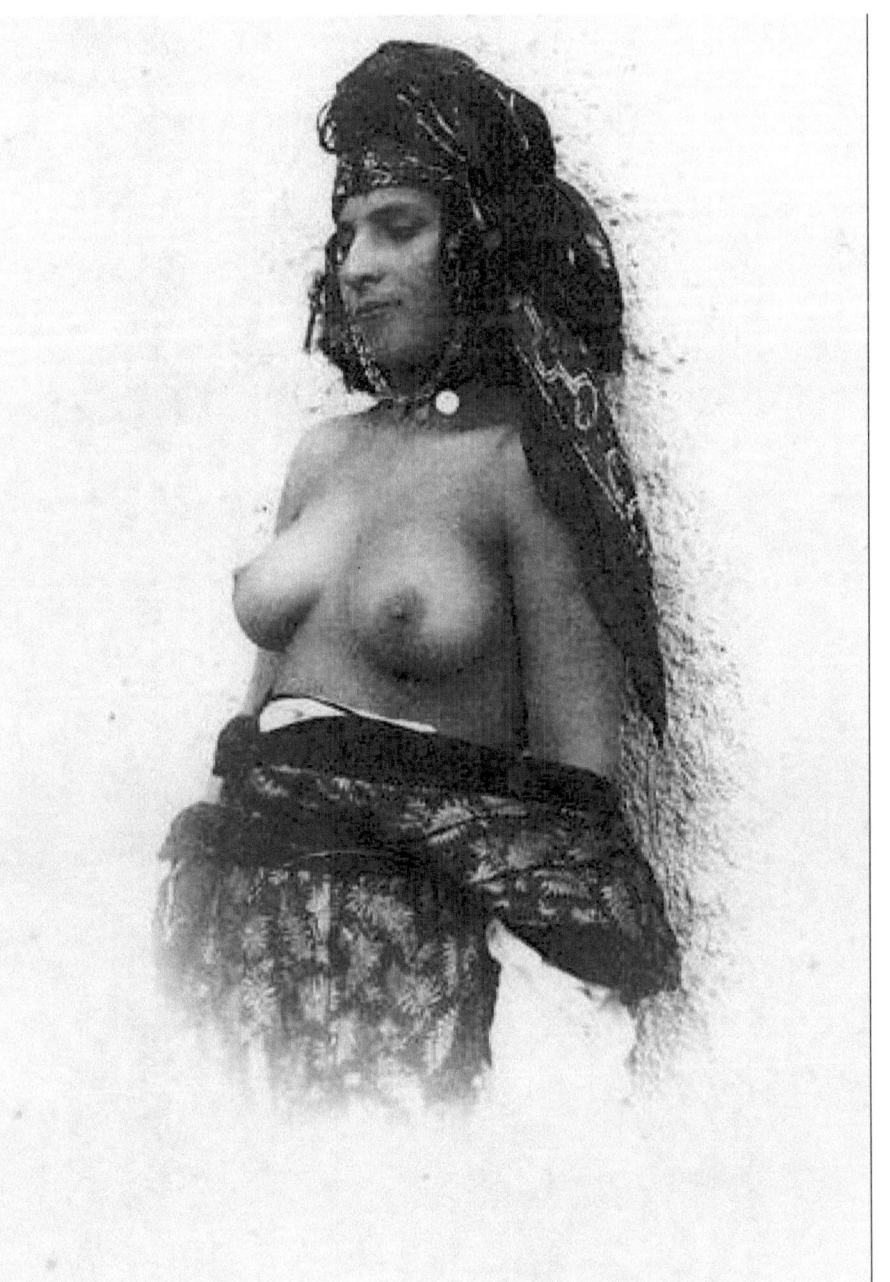

Femme du Sud-Algérien

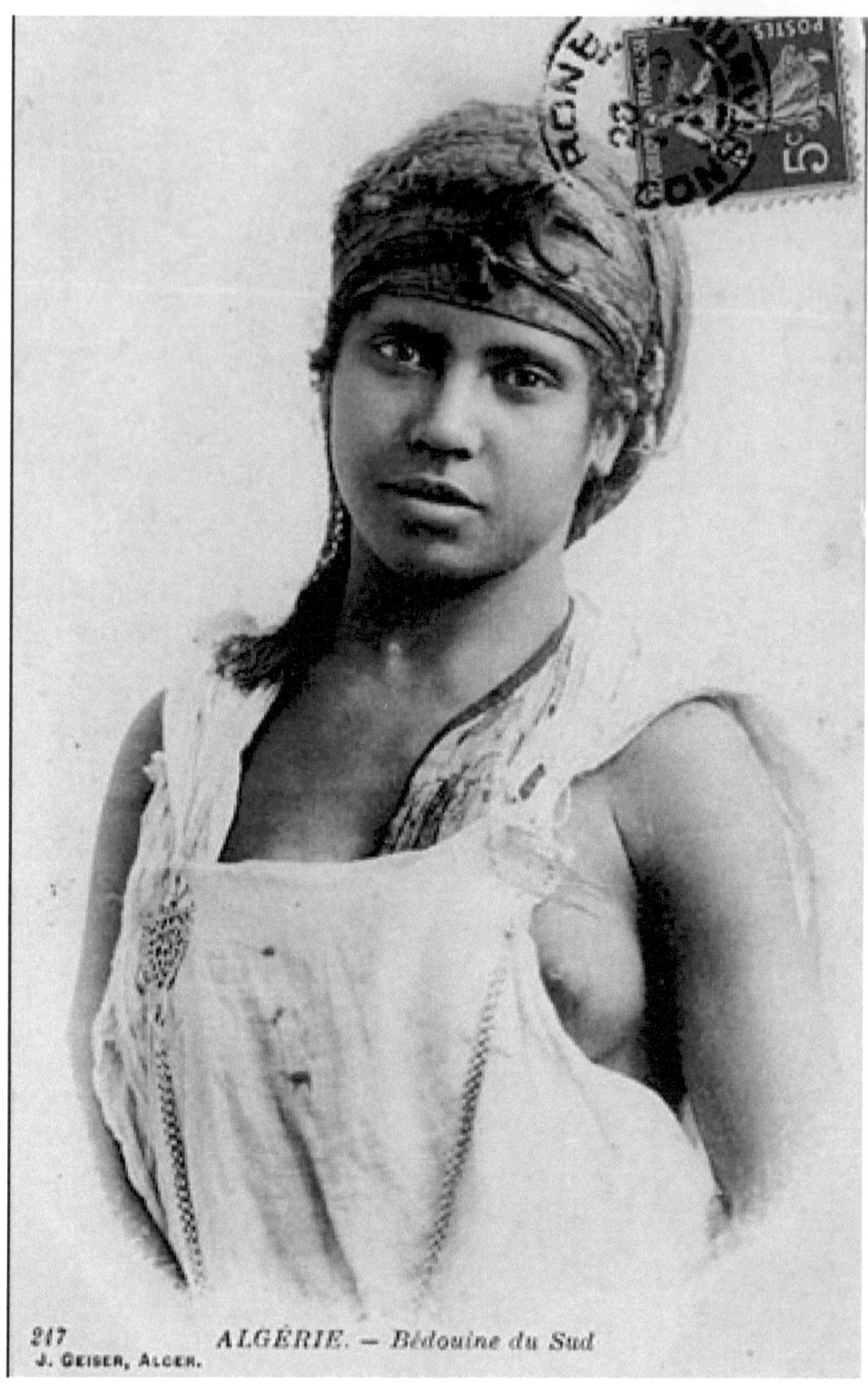

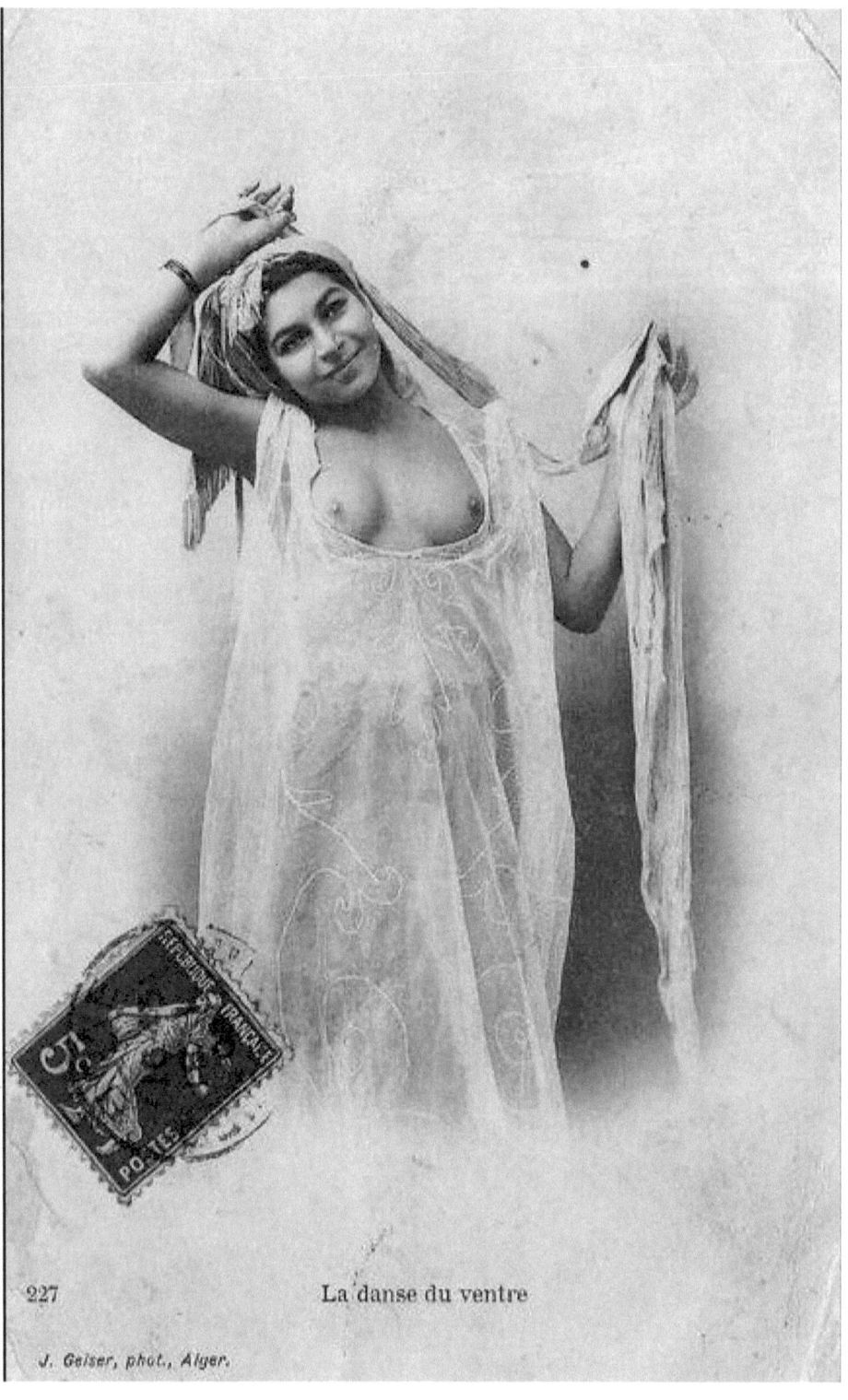

La danse du ventre

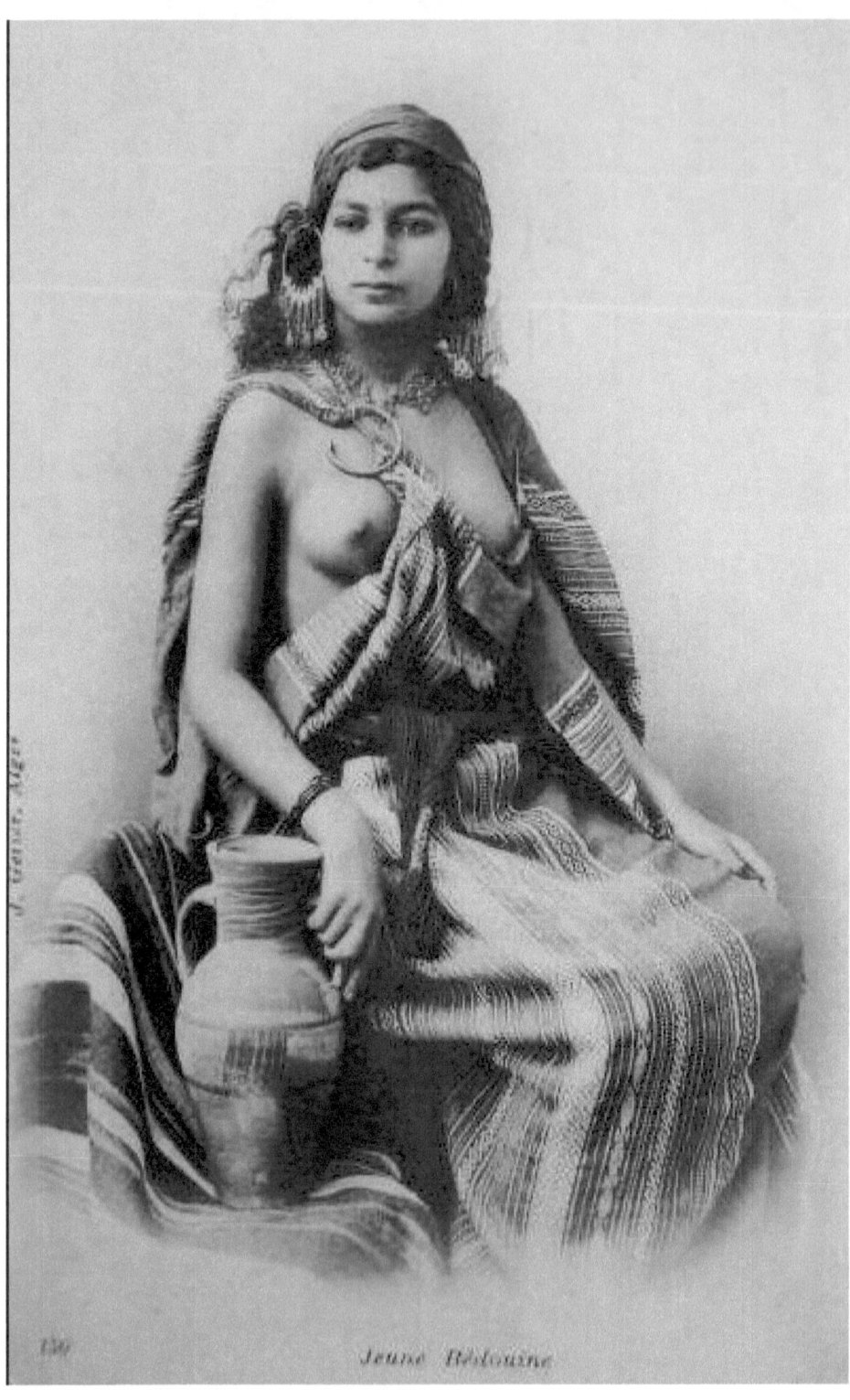

Jeune Bédouine

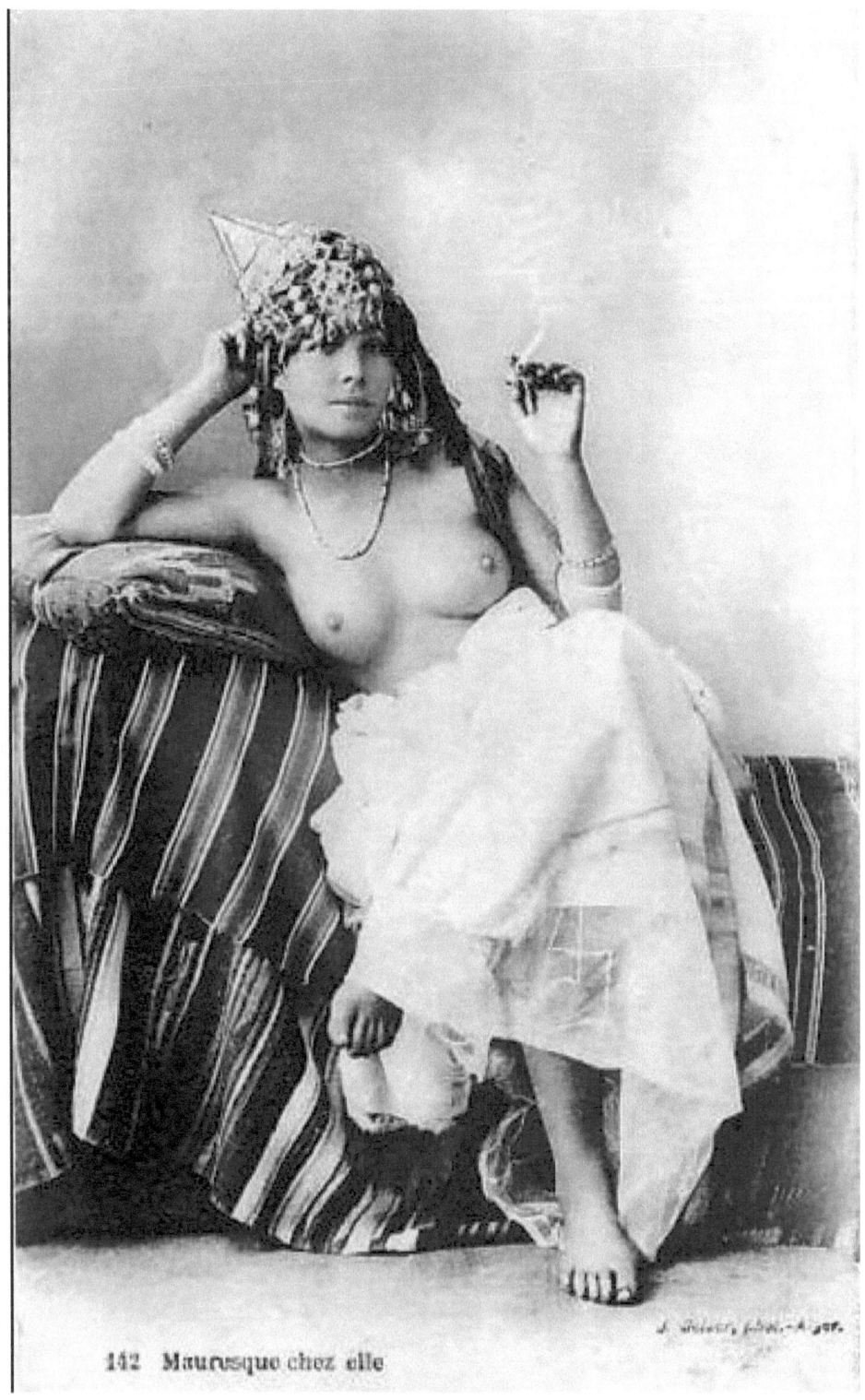

142 Mauresque chez elle

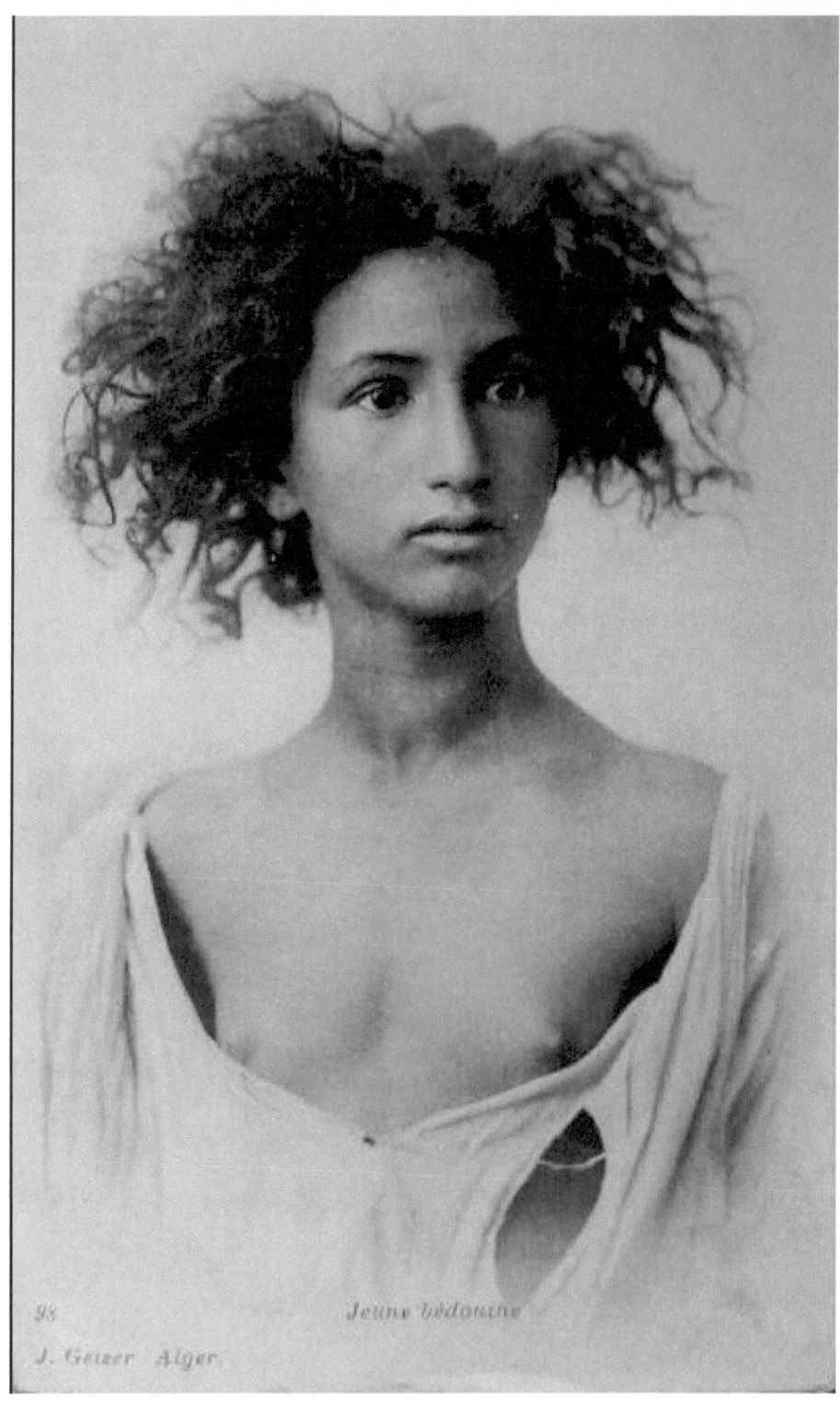

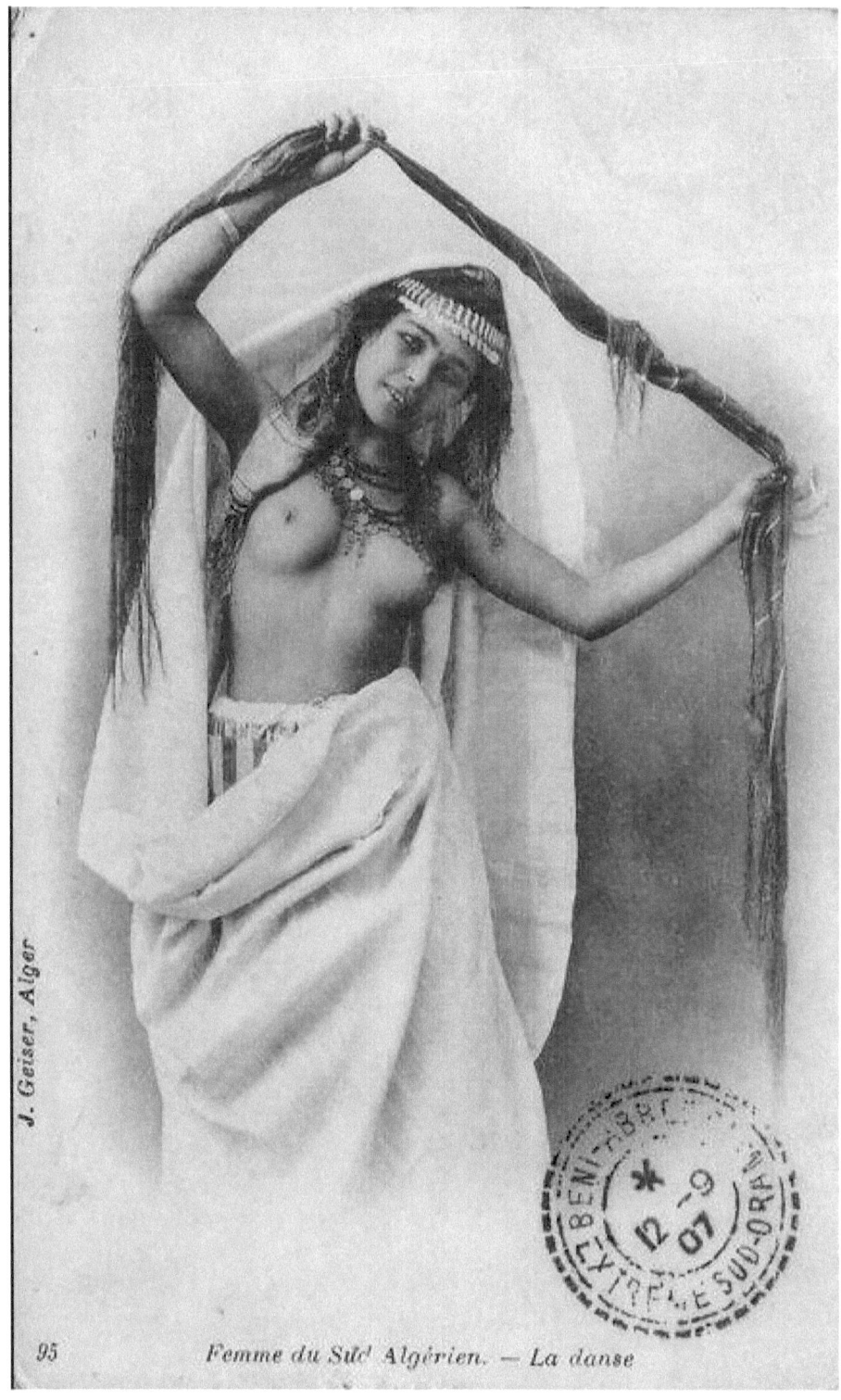

Femme du Sud Algérien. — La danse

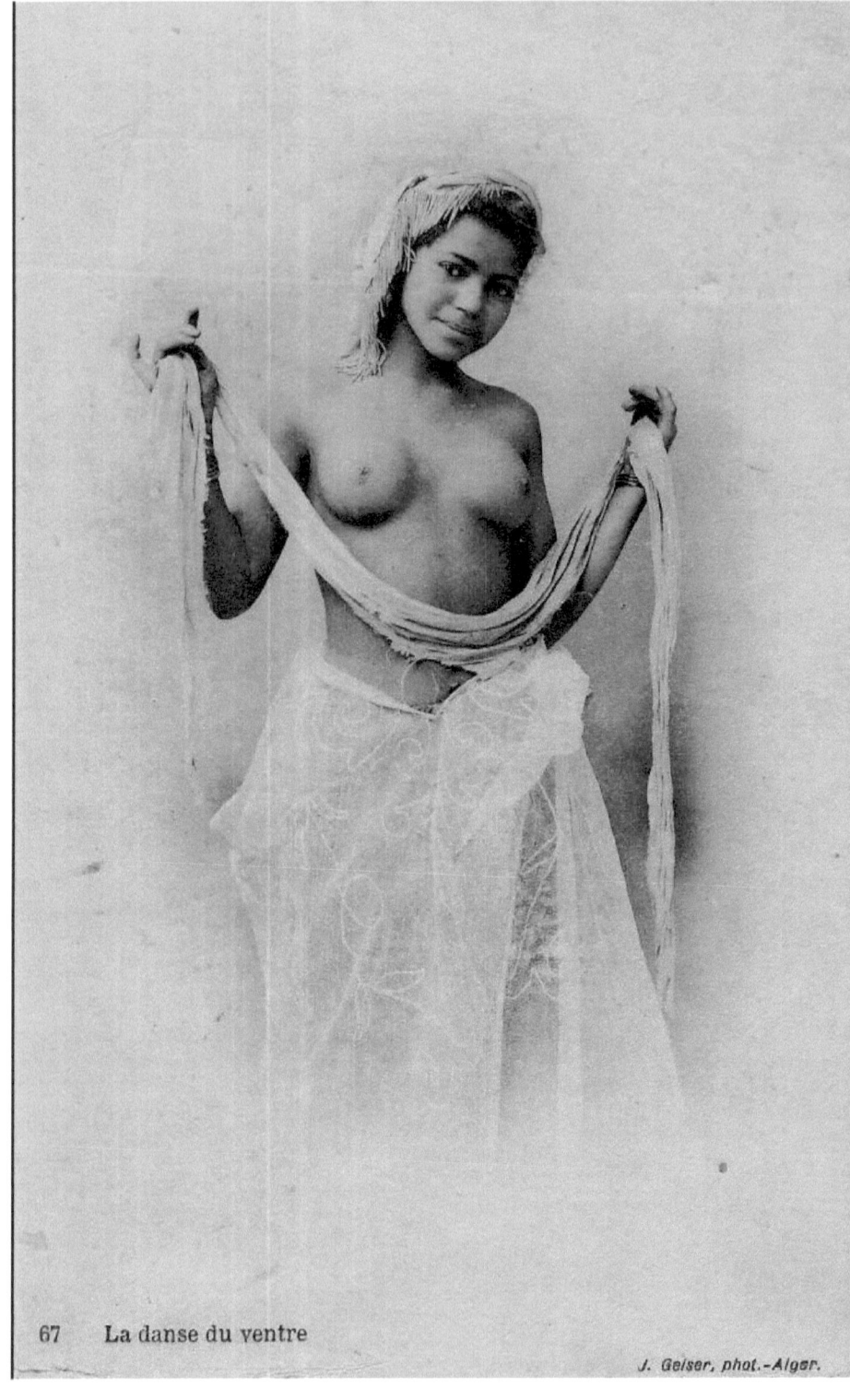

67 La danse du ventre

J. Geiser, phot.-Alger.

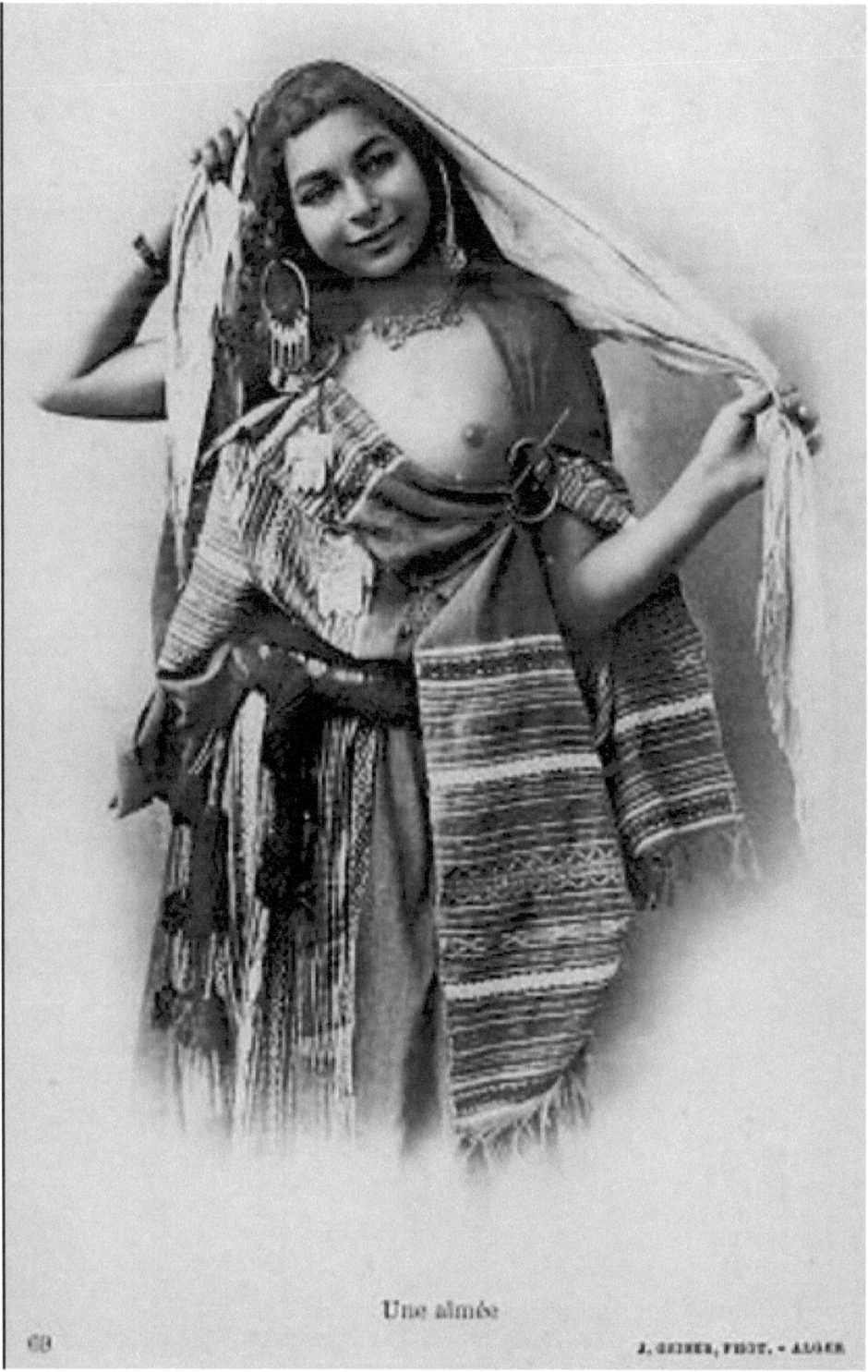

Une almée

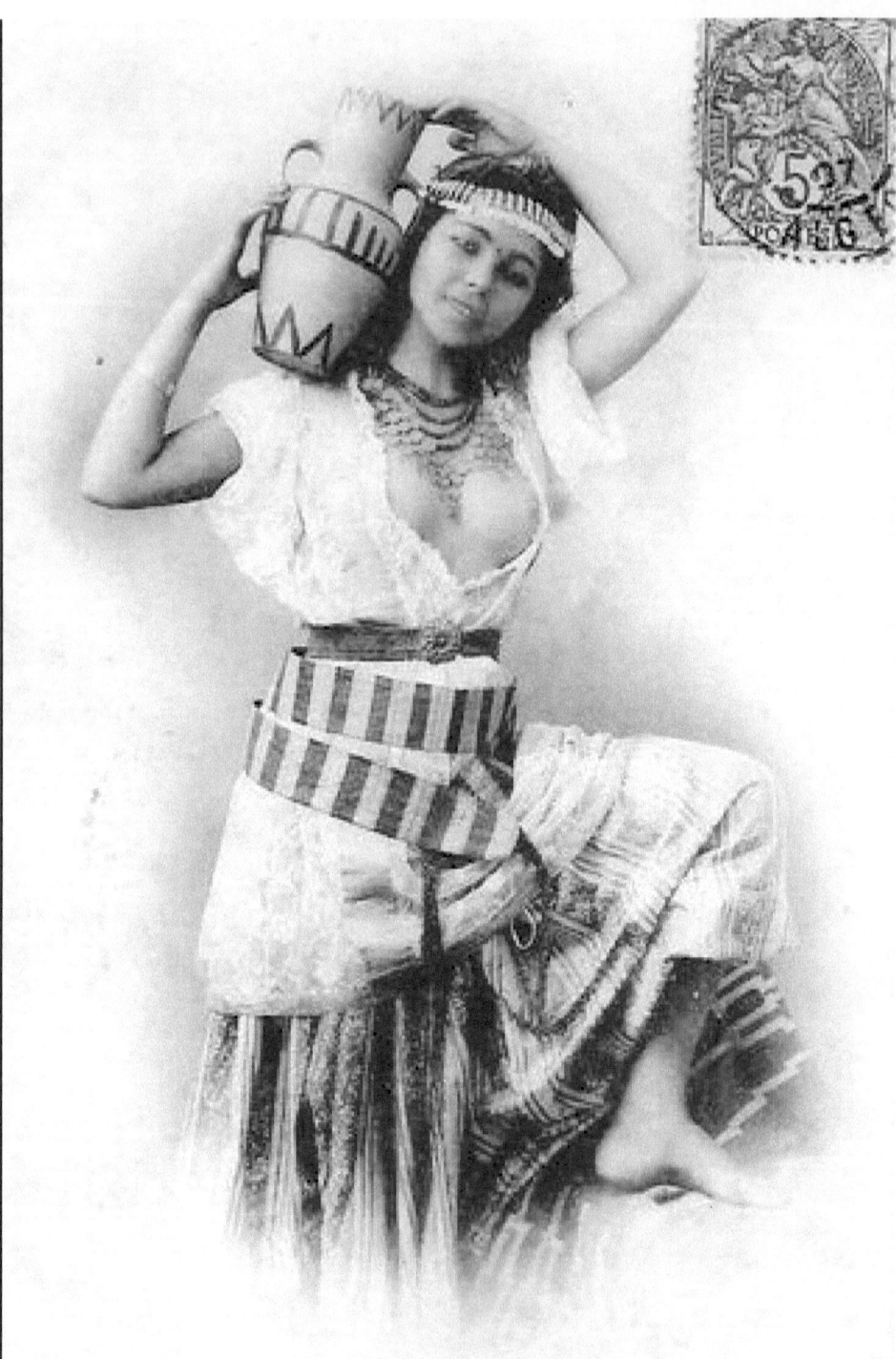

ALGÉRIE. — Femme du Sud

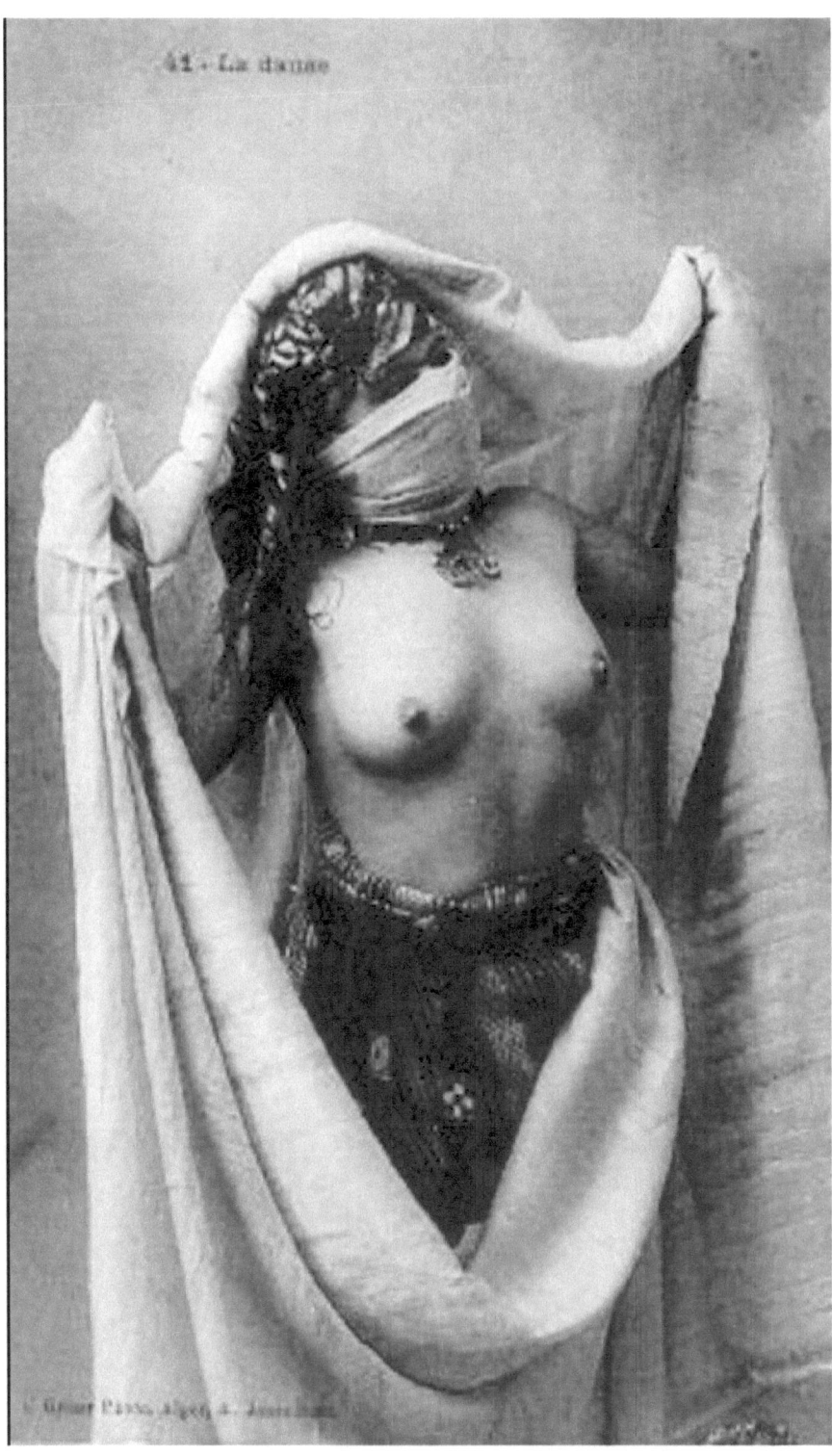

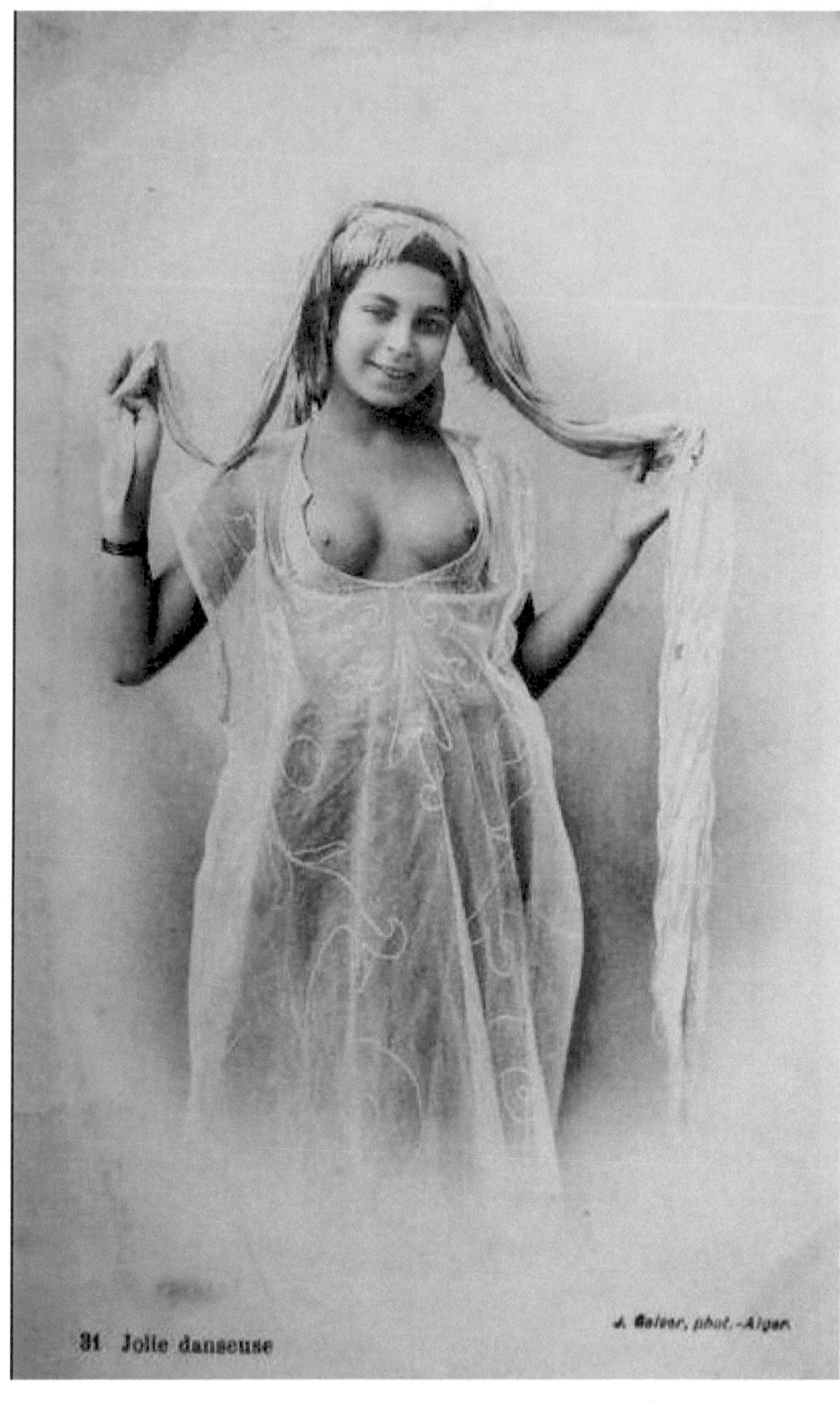

31 Jolie danseuse

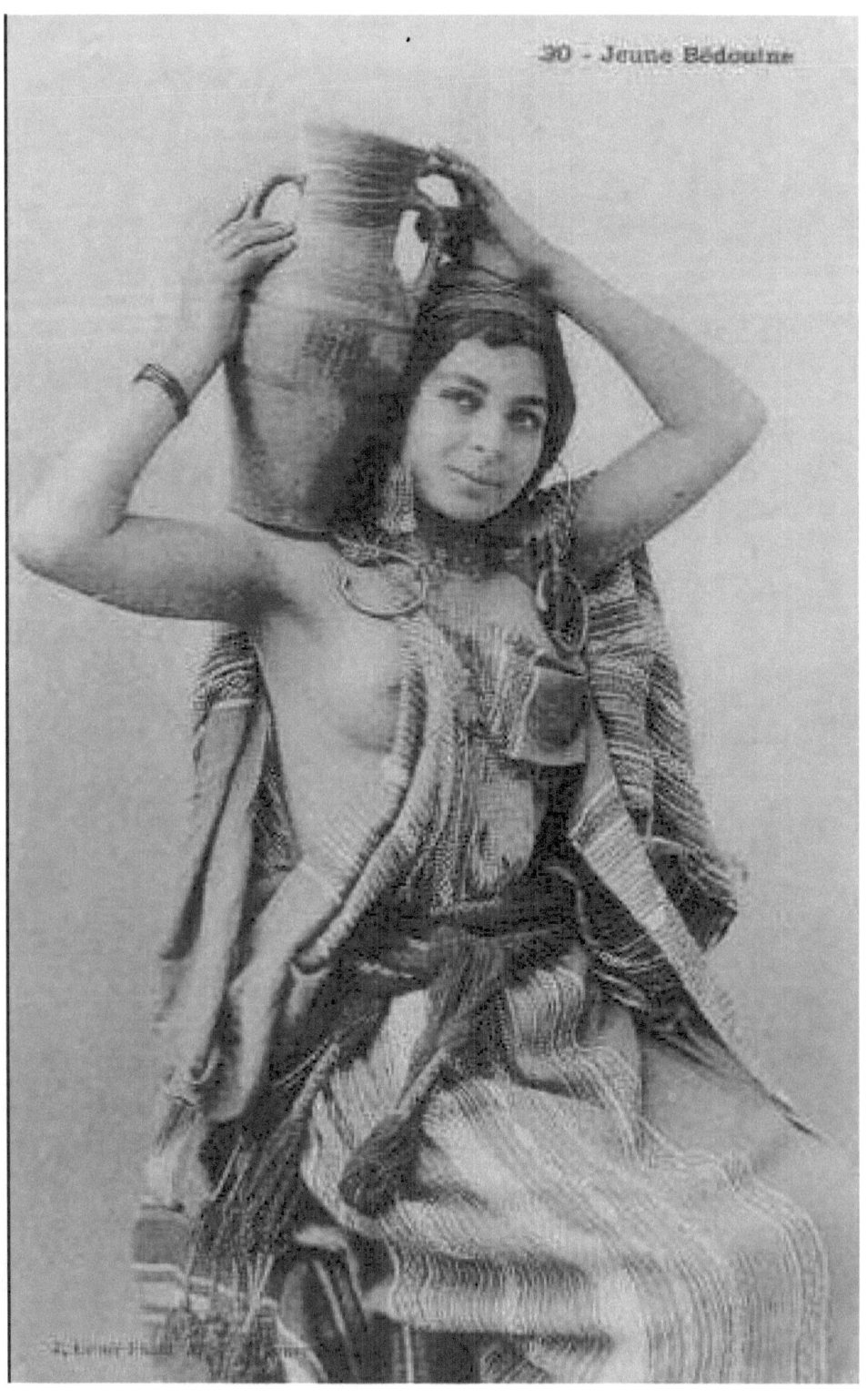

30 - Jeune Bédouine

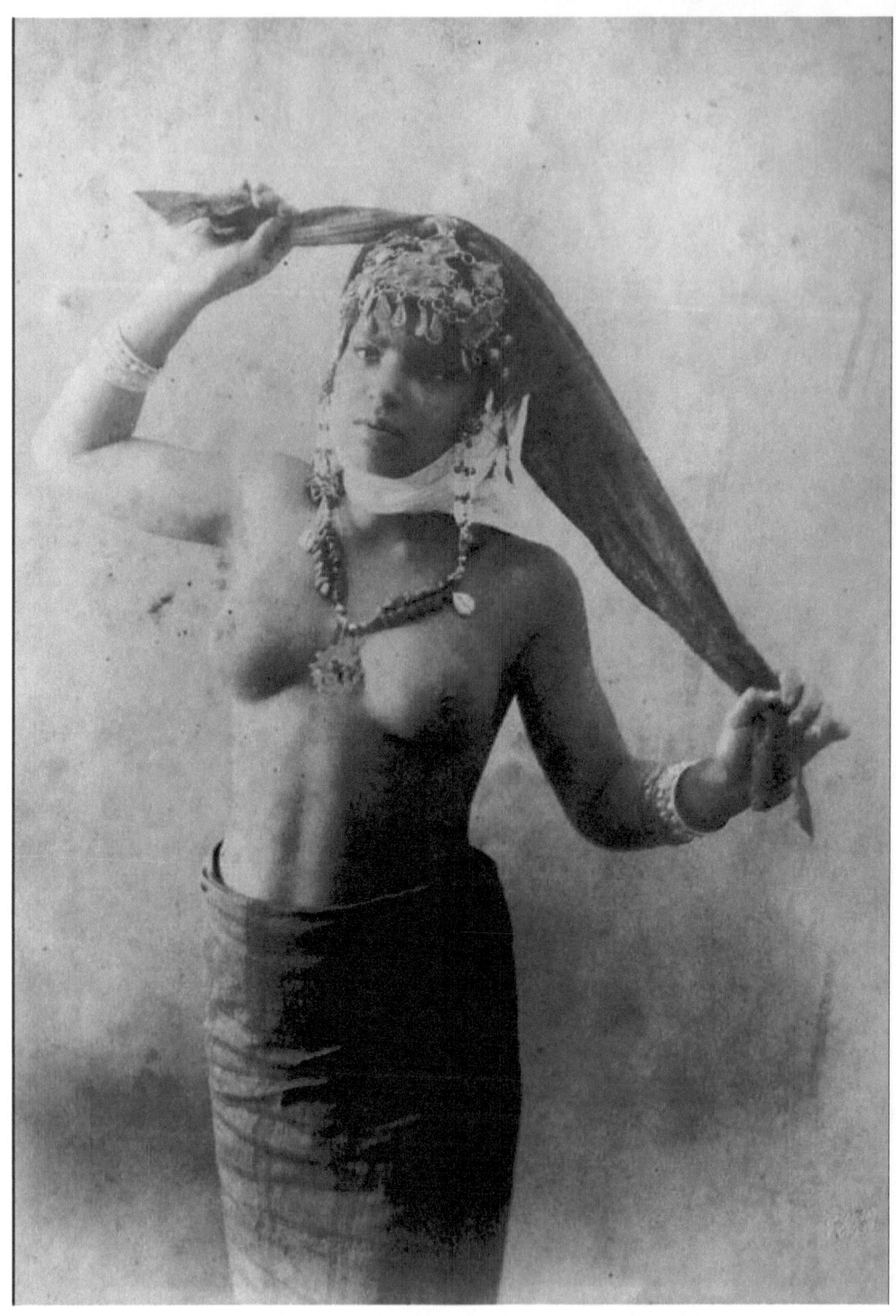

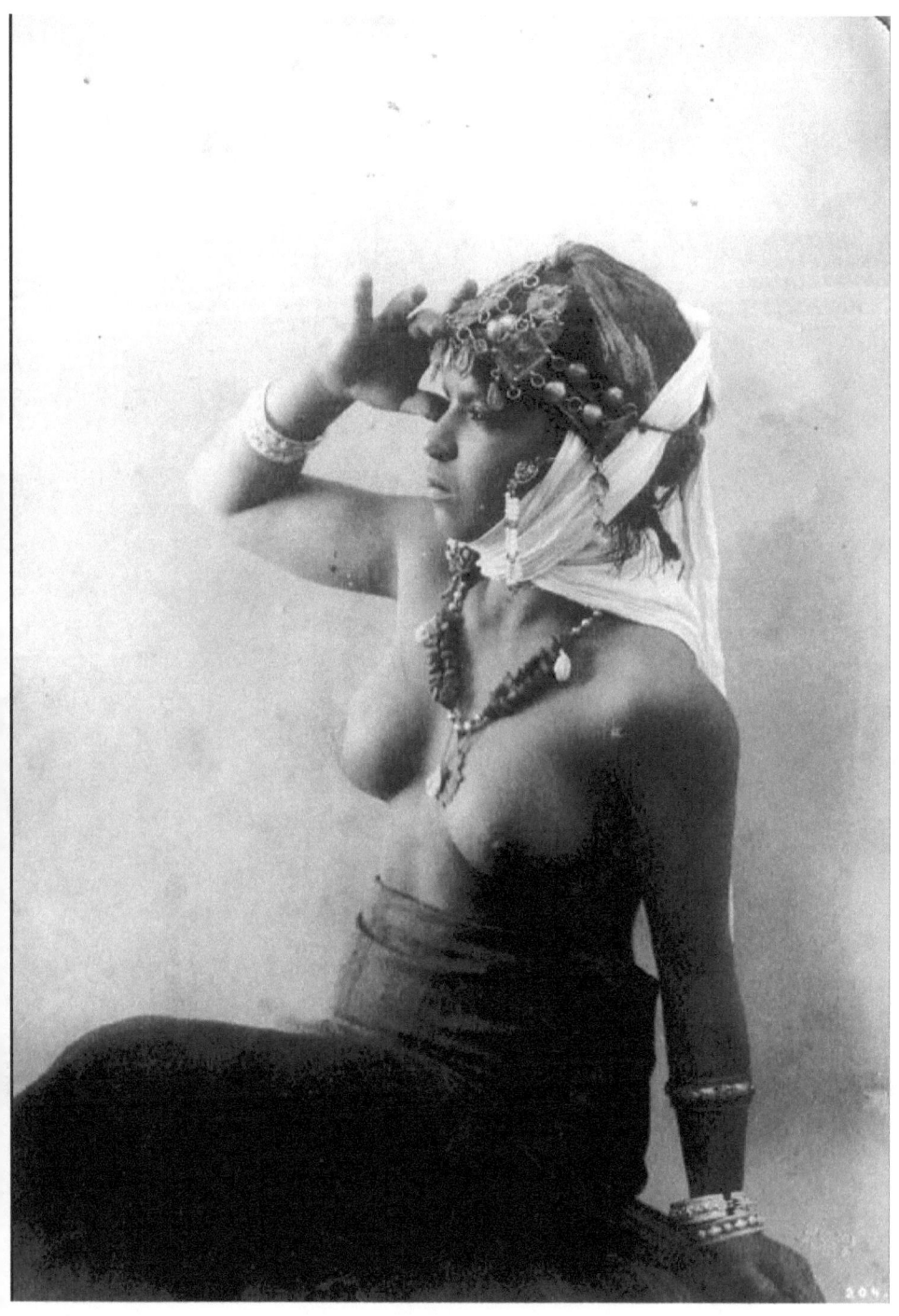

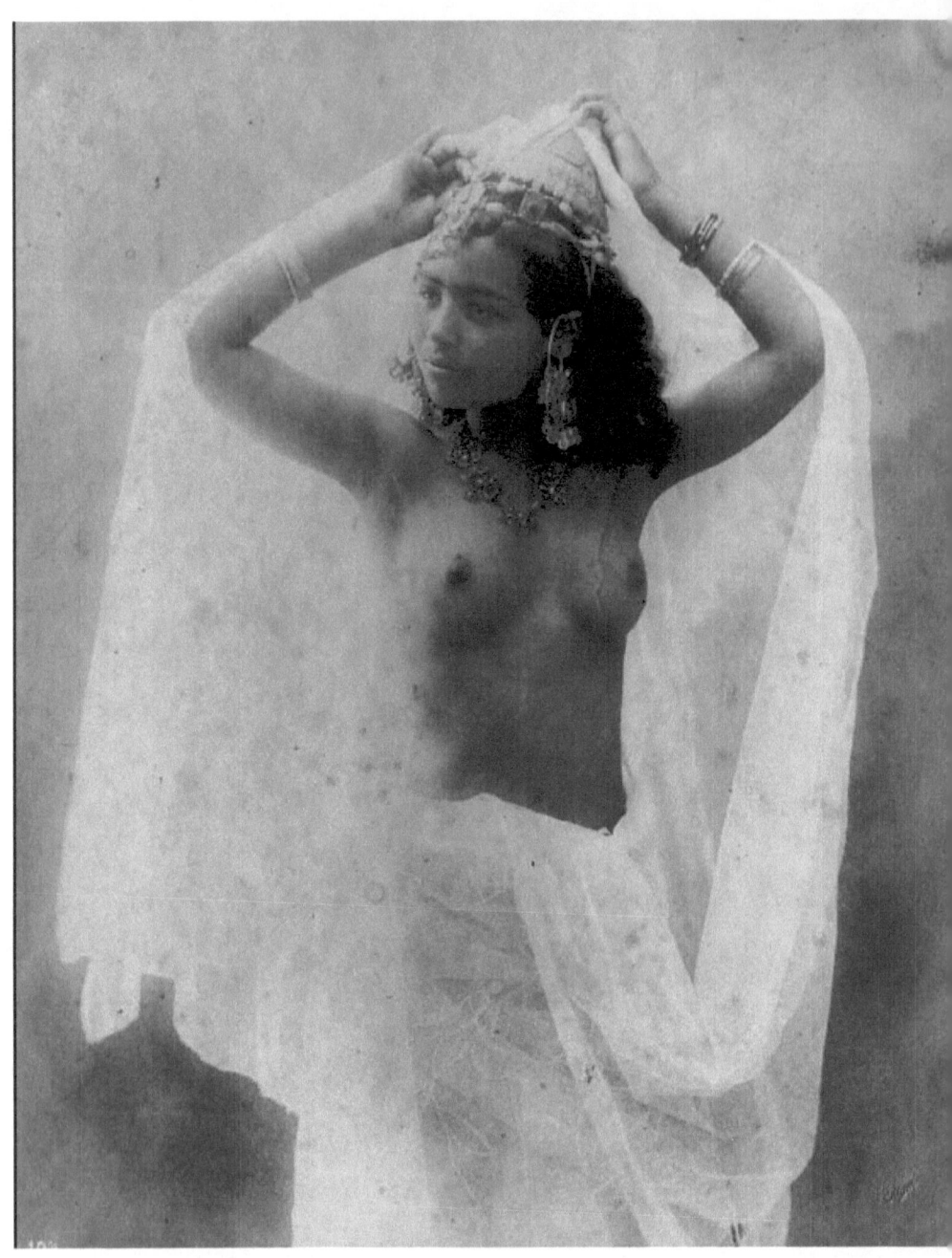

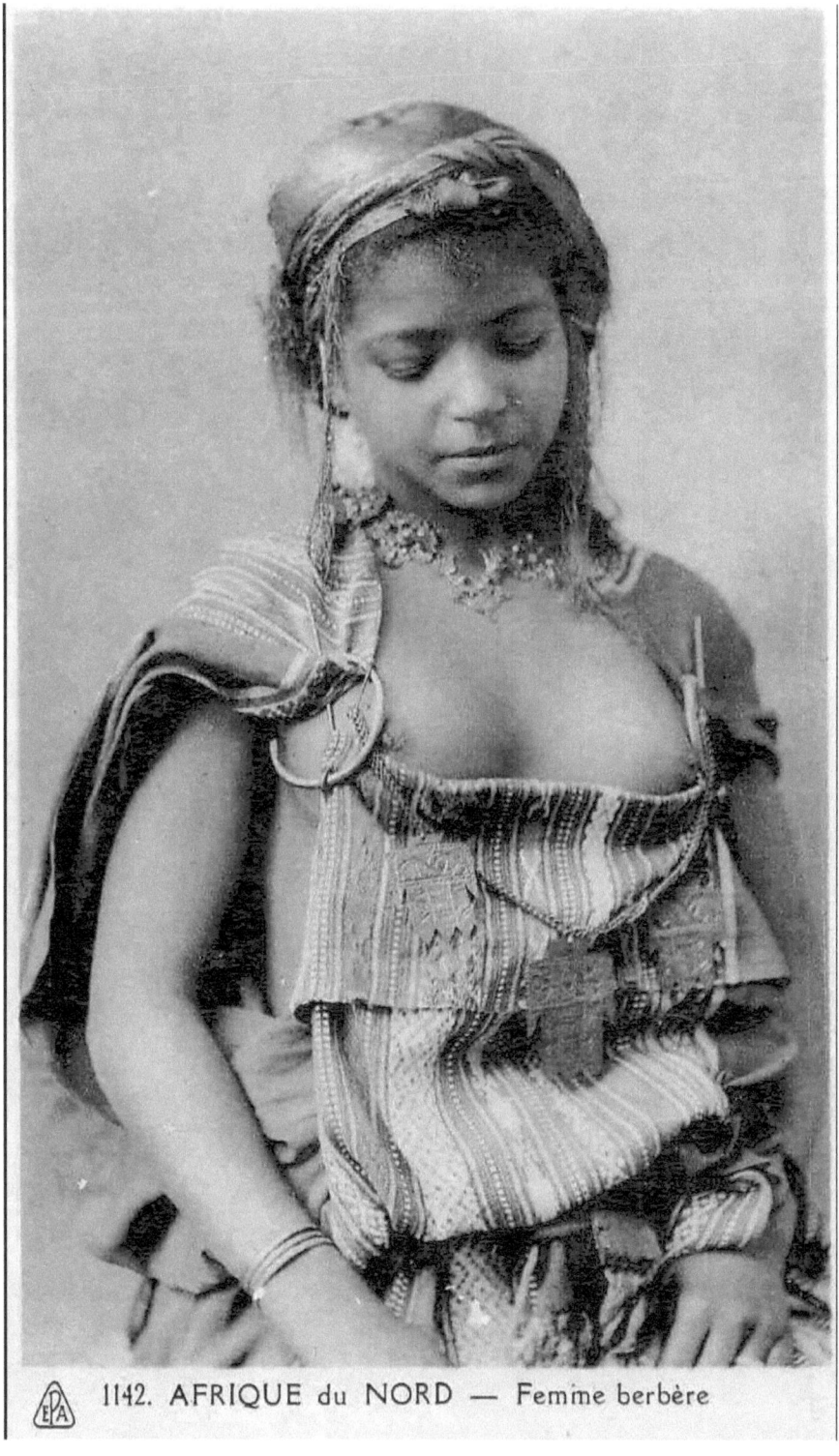
1142. AFRIQUE du NORD — Femme berbère

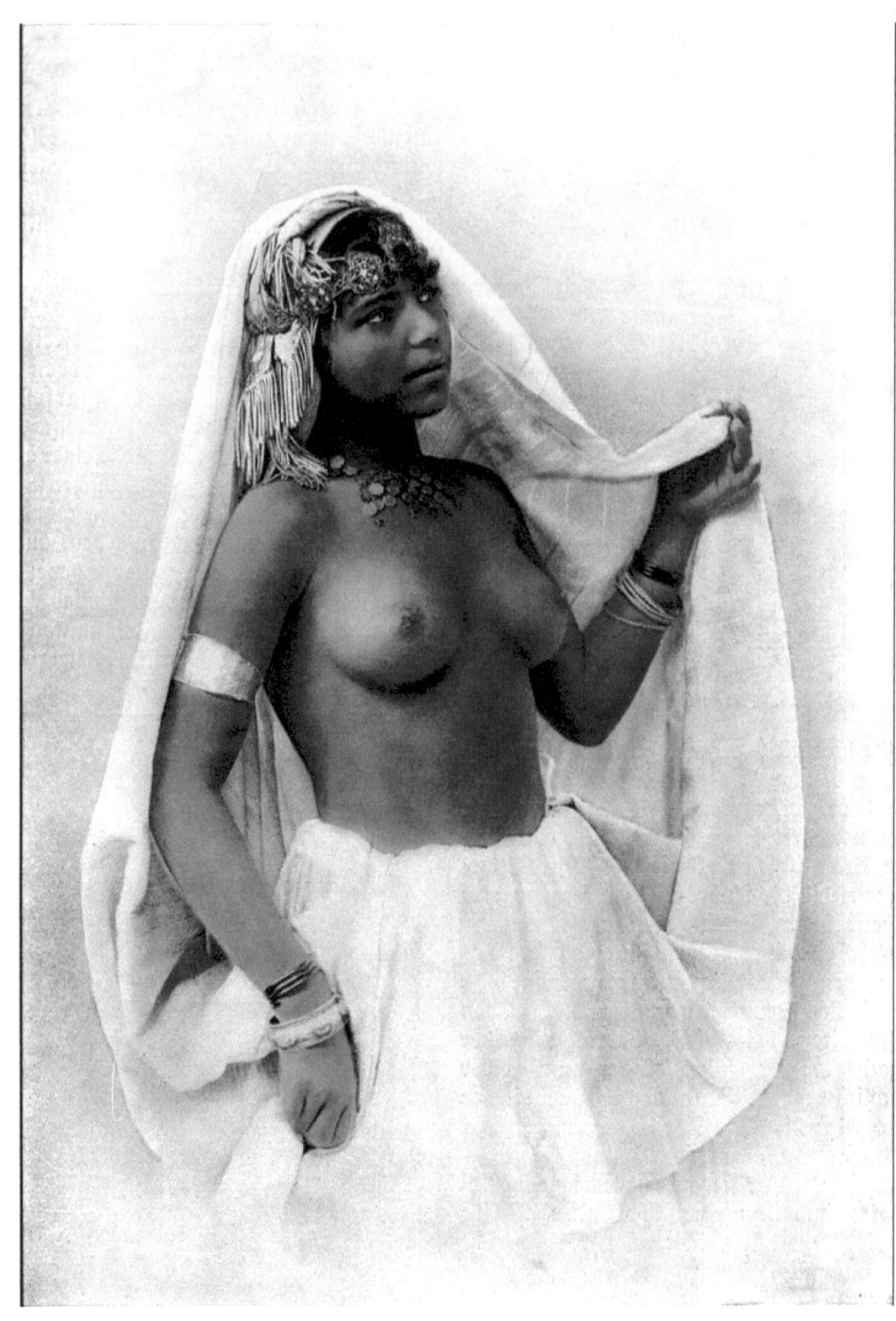

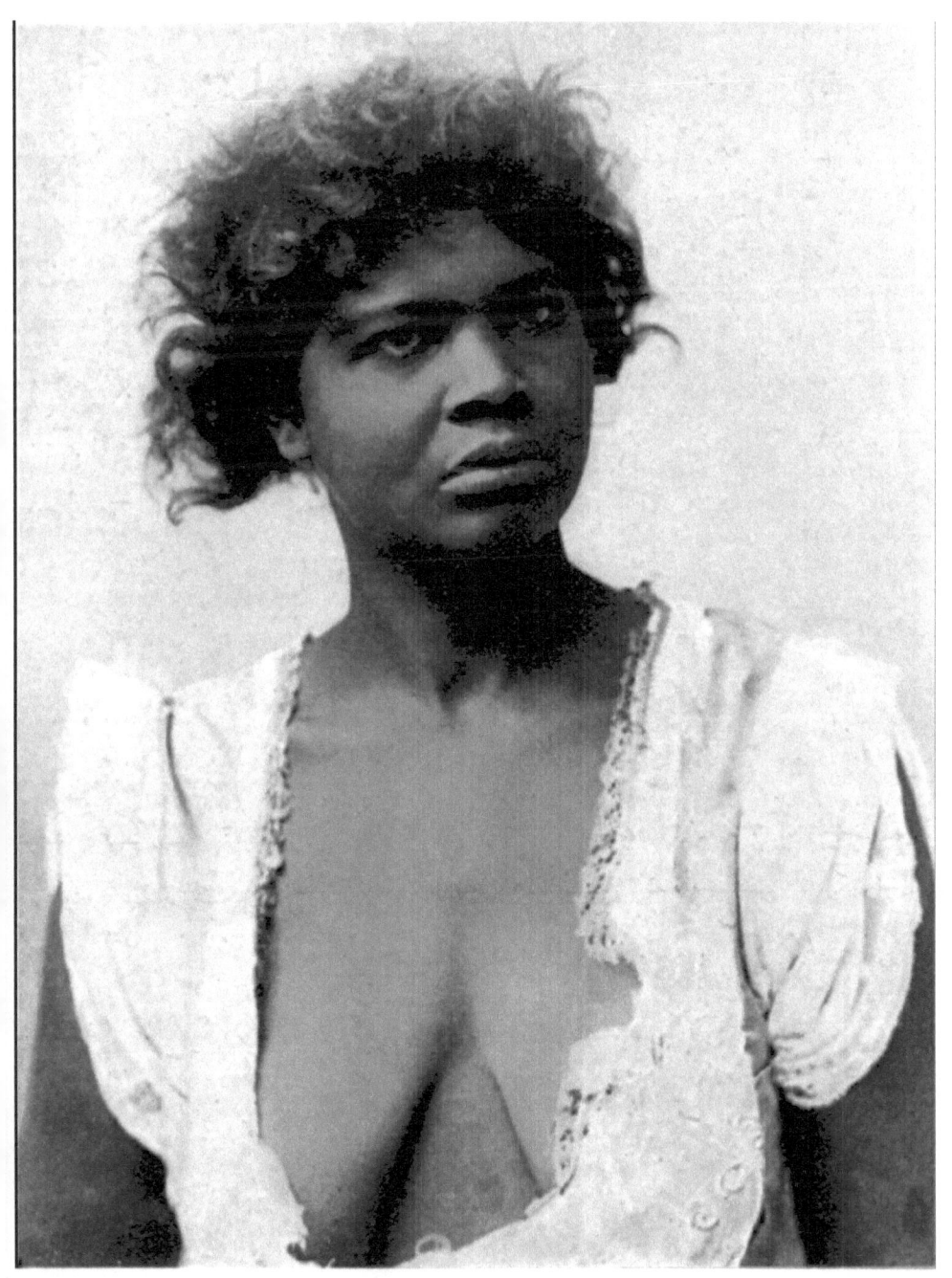

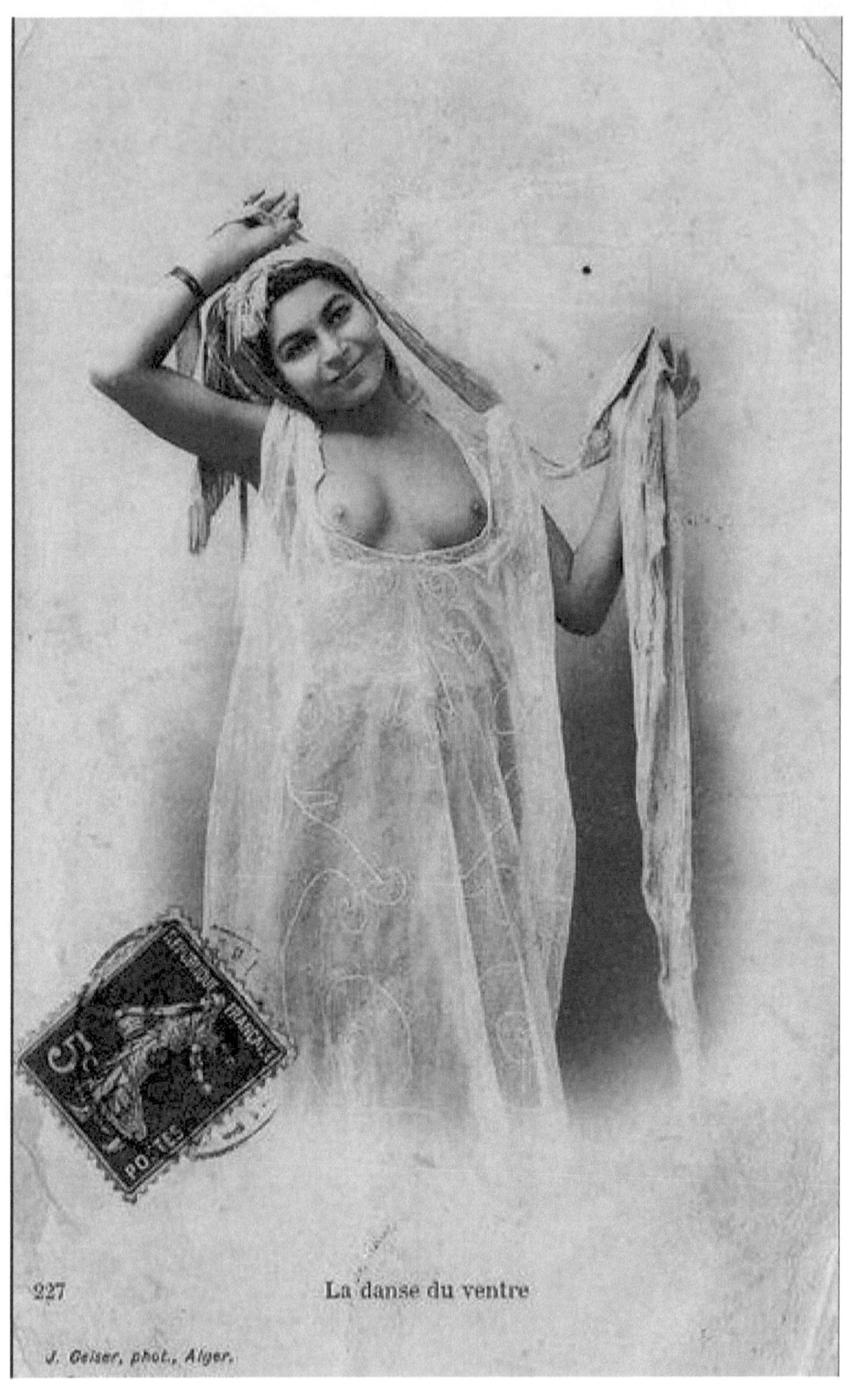

227 La danse du ventre

J. Geiser, phot., Alger.

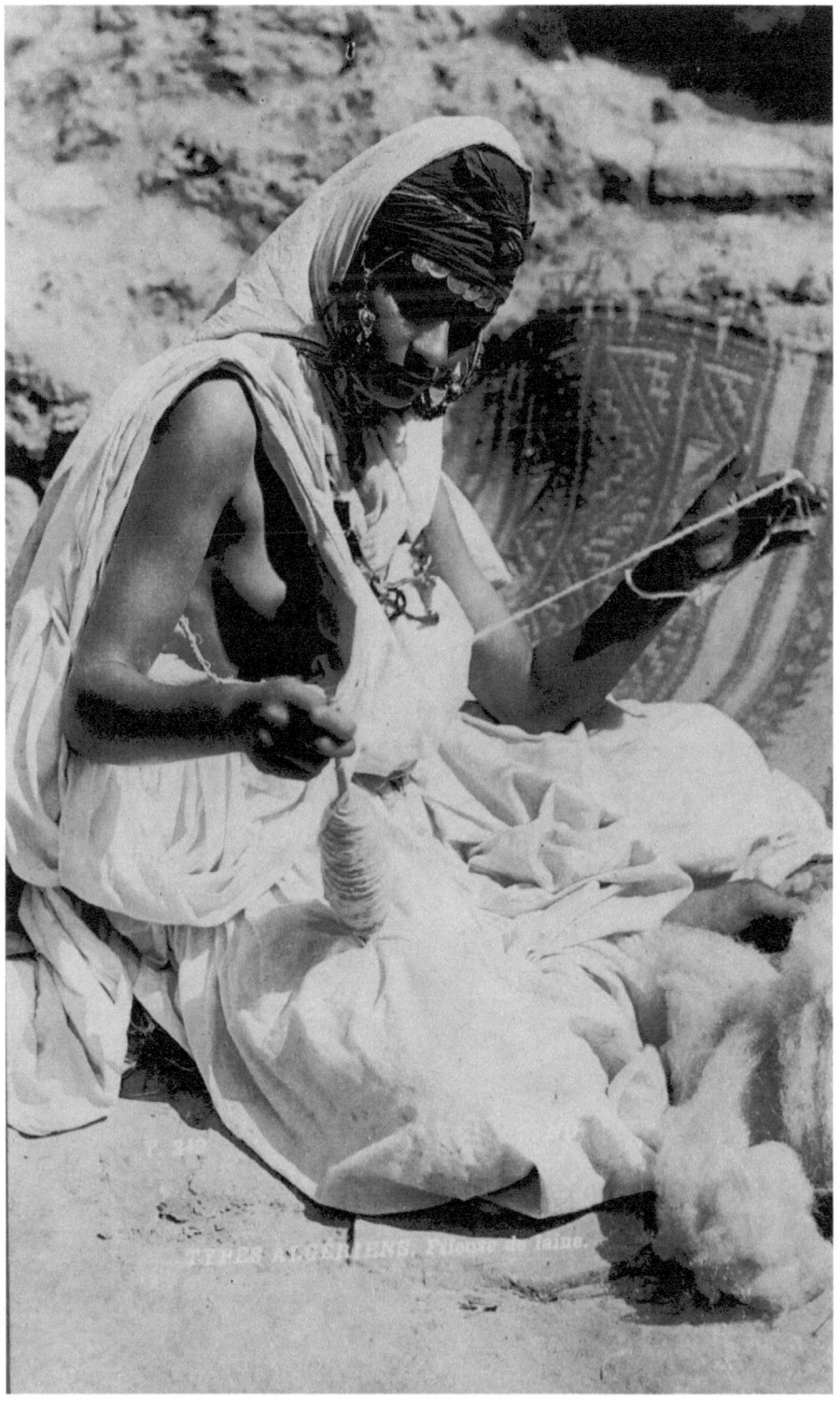

872 A *Jeune Femme kabyle parée de ses bijoux*

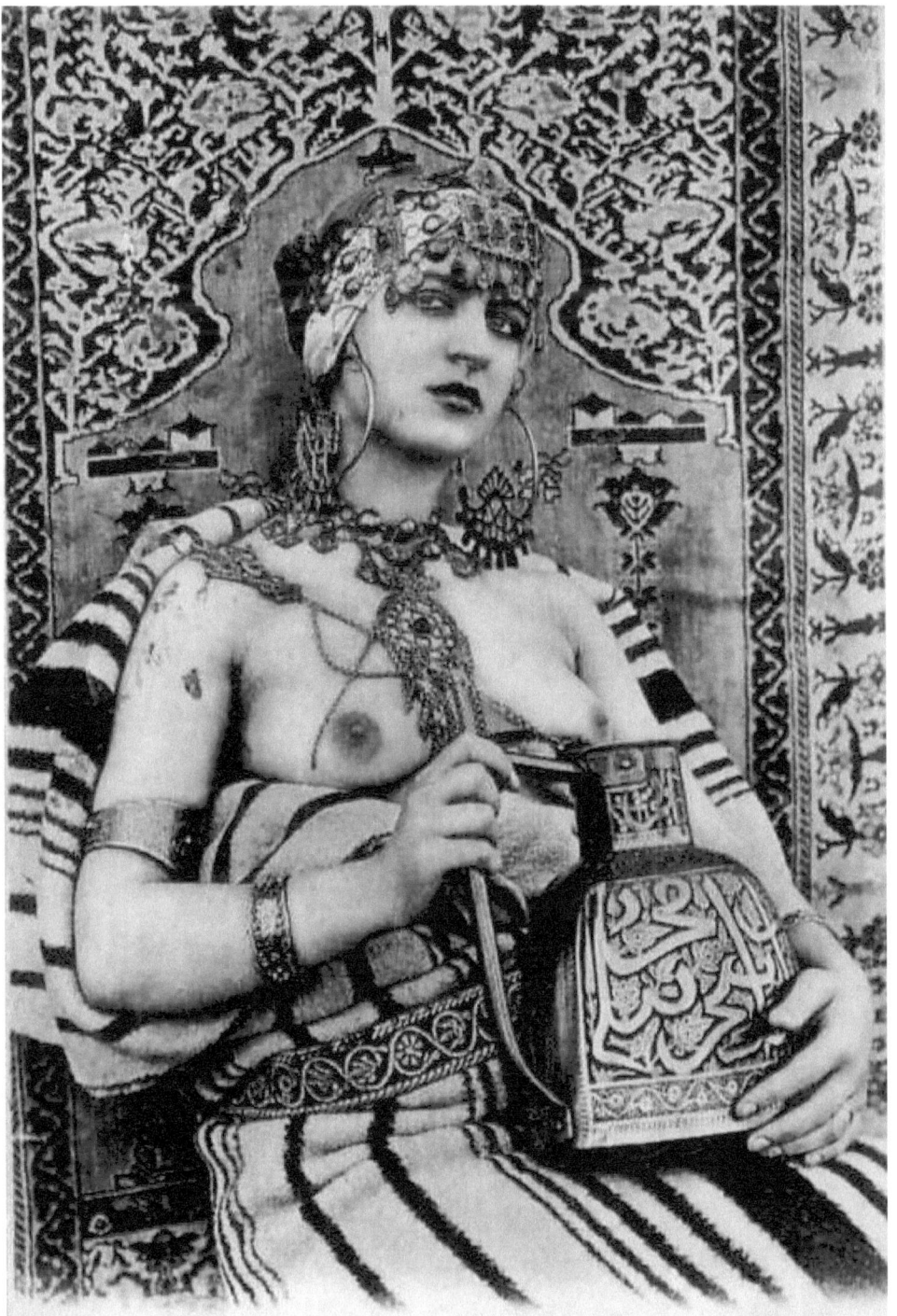
876 A Jeune Femme Kabyle parée de ses bijoux. ND. Phot.

866. SCÈNES ET TYPES. Jeune Femme Kabyle parée de ses bijoux. ND

821 A — Mauresques. — Collection Spéciale P. A. — ND. Phot.

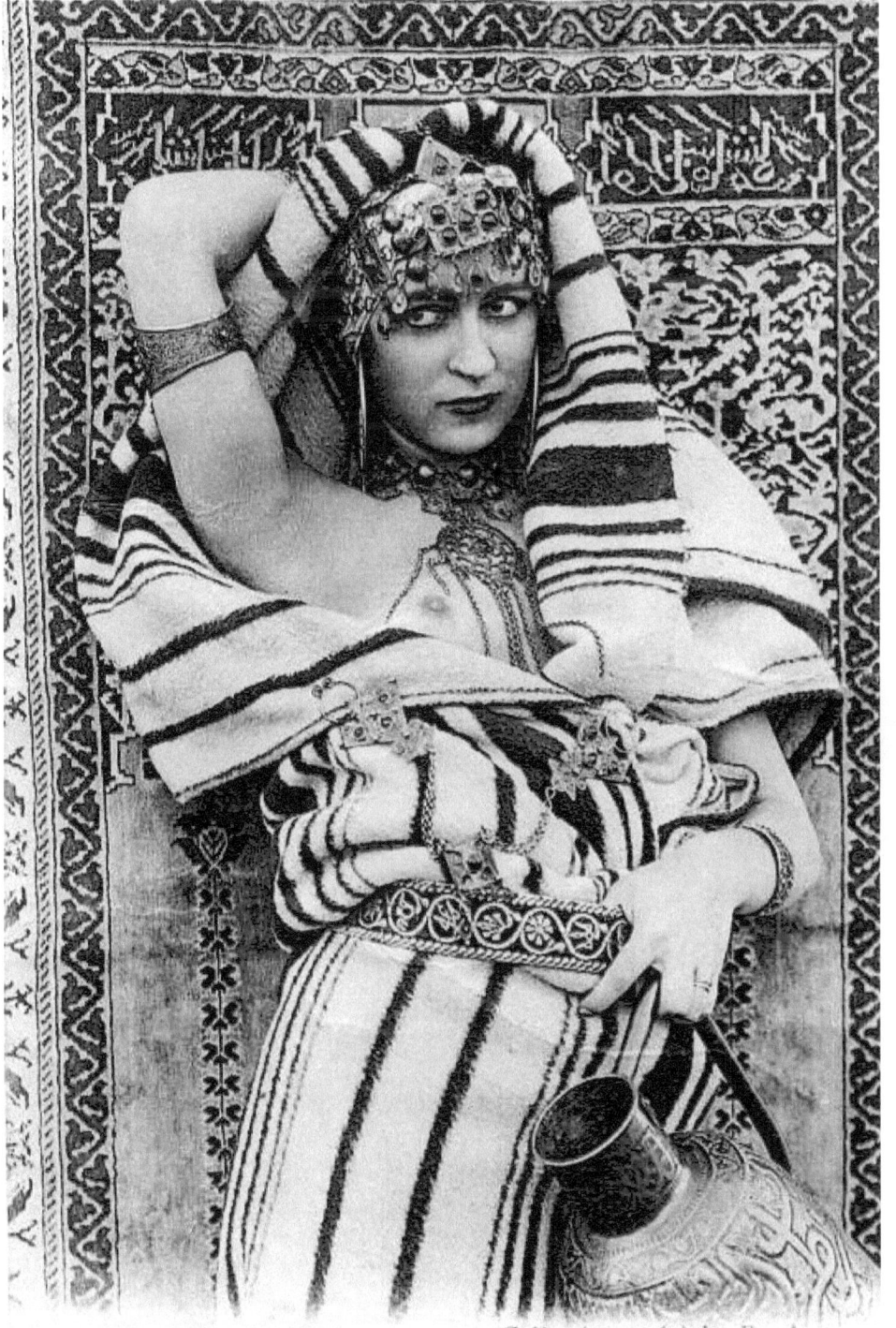

862 A — Jeune Femme kabyle parée de ses bijoux.
Collection spéciale P. A.

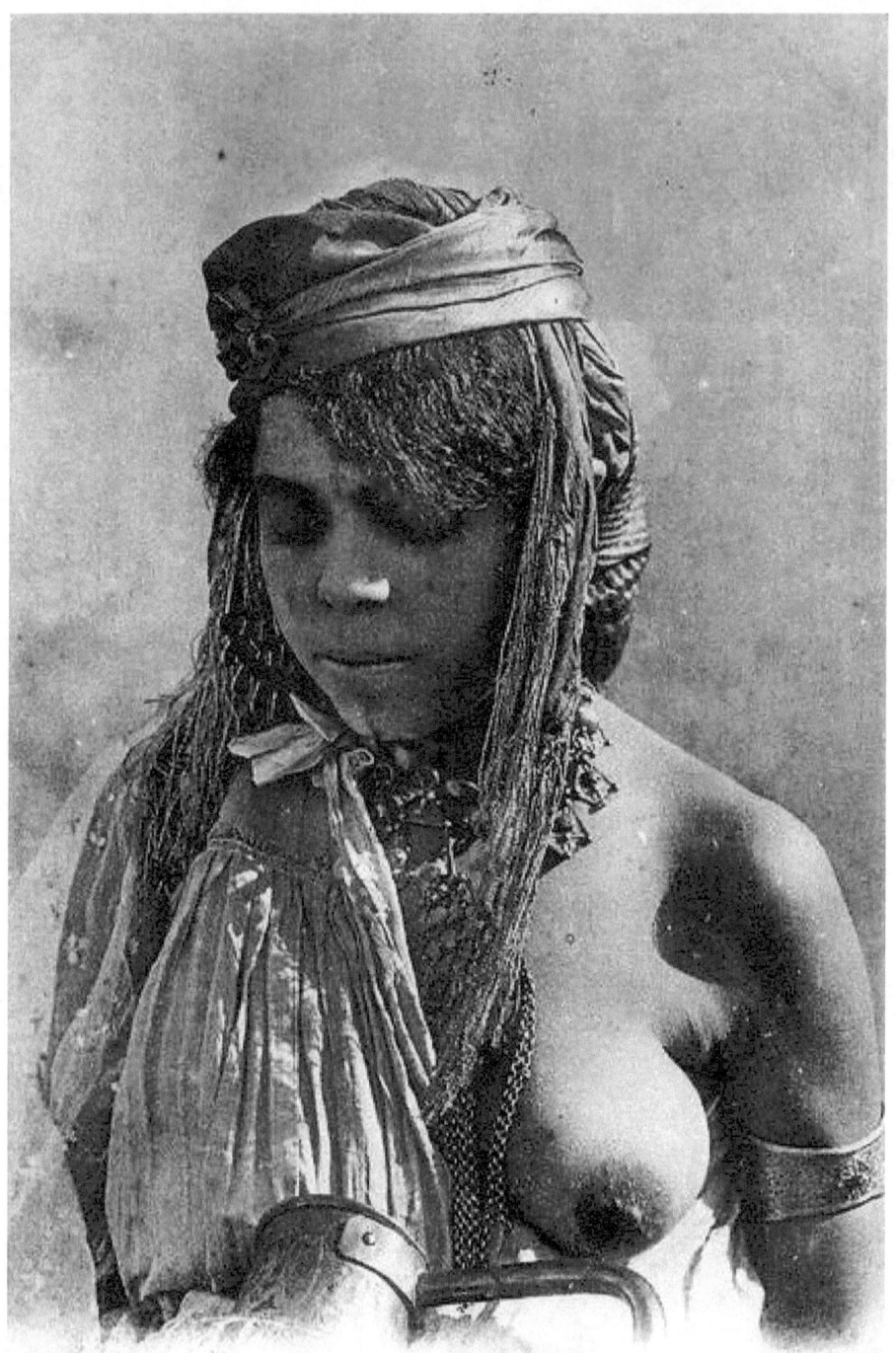

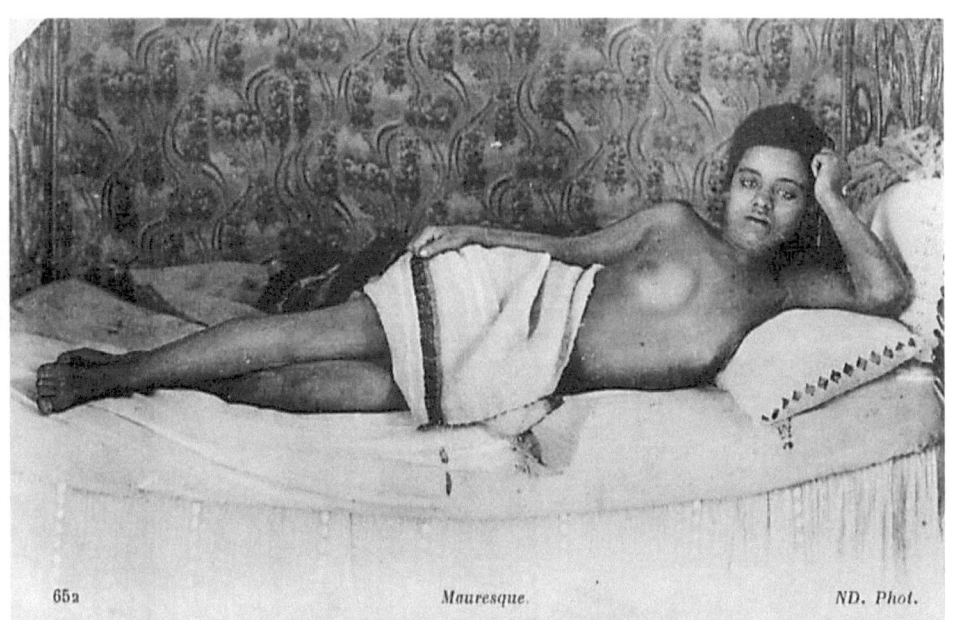

652 *Mauresque.* ND. Phot.

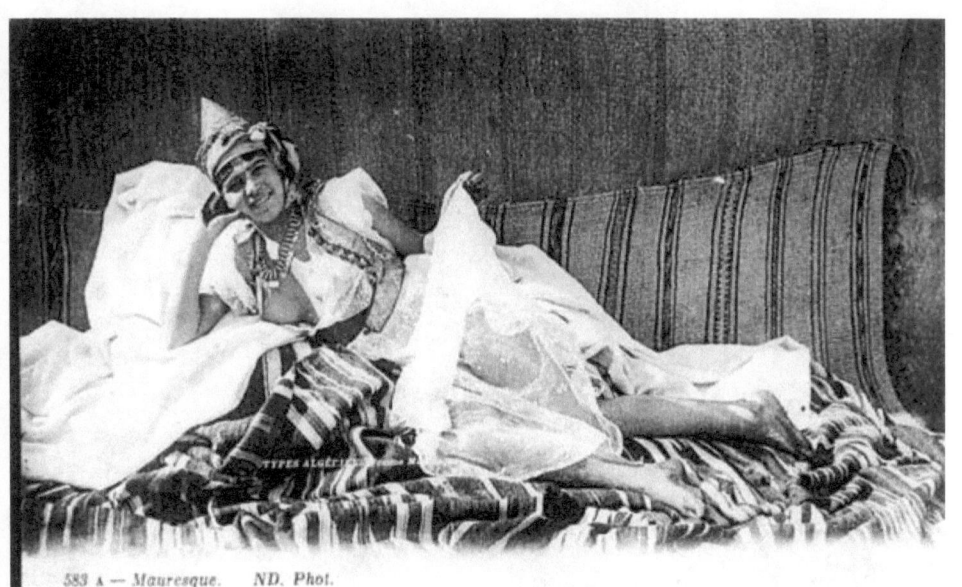

583 A — *Mauresque.* ND. Phot.

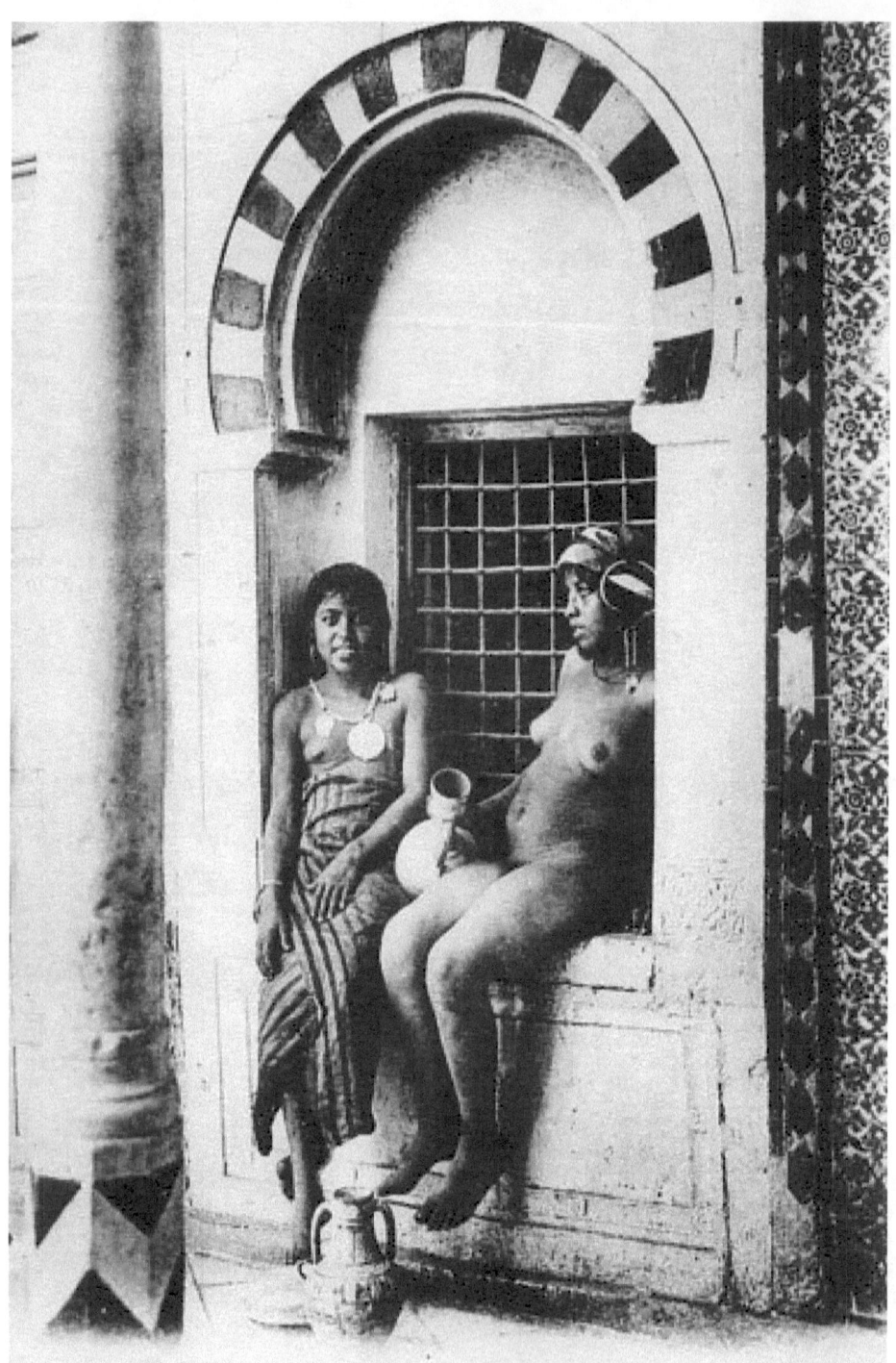
606 T — JEUNES BÉDOUINES — ND

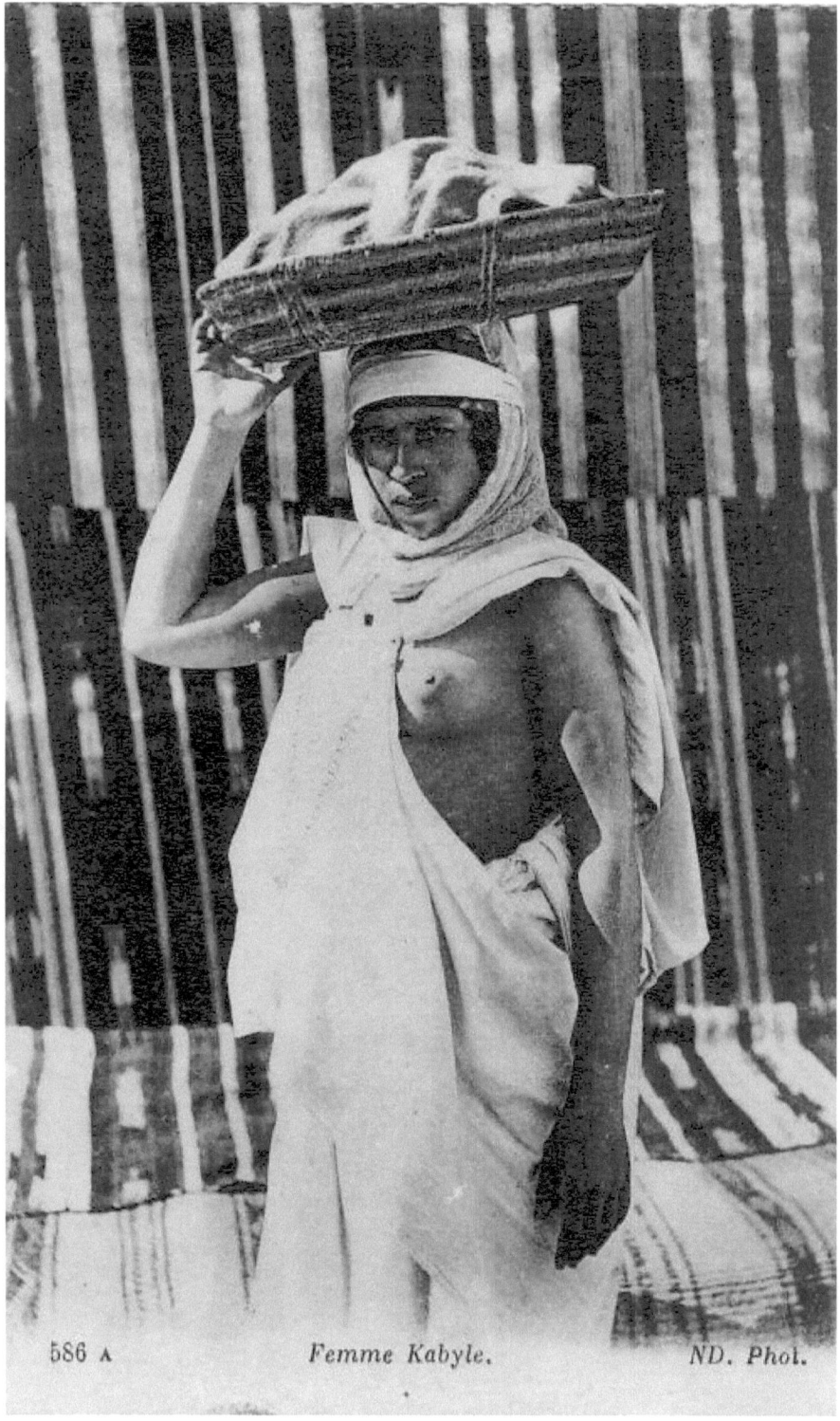

586 A — Femme Kabyle. — ND. Phot.

581 a Mauresque. — ND Phot.

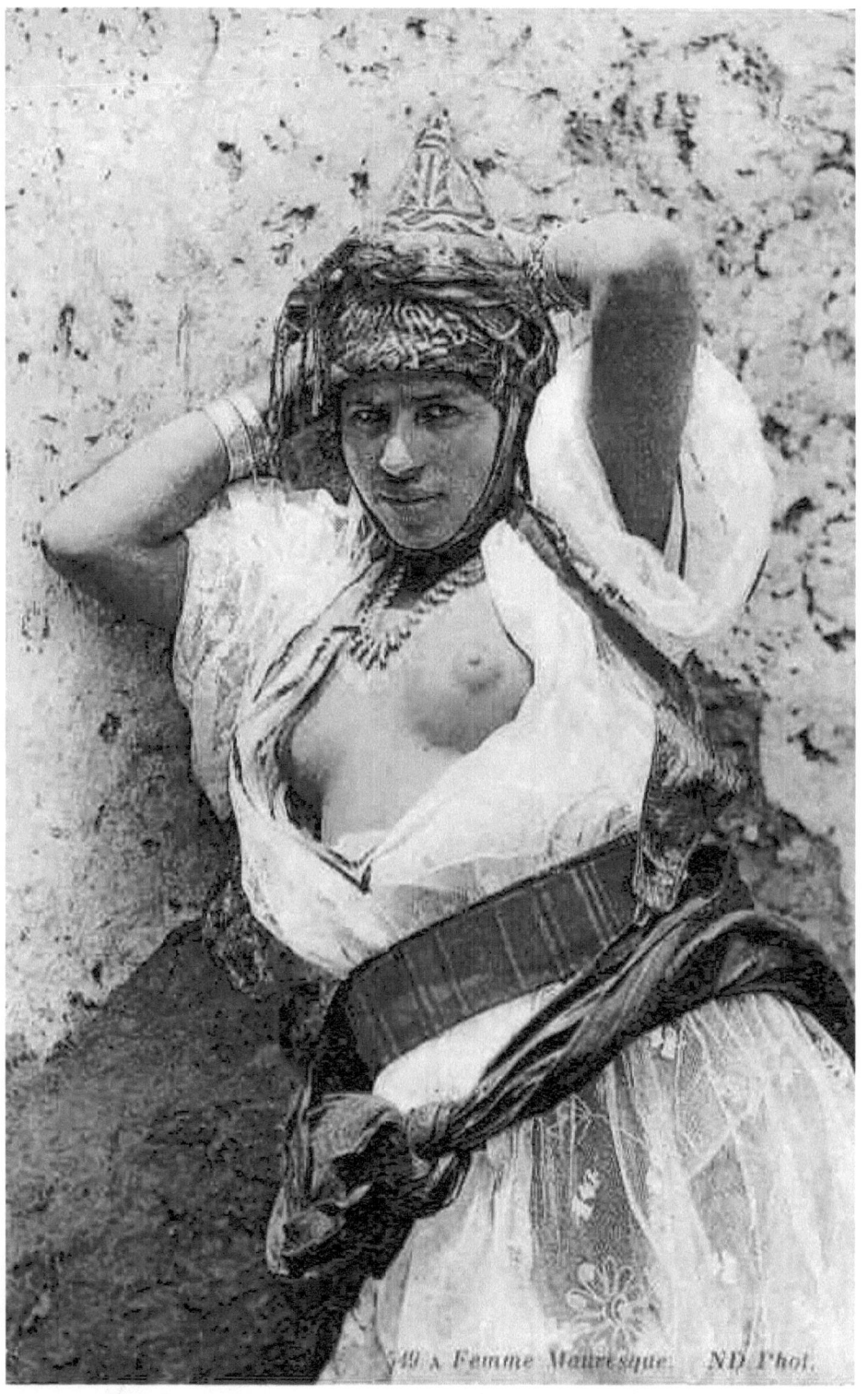

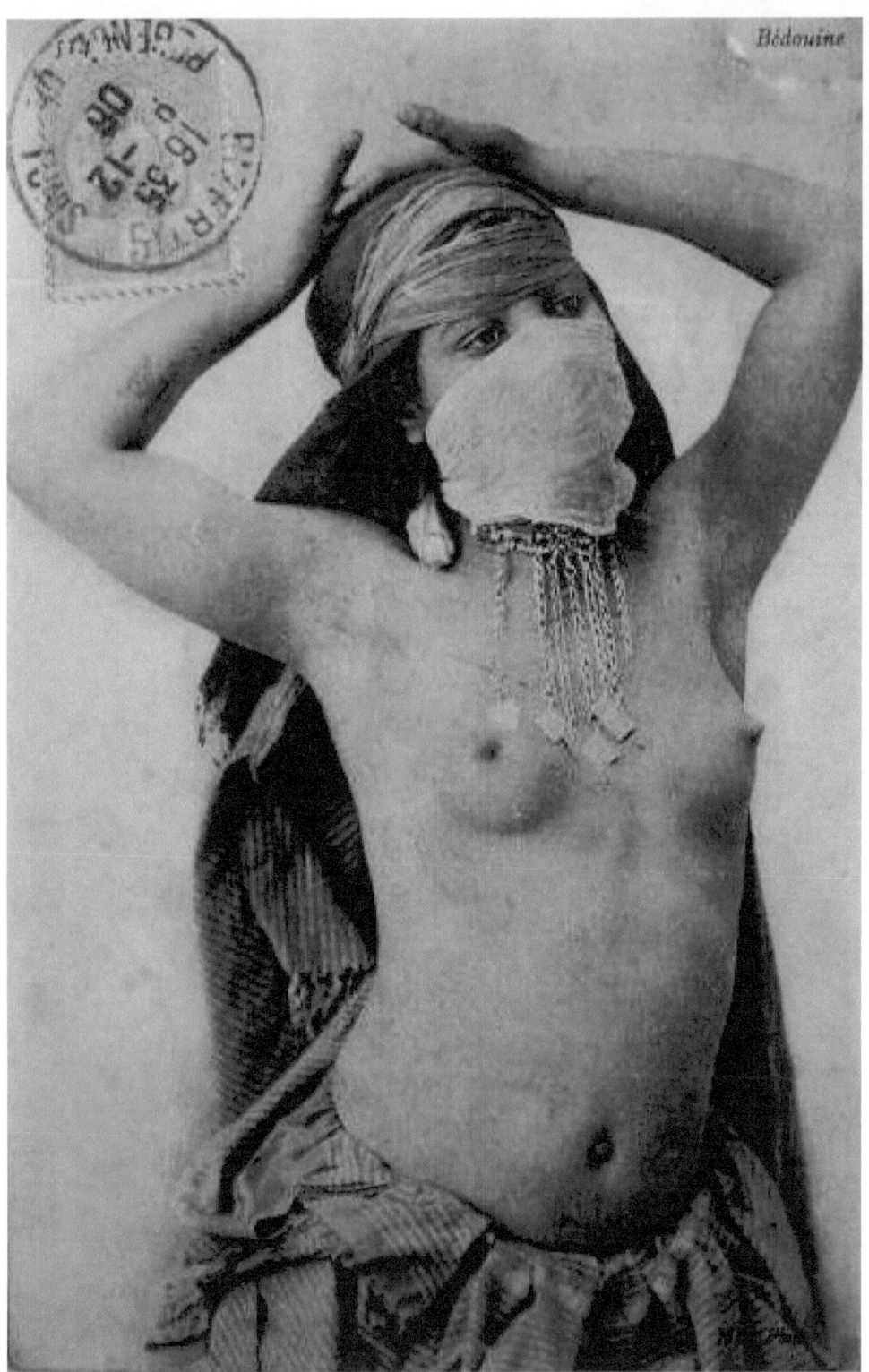

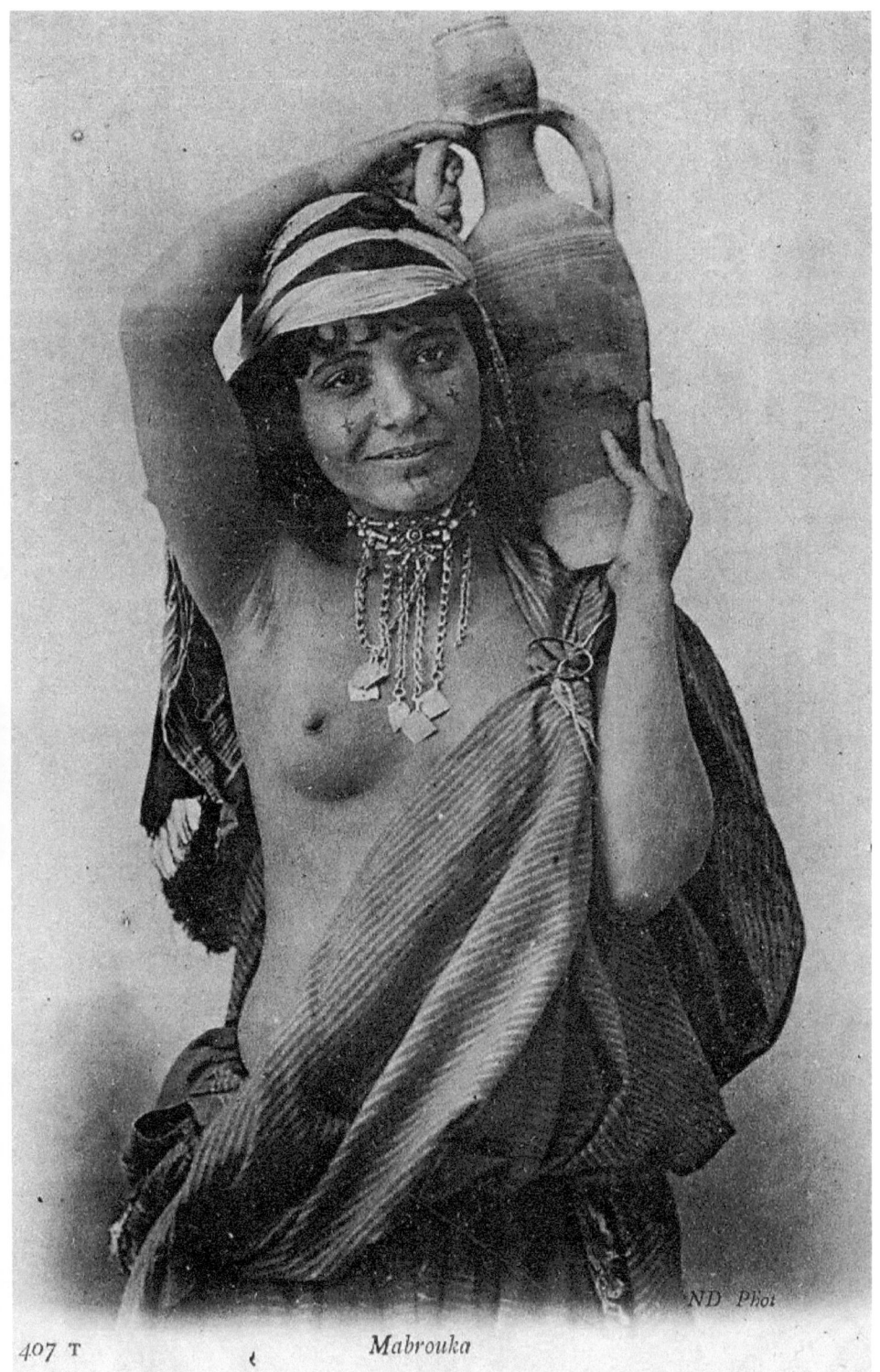

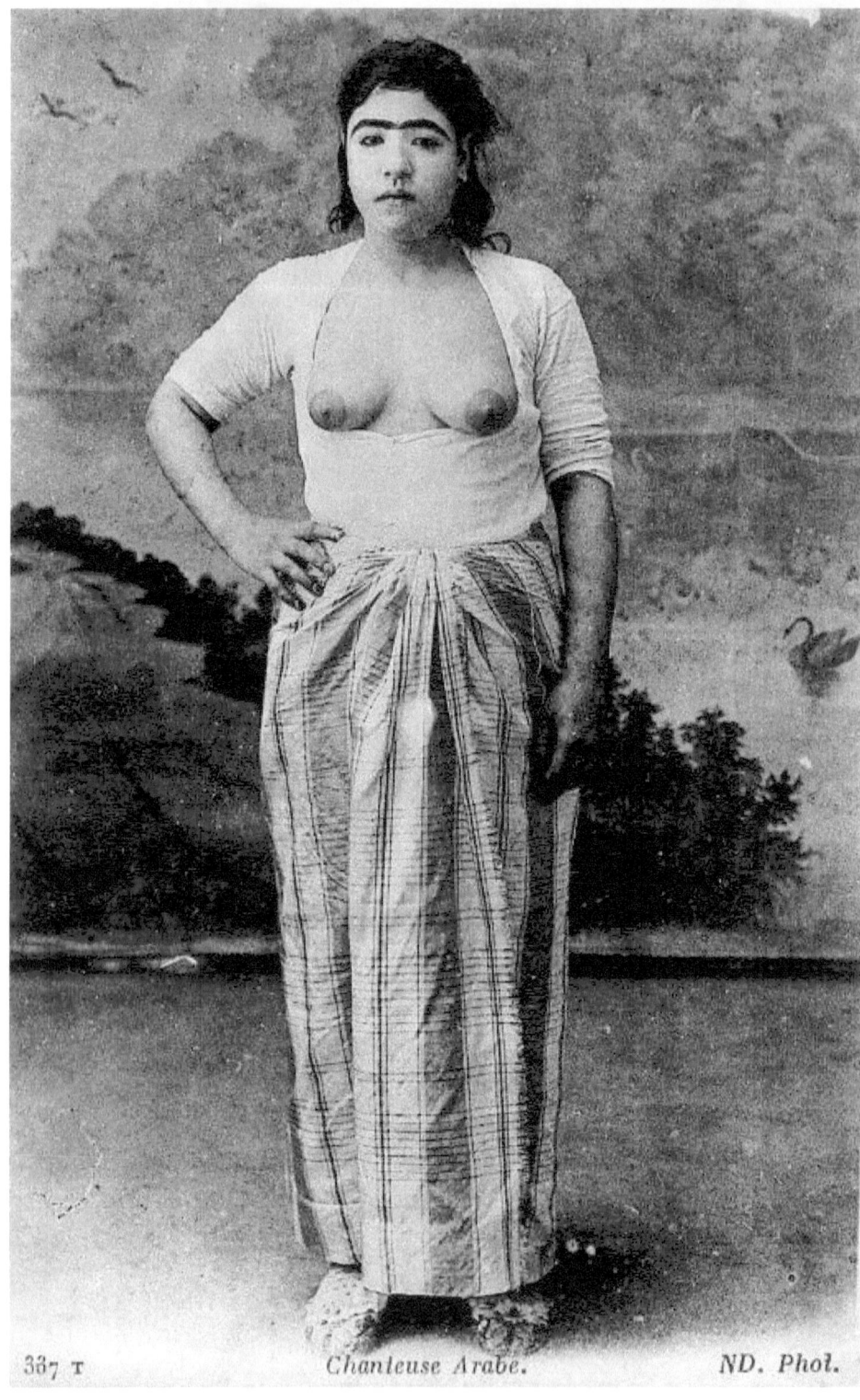
Chanteuse Arabe.

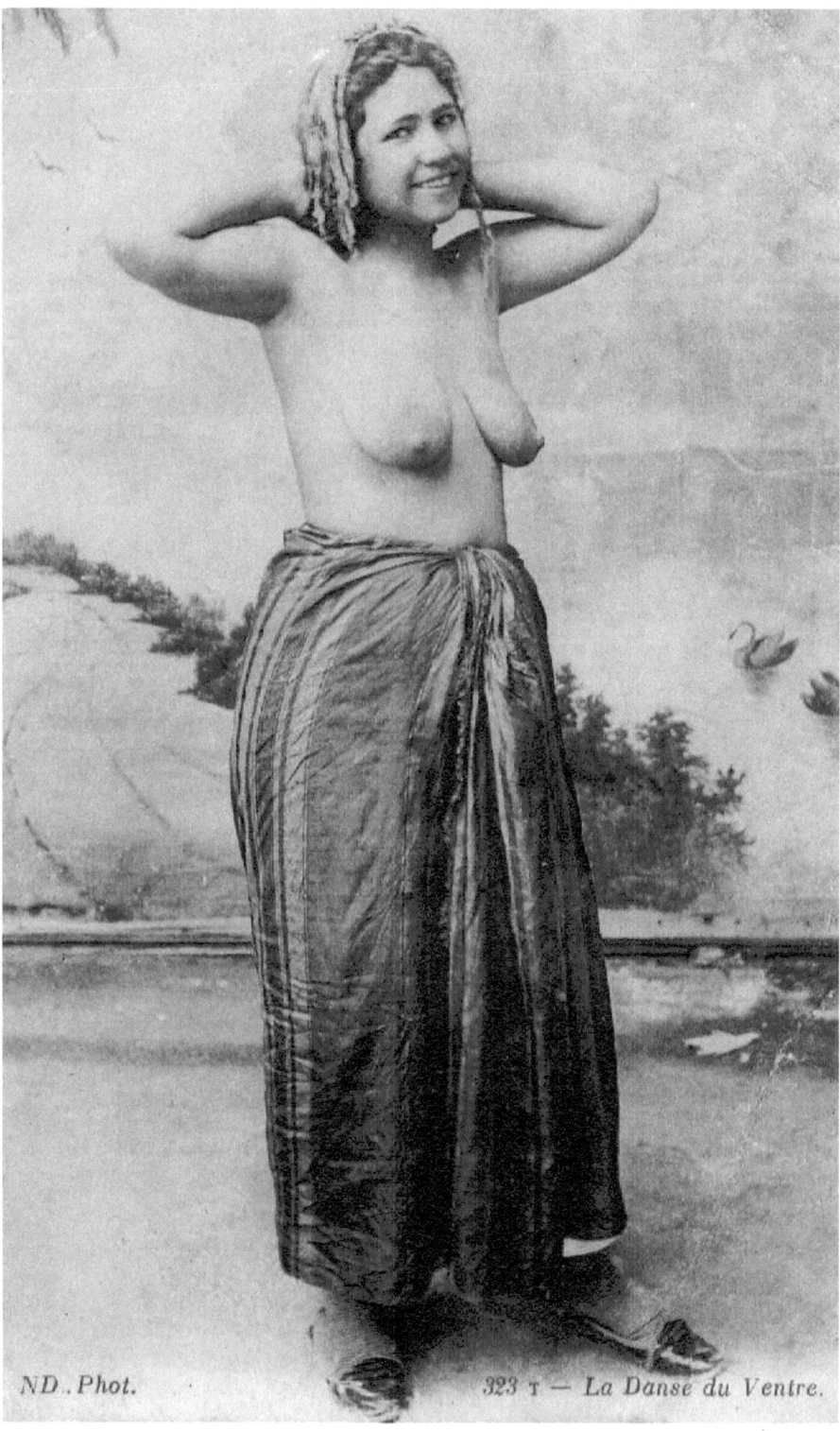

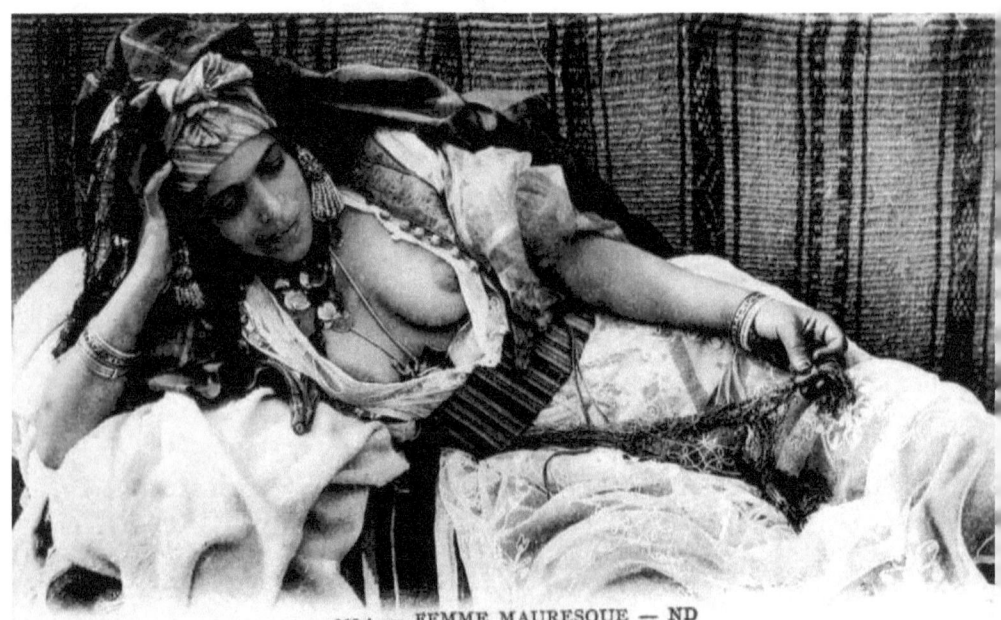

Jeune Mauresque et Femme Kabyle. ND, Phot.

229 A — FEMME MAURESQUE — ND

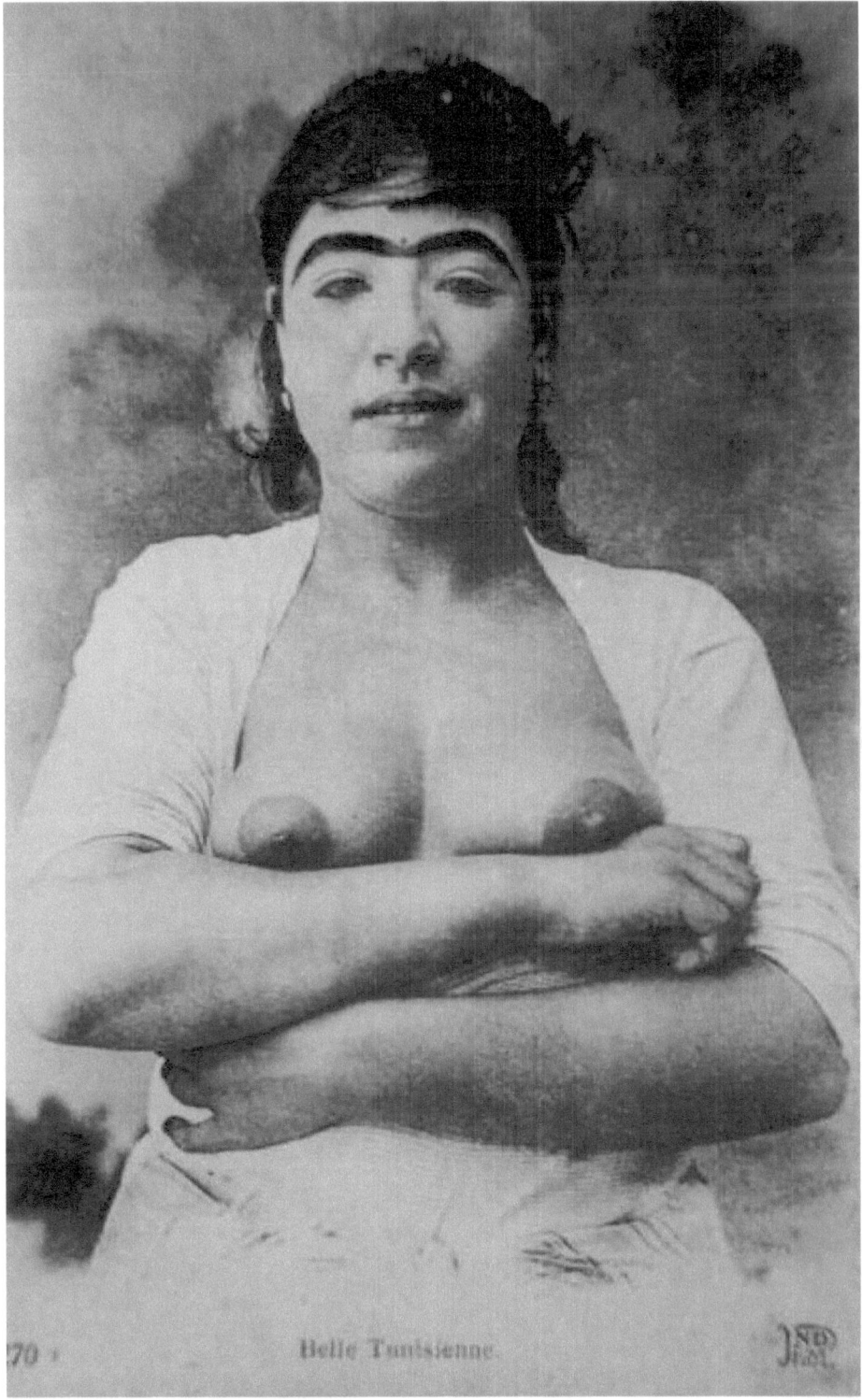

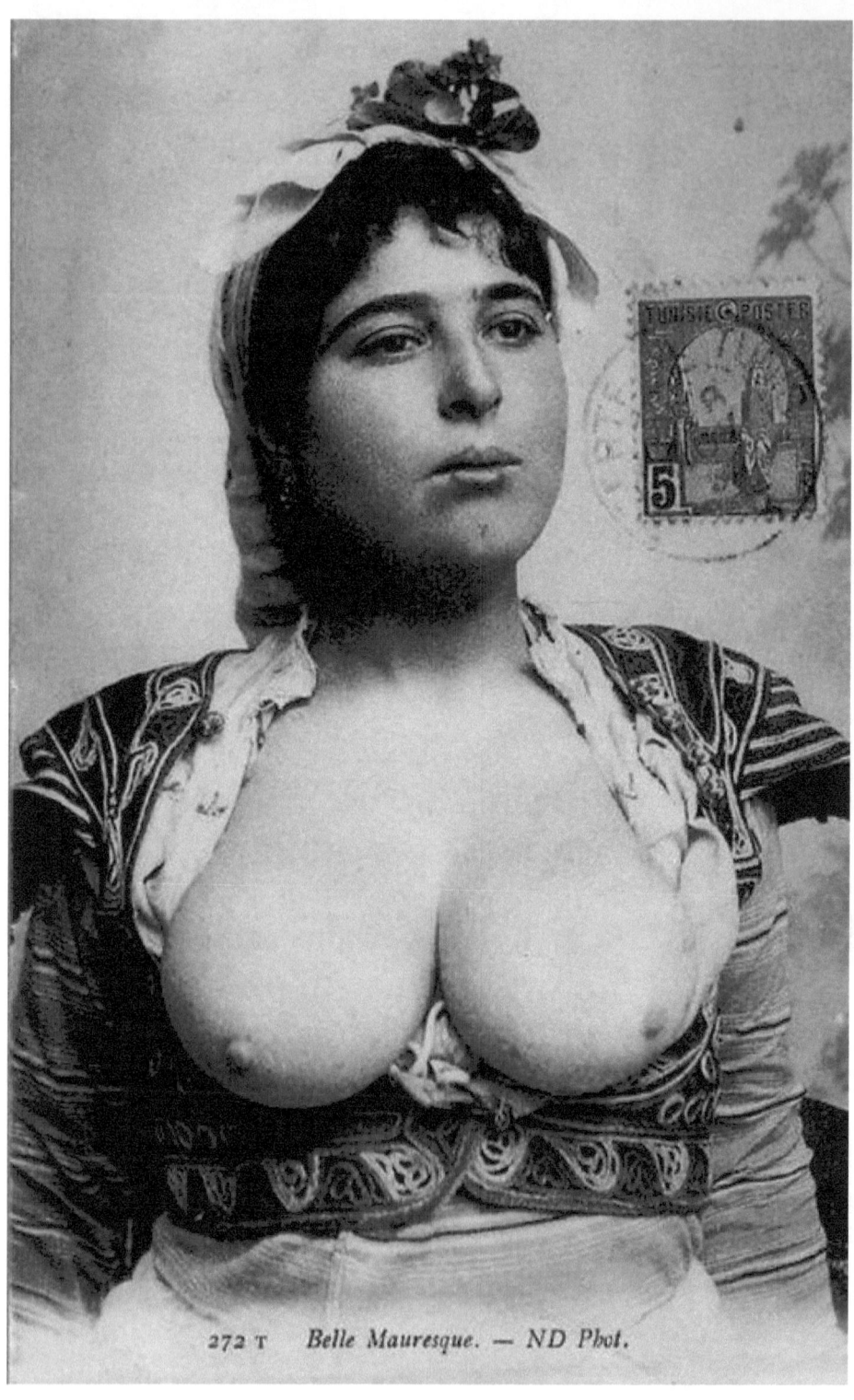
272 T Belle Mauresque. — ND Phot.

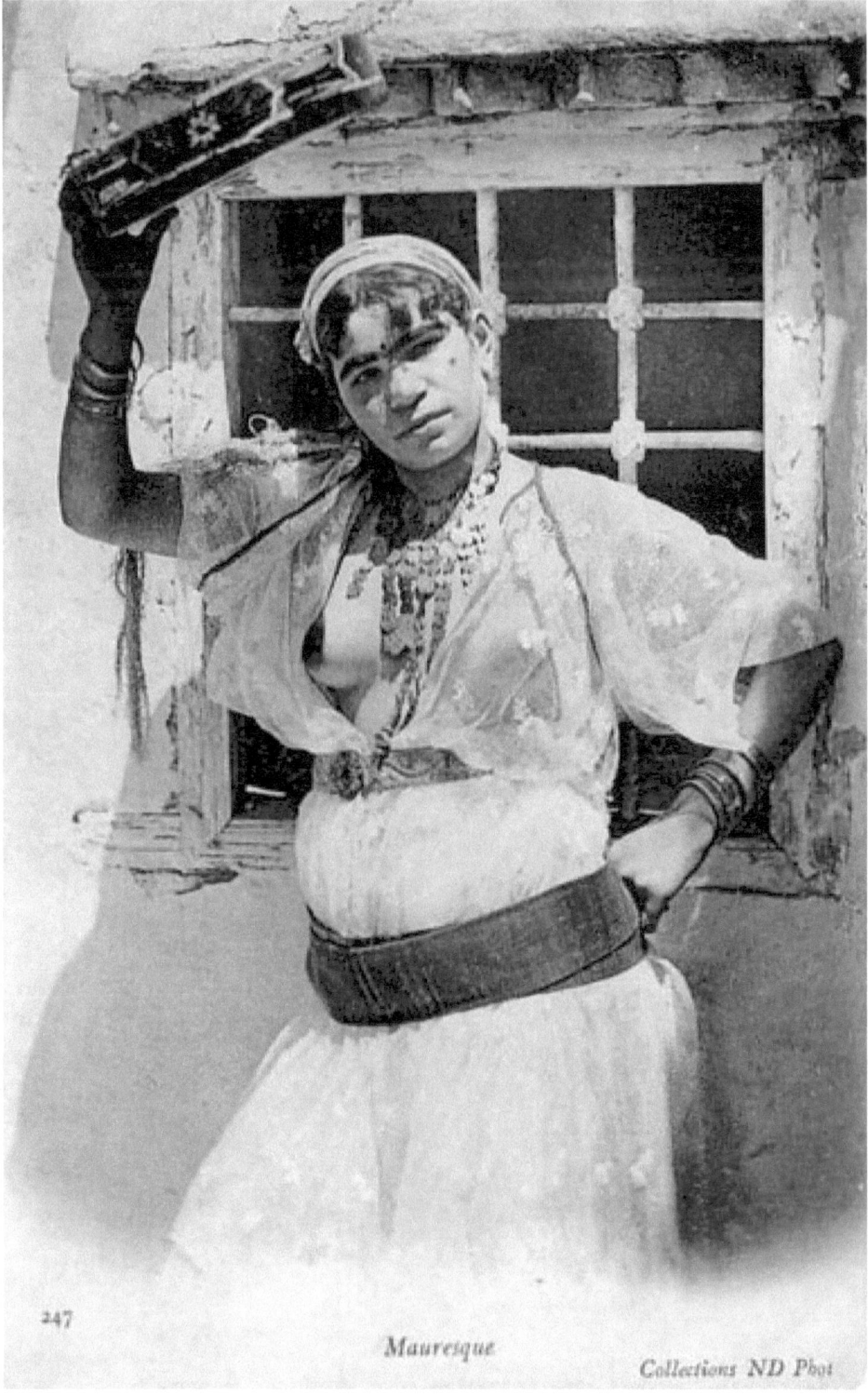

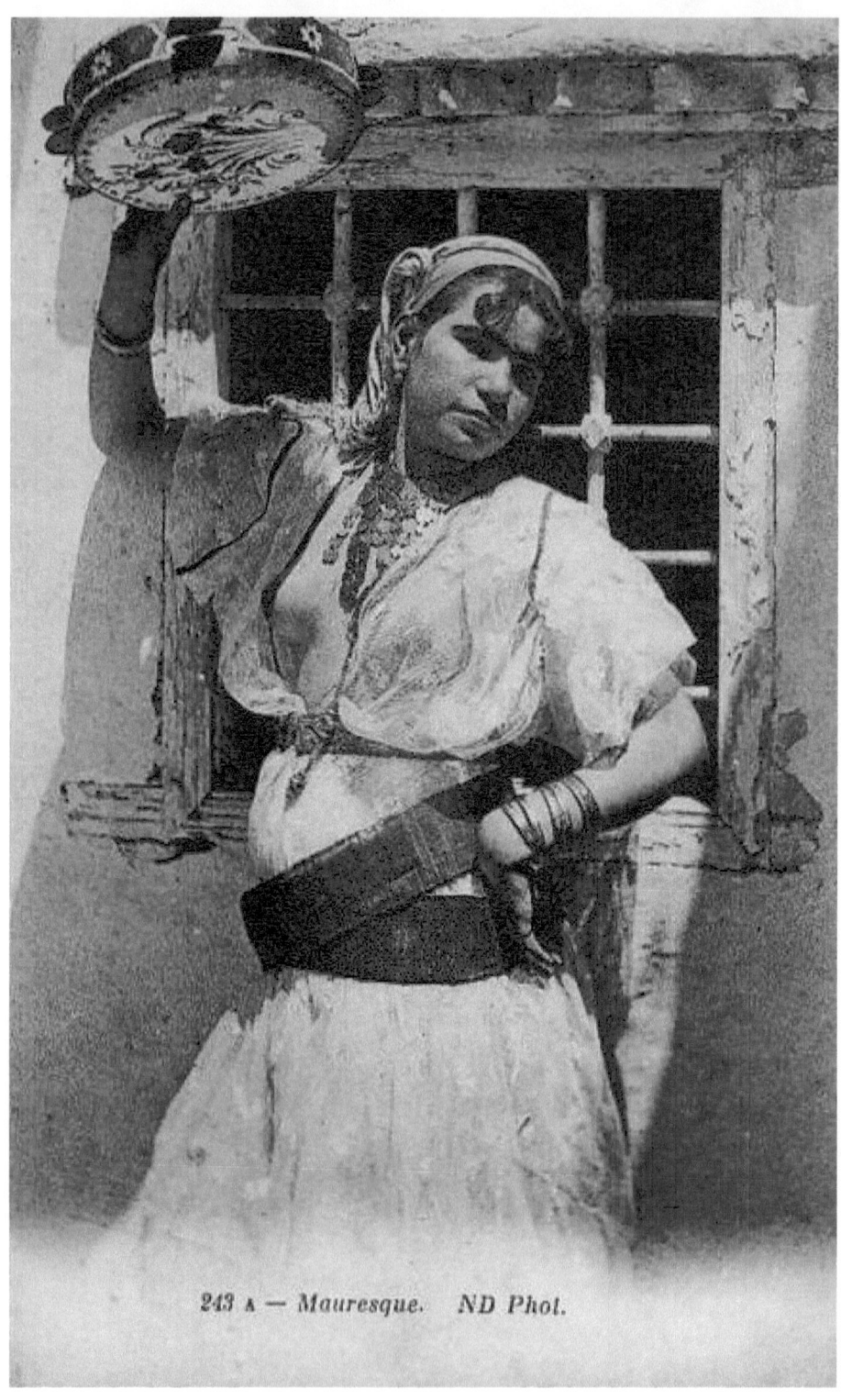
243 A — Mauresque. ND Phot.

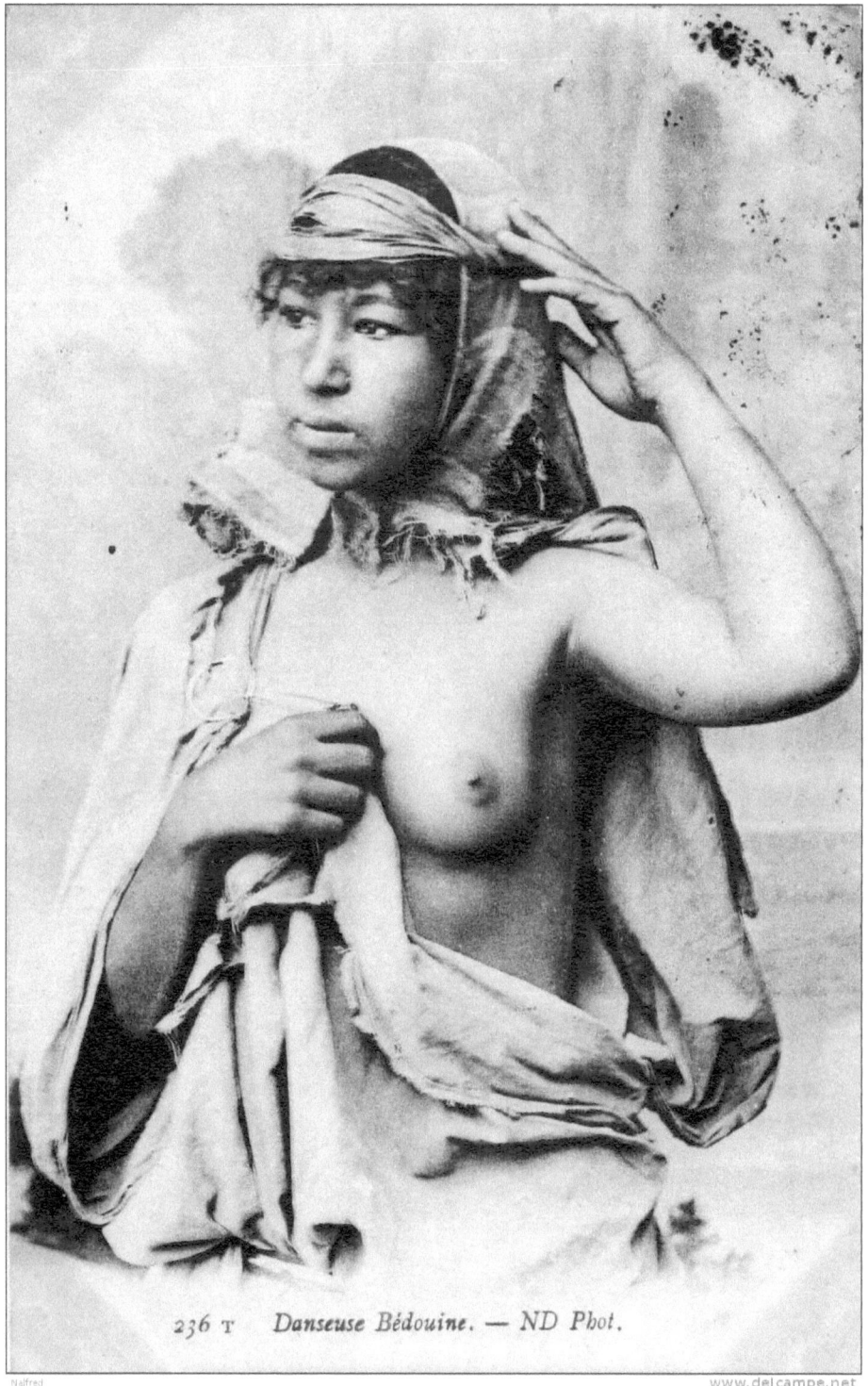

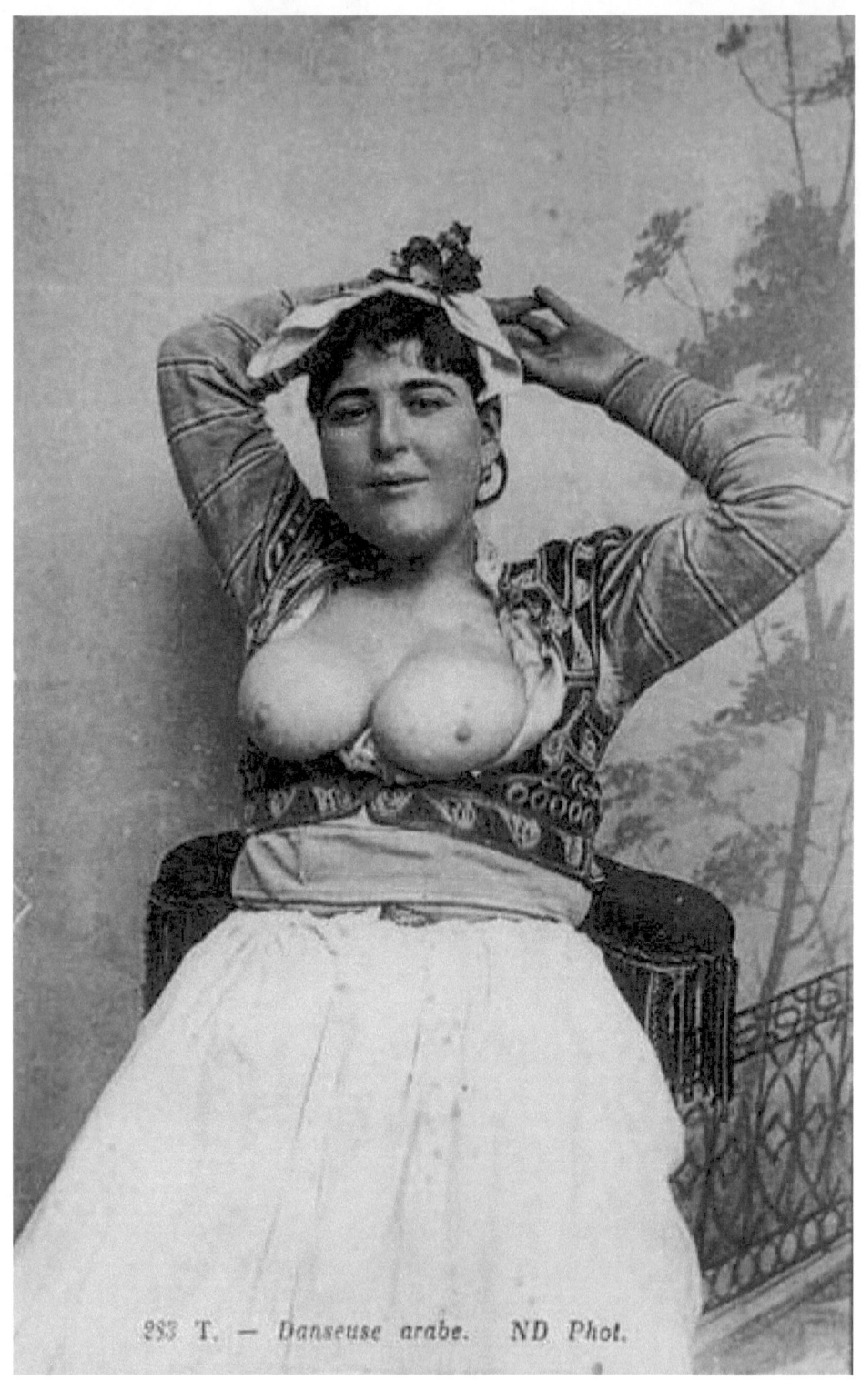

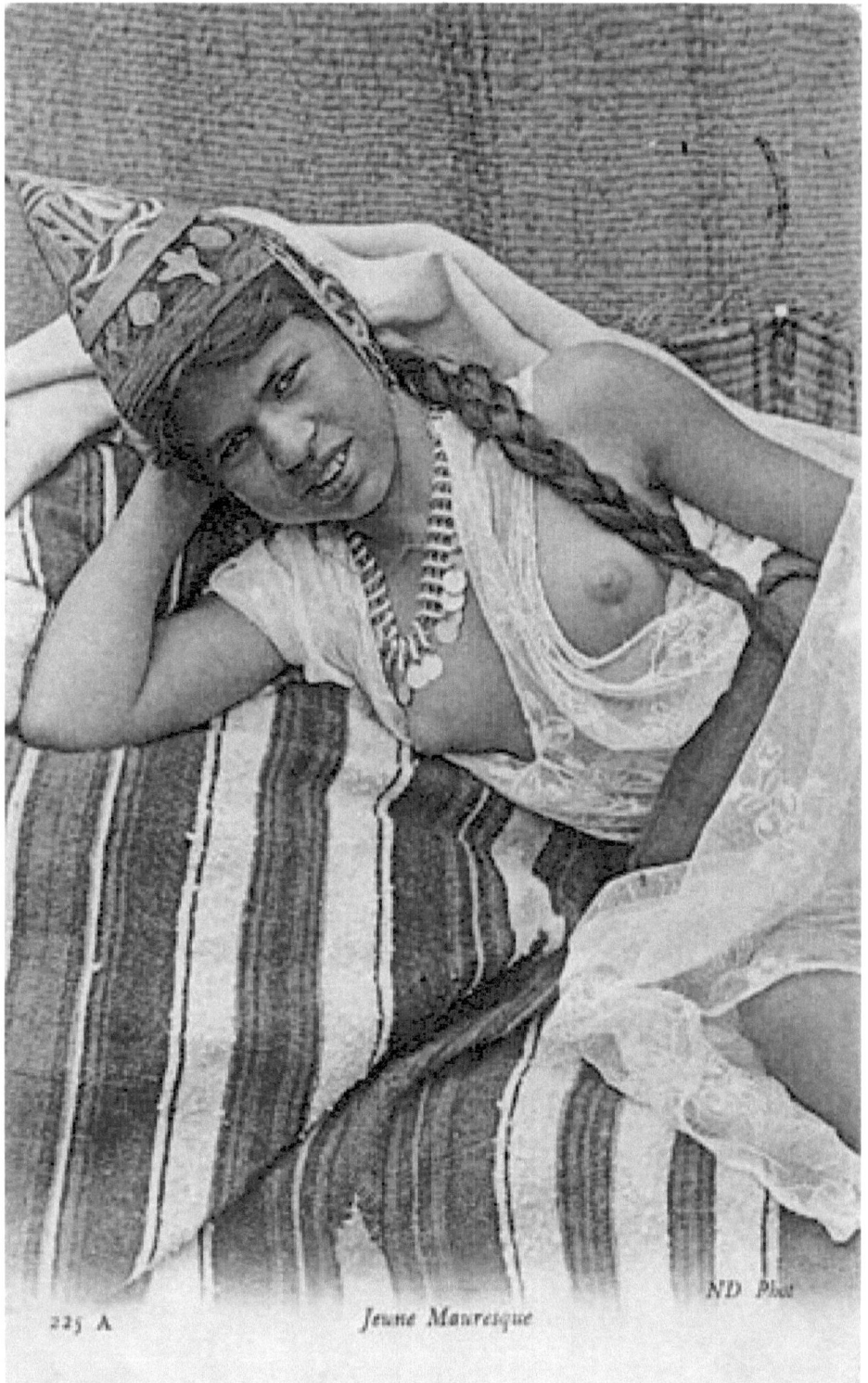
Jeune Mauresque

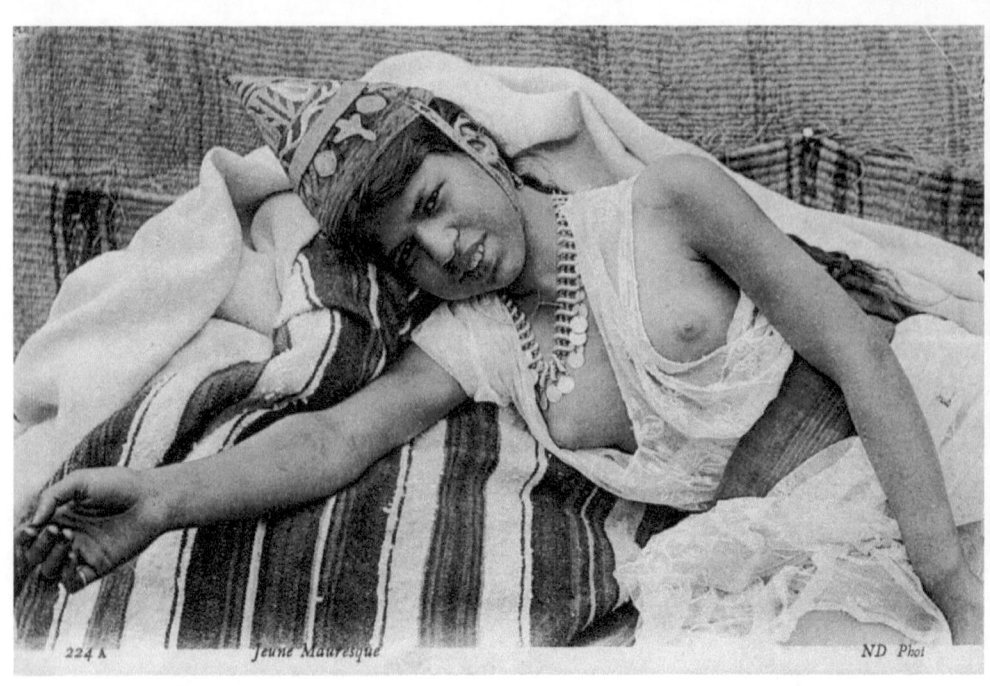

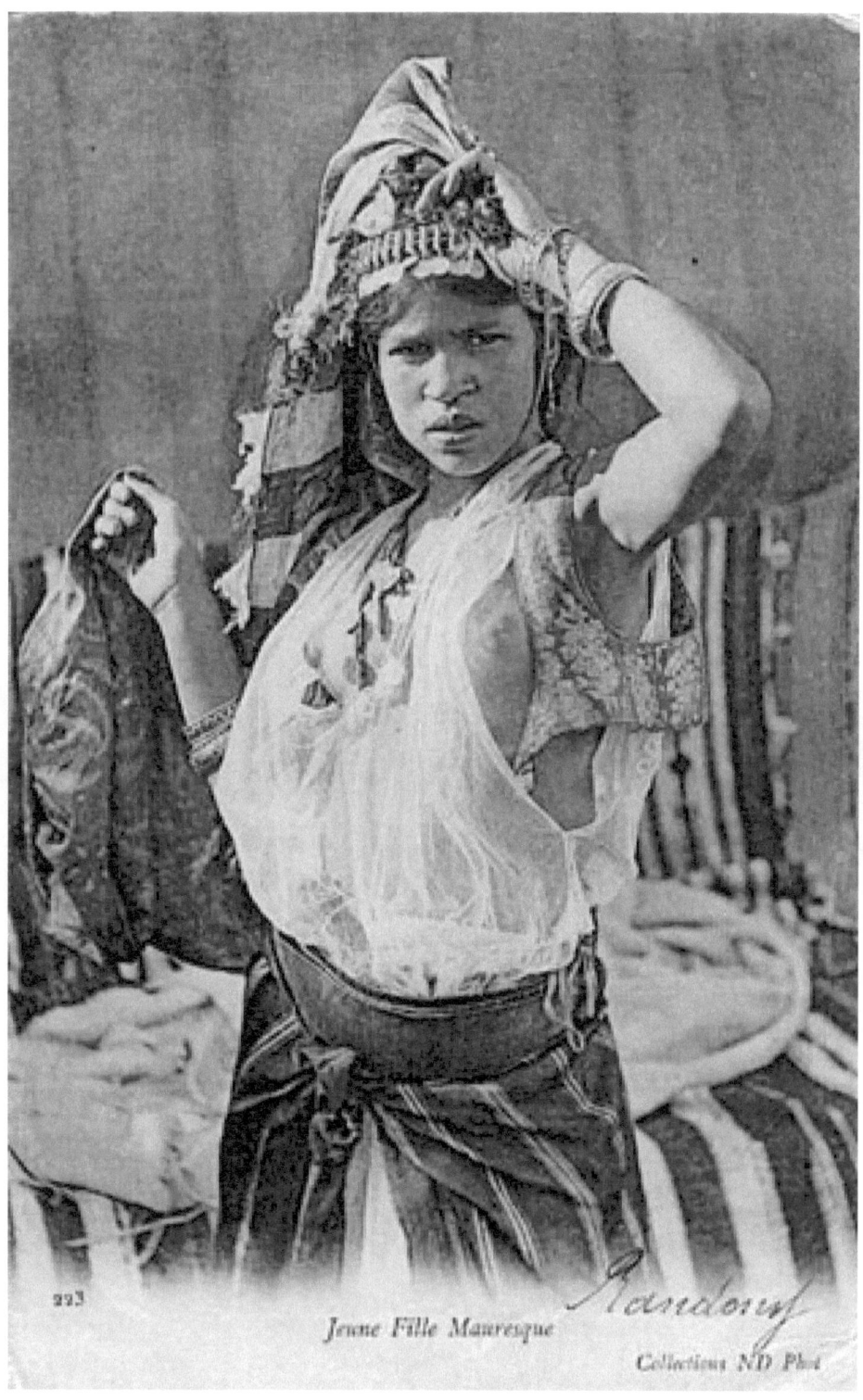
Jeune Fille Mauresque

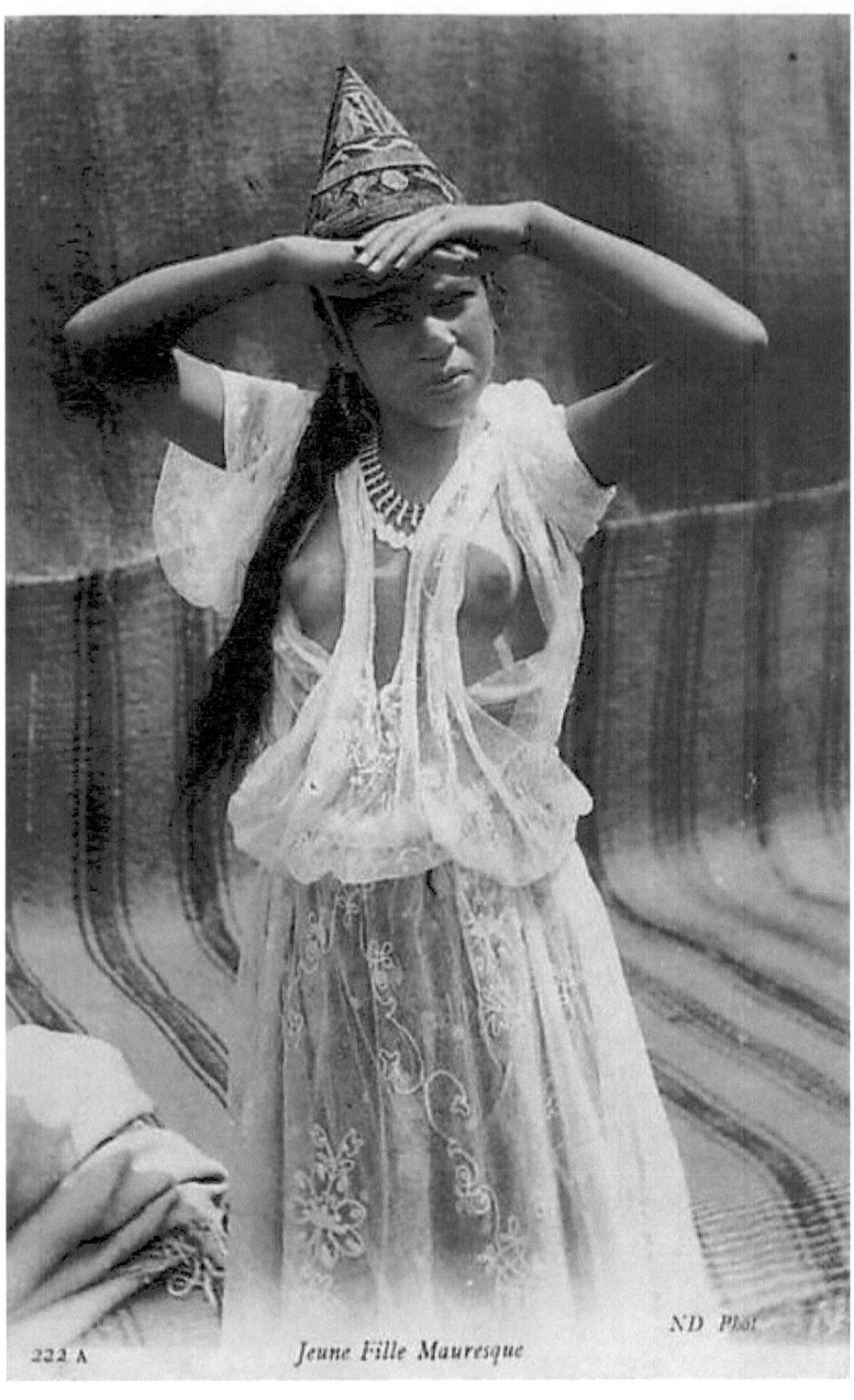

Jeune Fille Mauresque

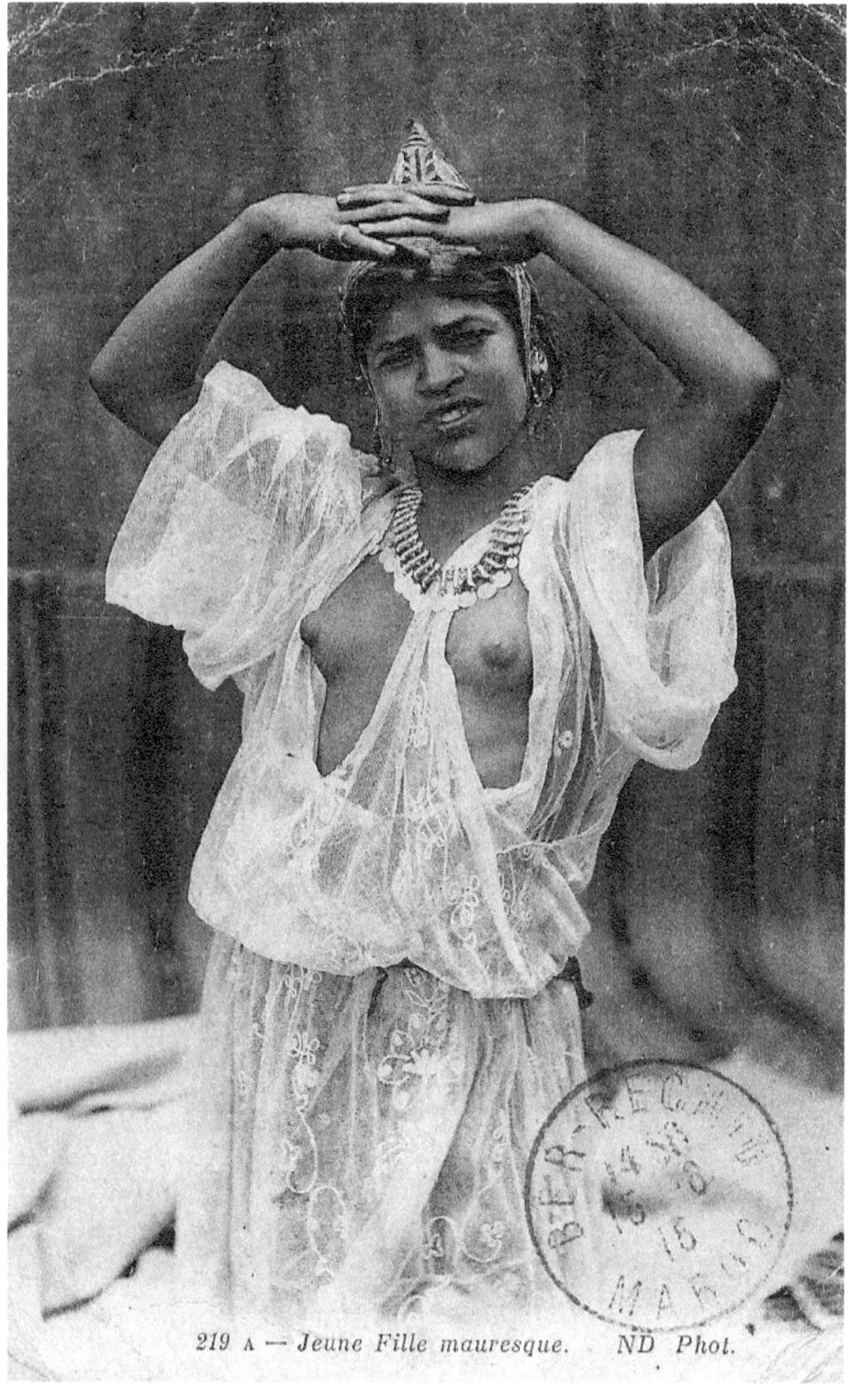

219 A — Jeune Fille mauresque. ND Phot.

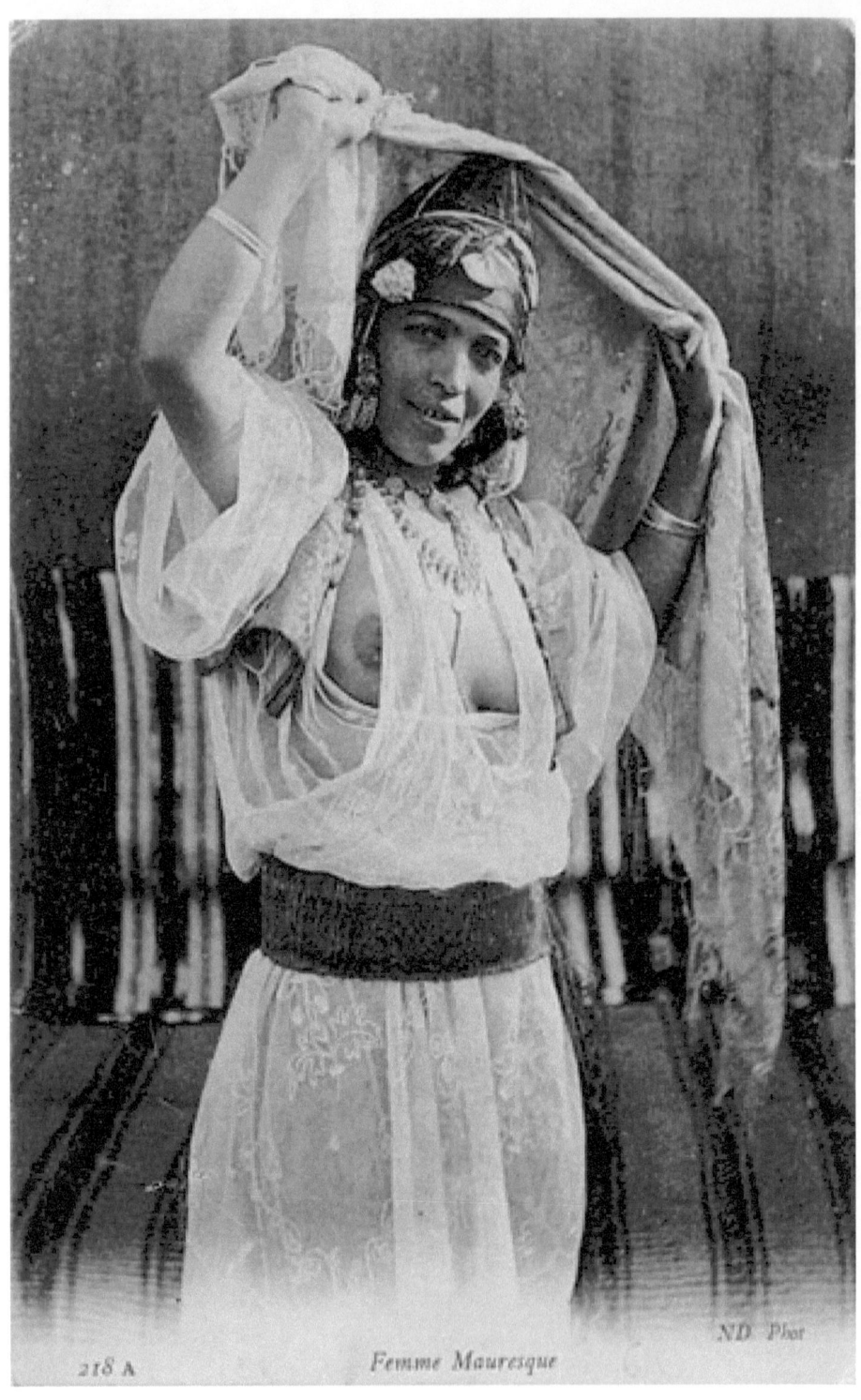

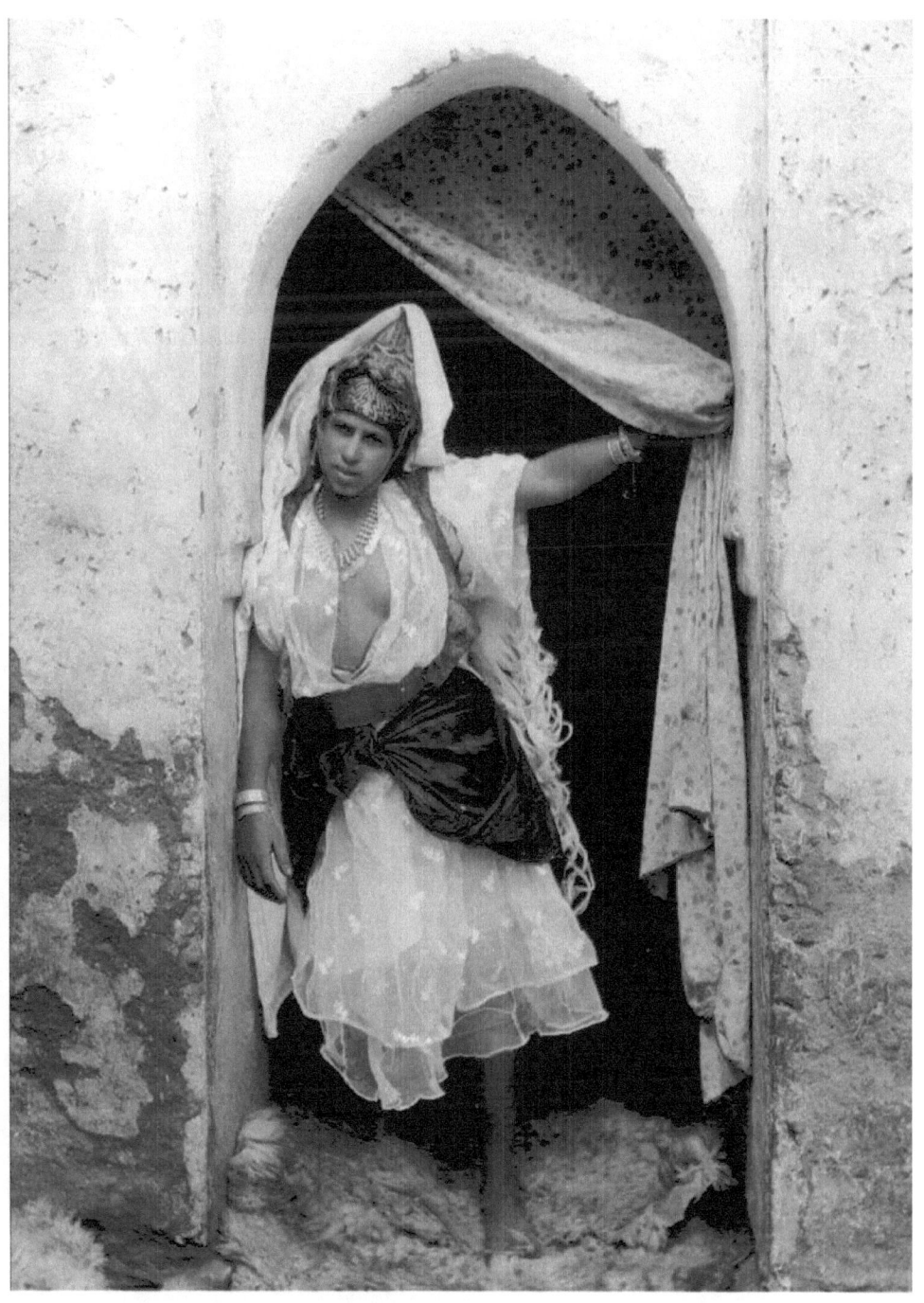

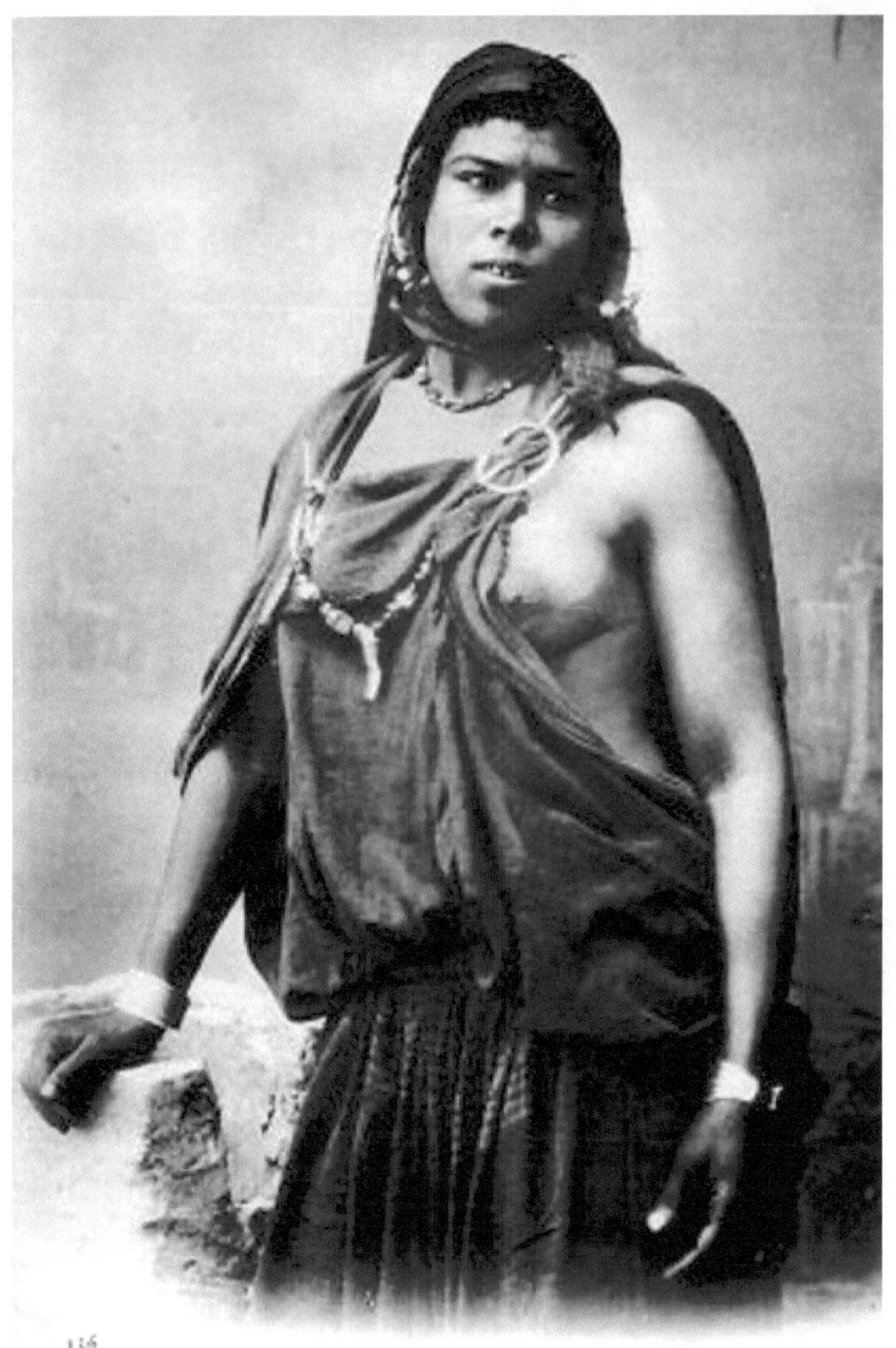

TUNISIE. — Bédouine

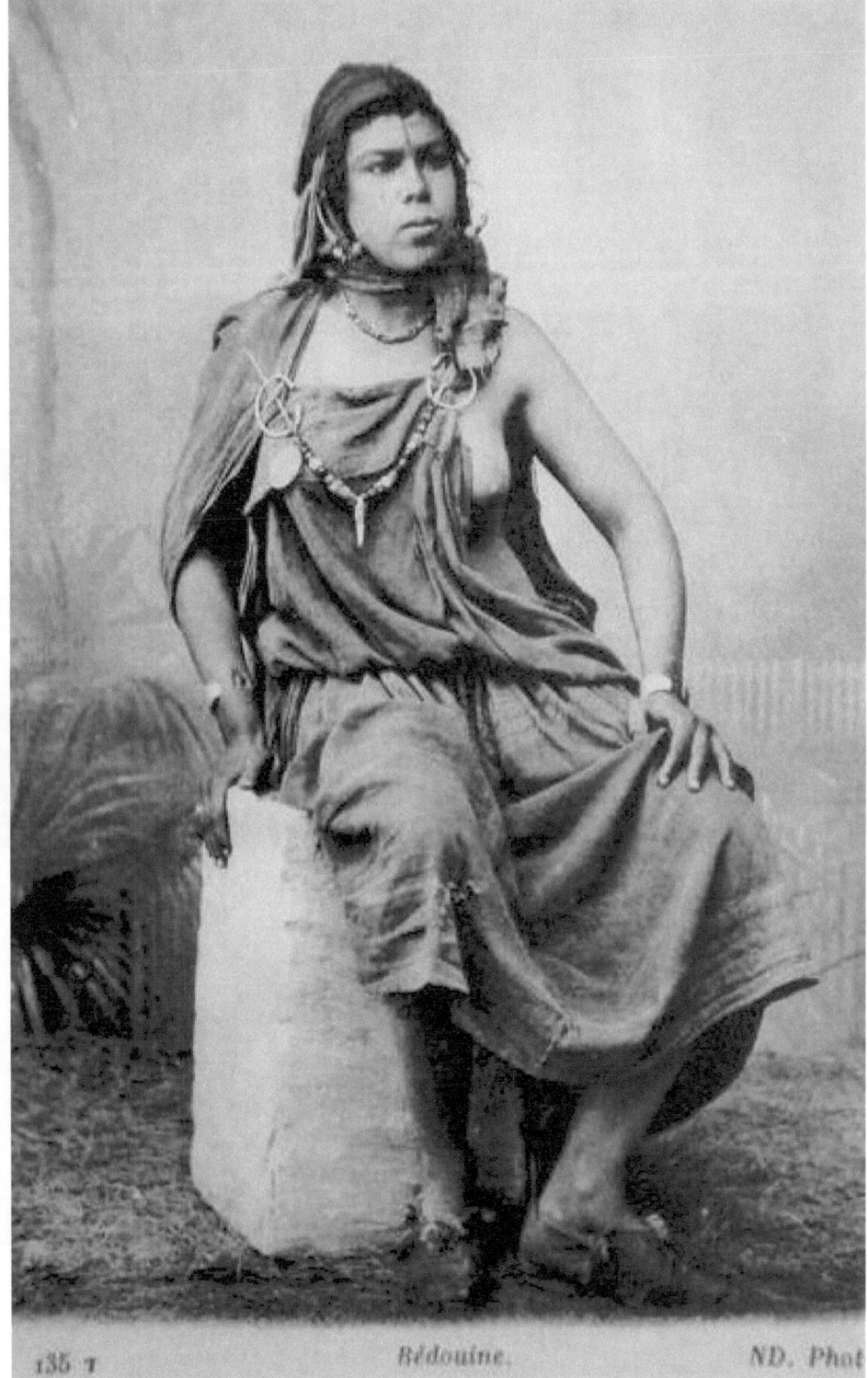

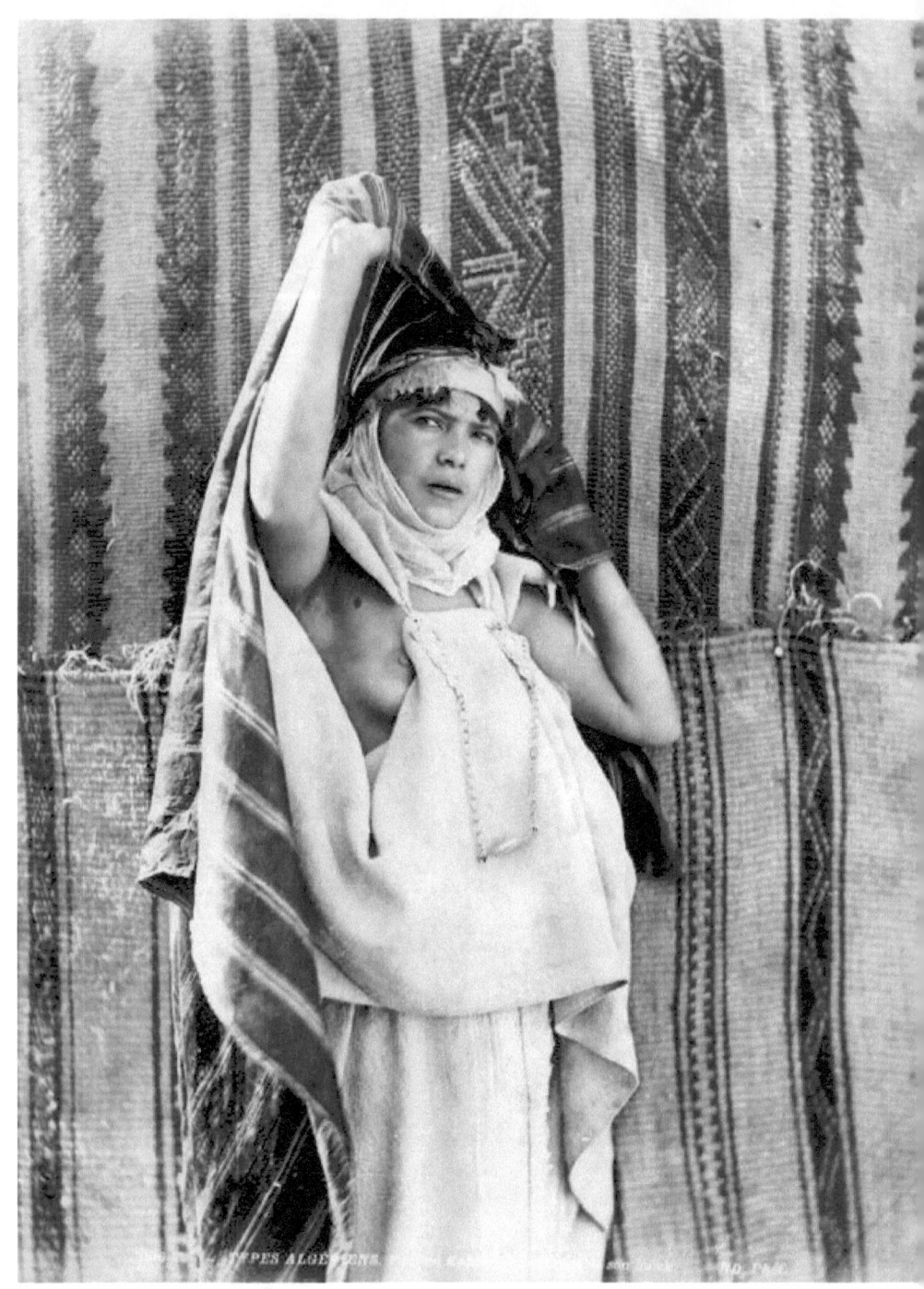

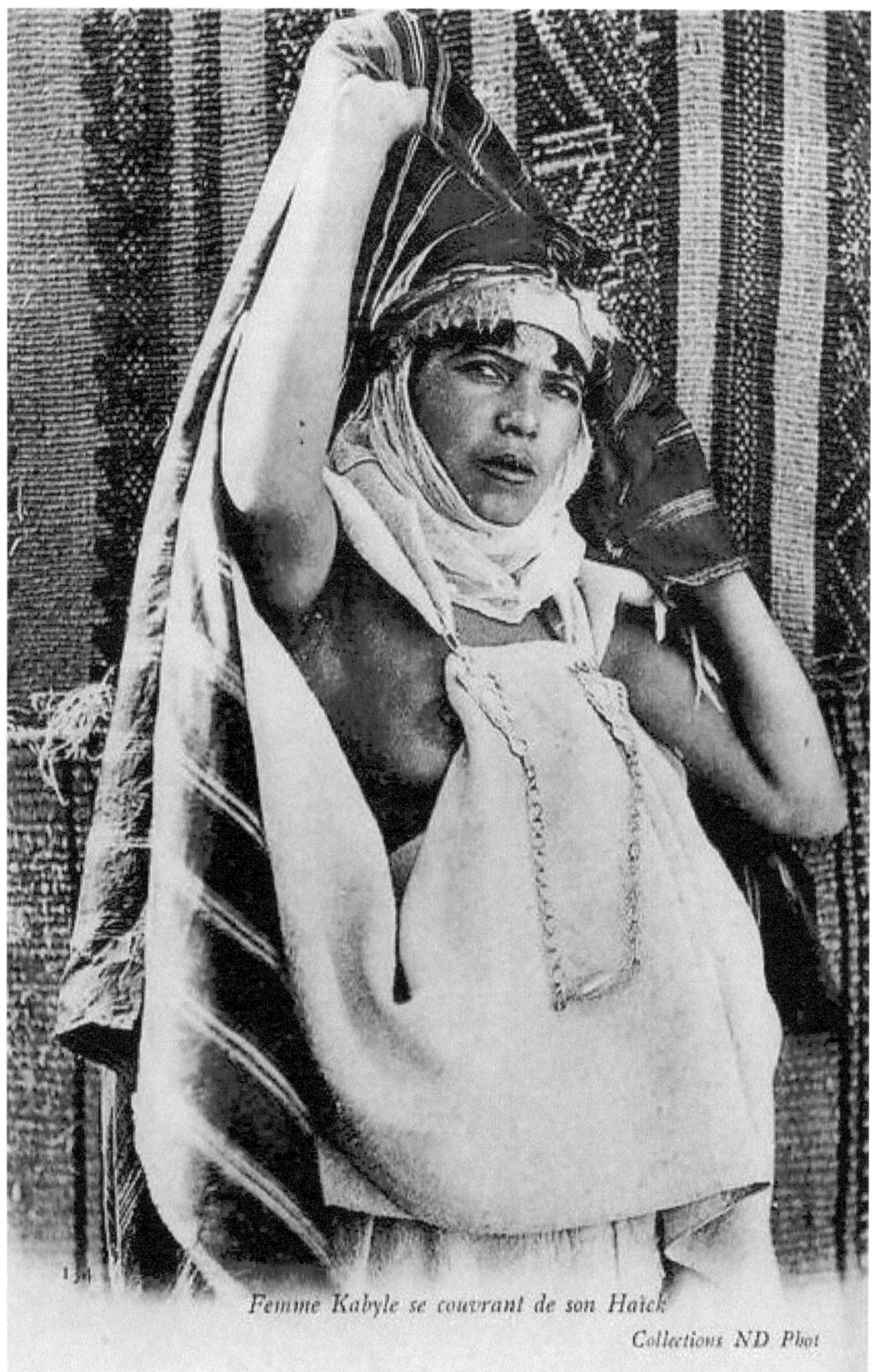

Femme Kabyle se couvrant de son Haïck

Collections ND Phot

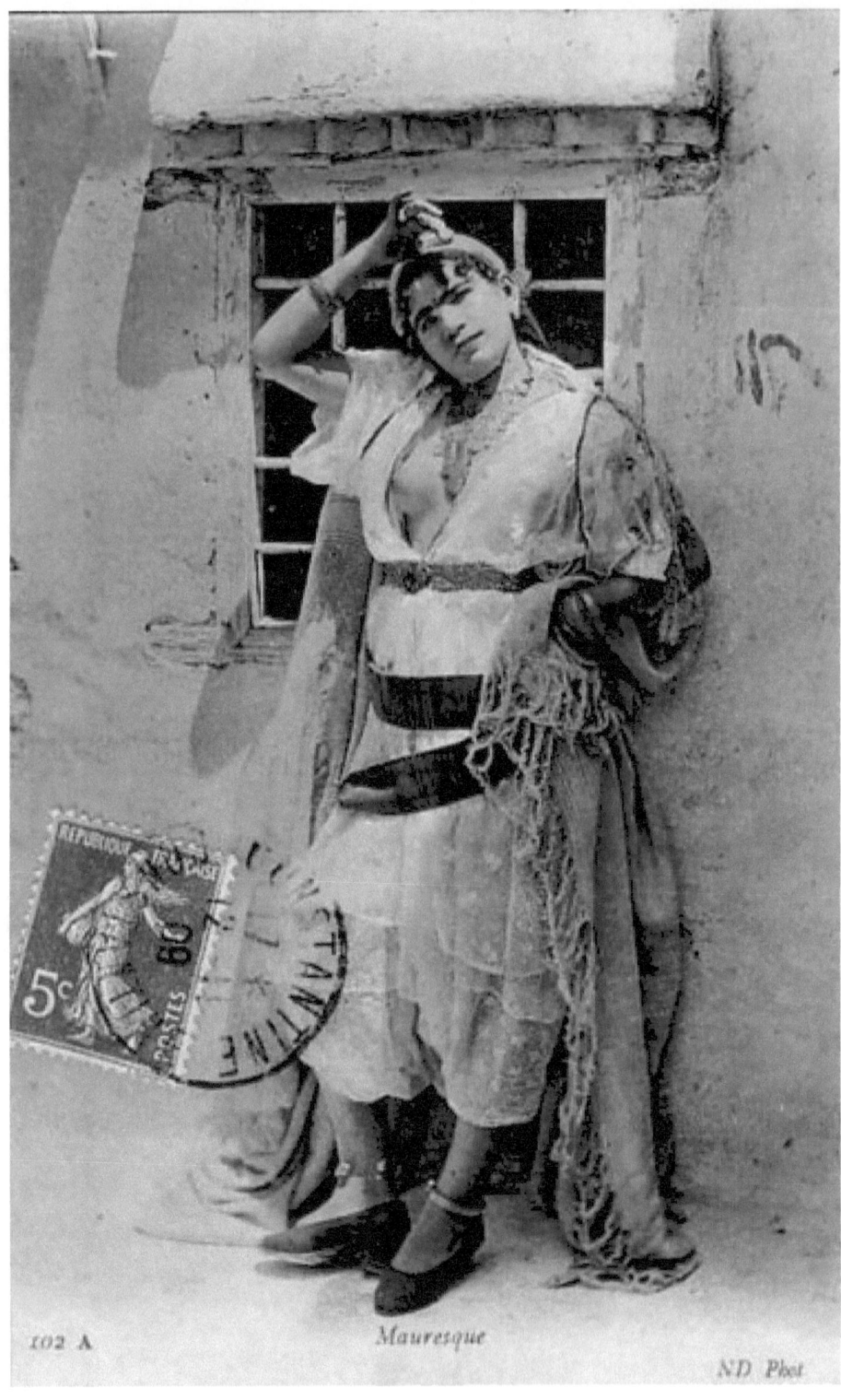

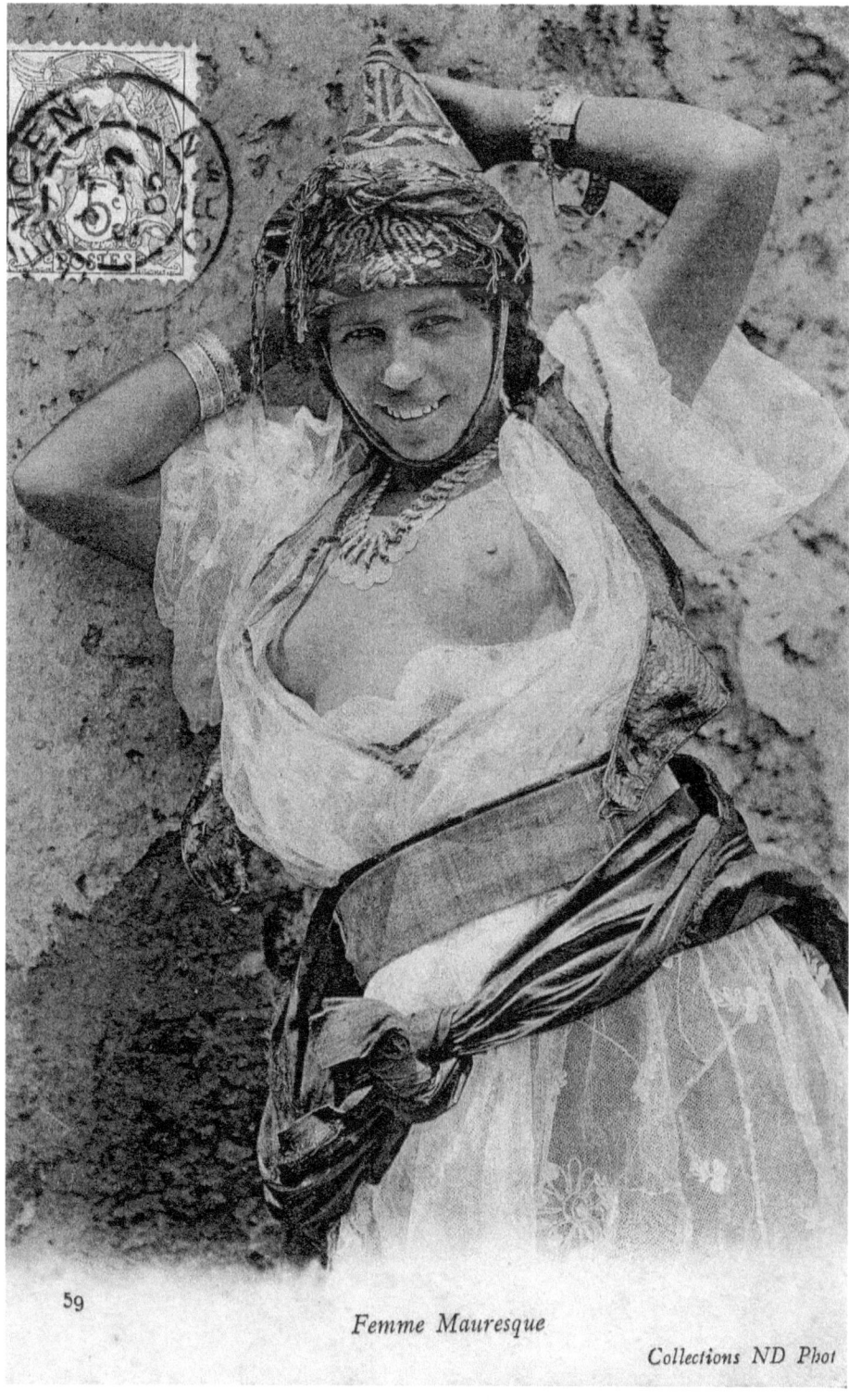
Femme Mauresque

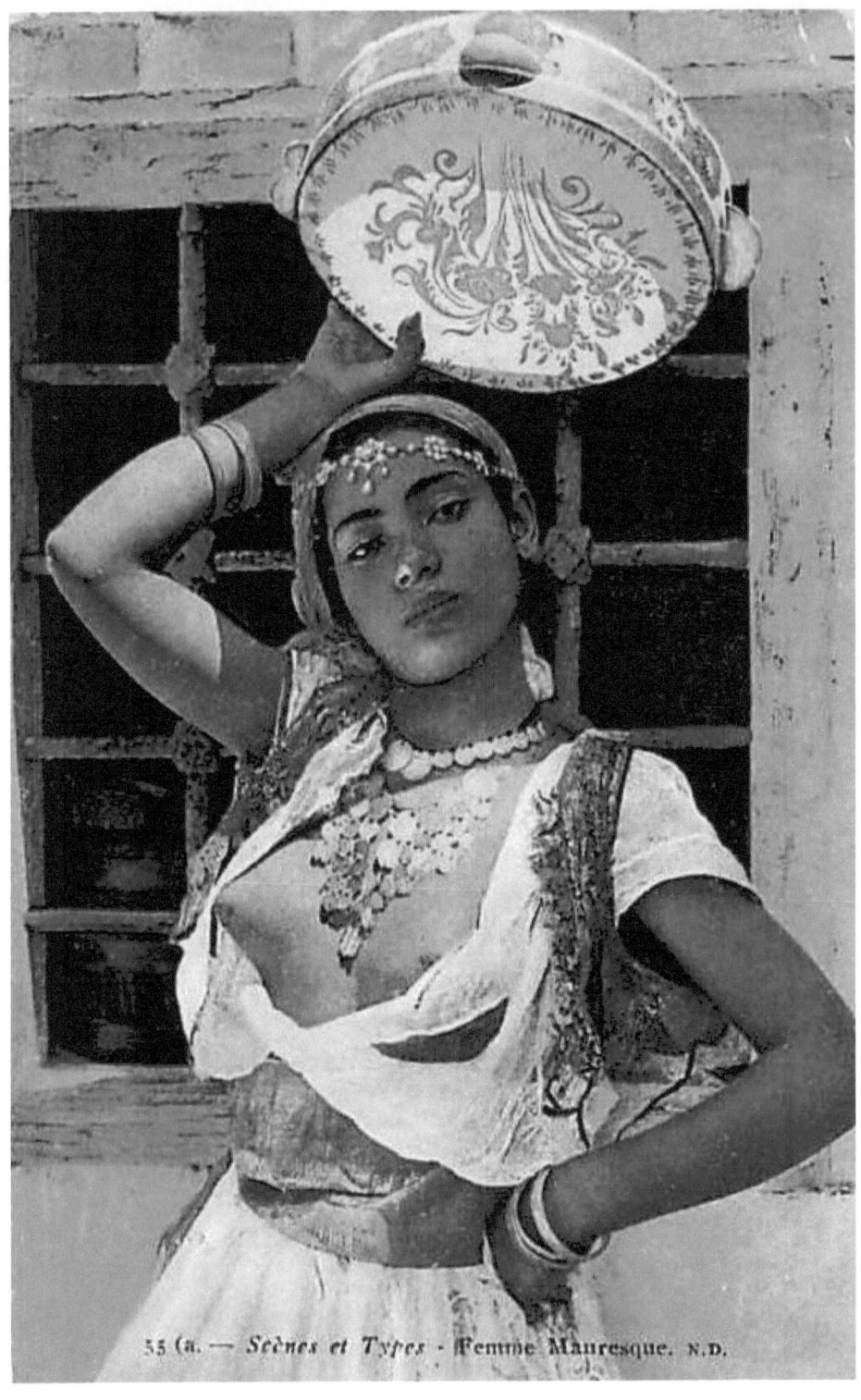

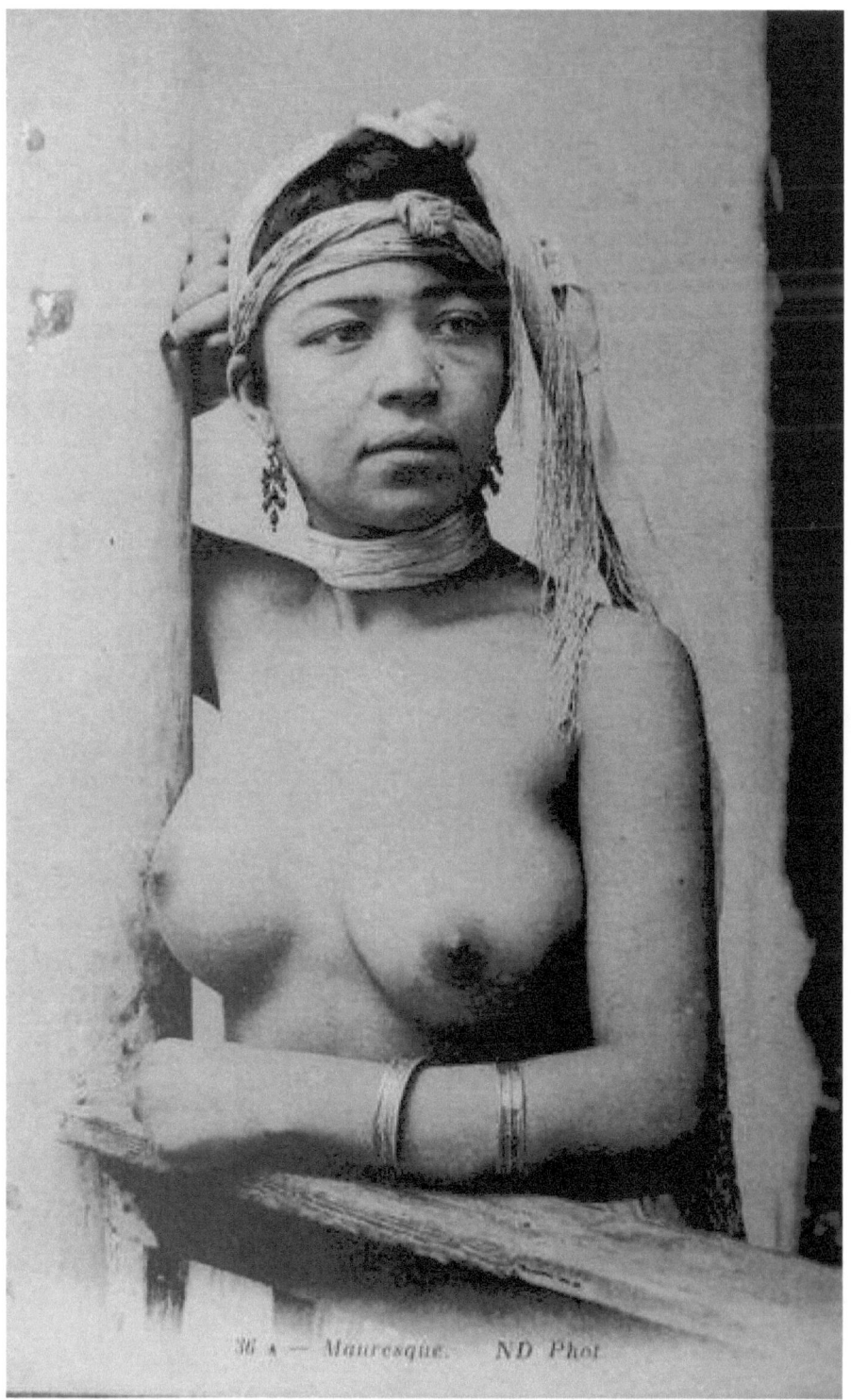

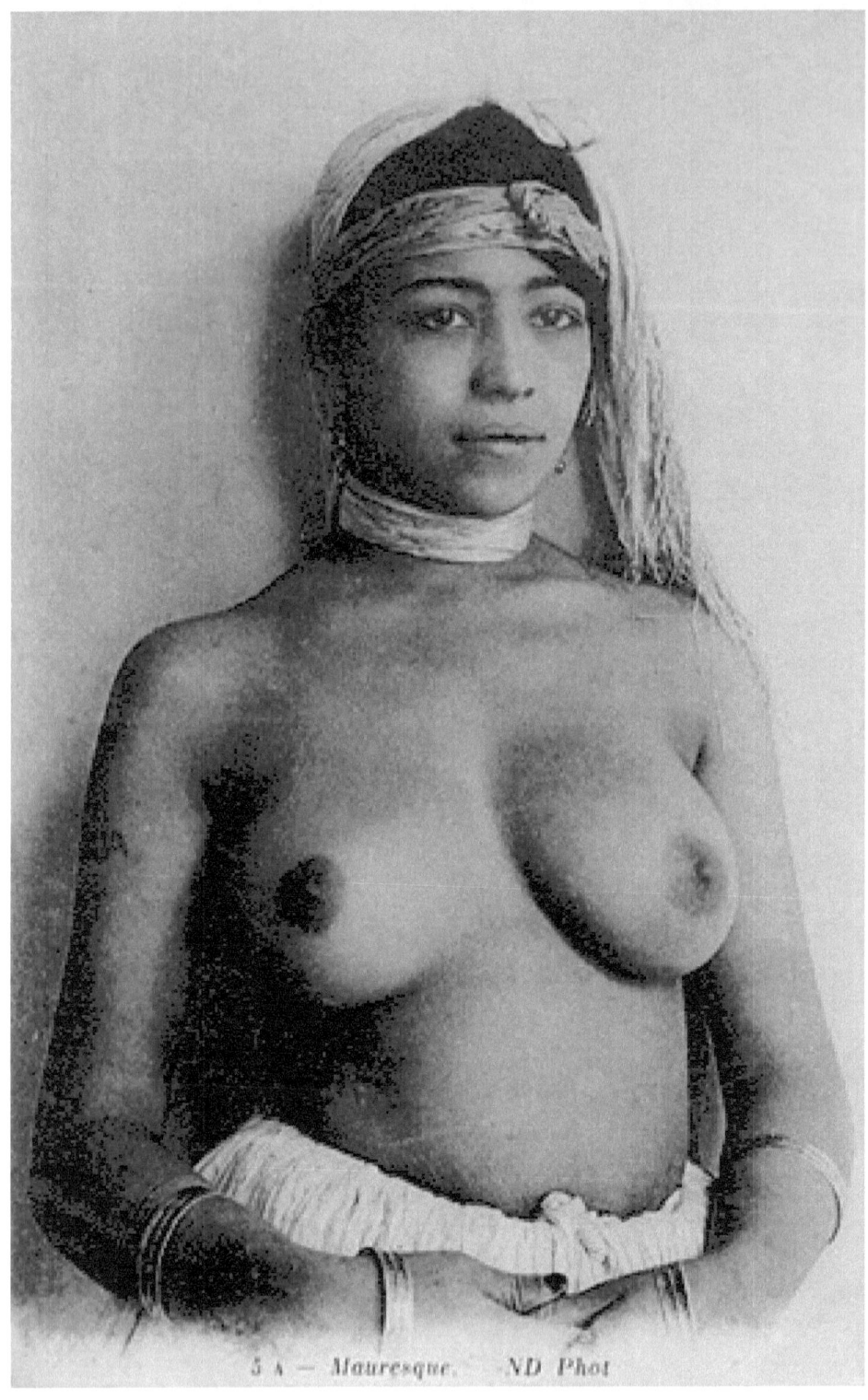

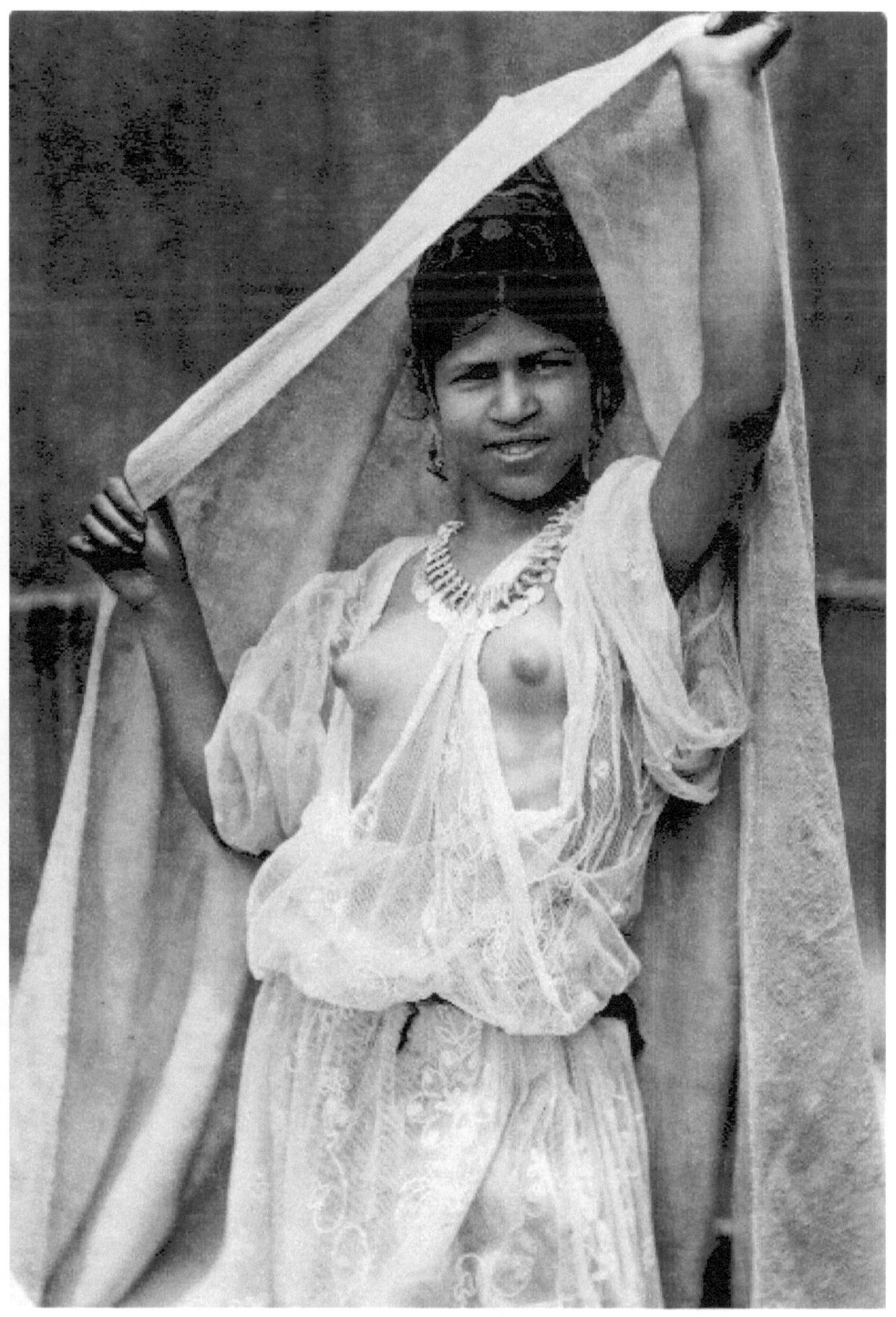

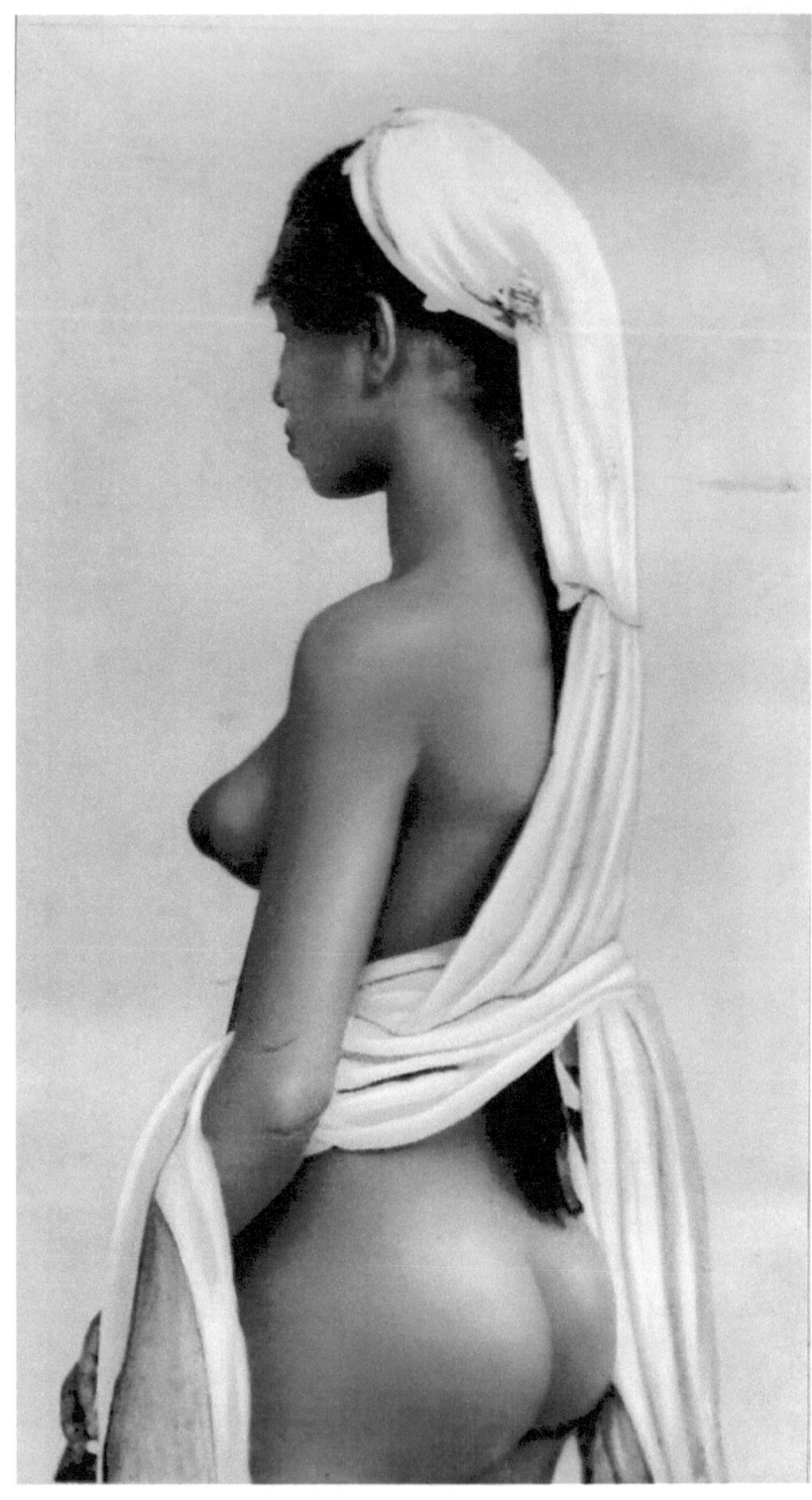

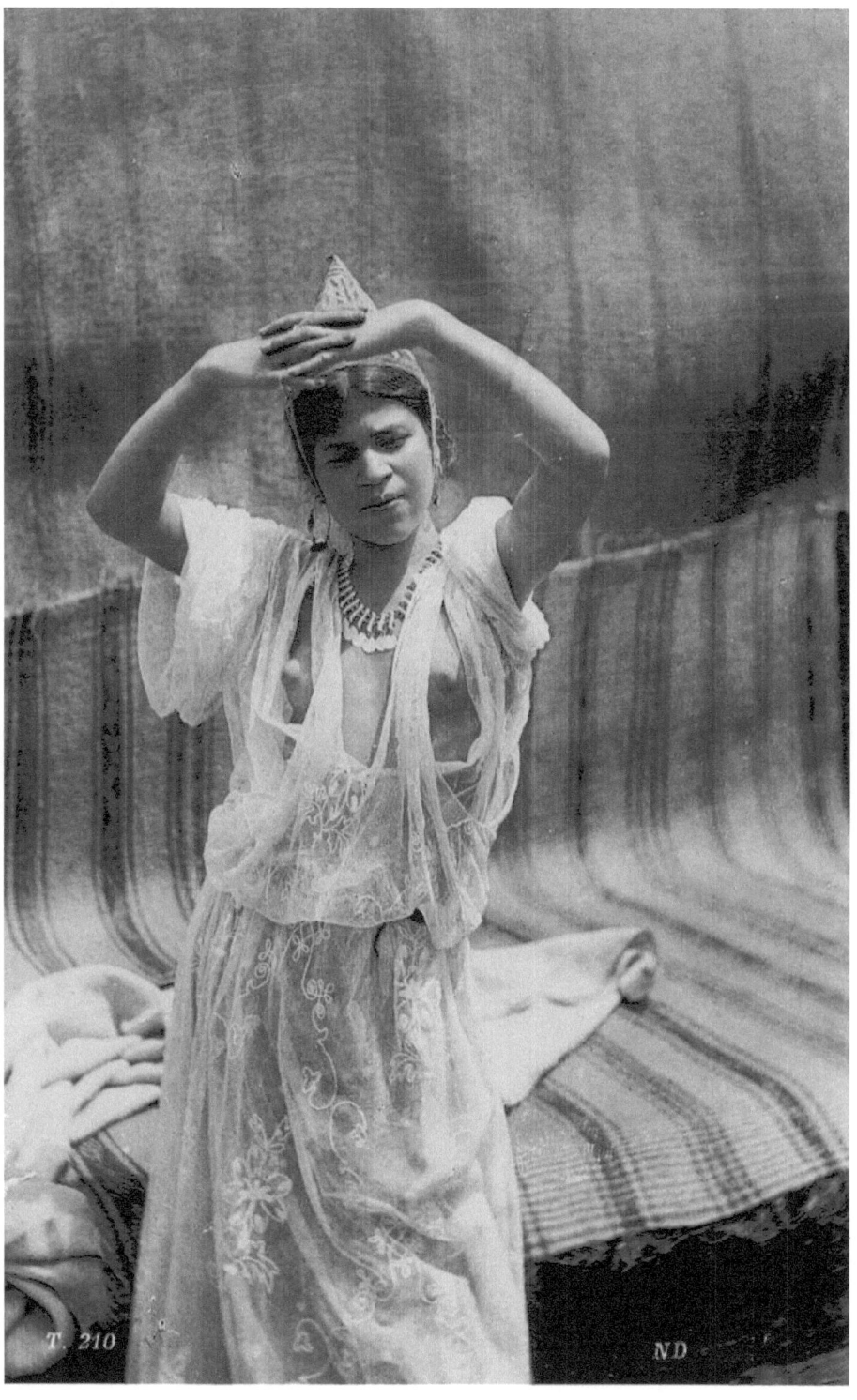

www.ingramcontent.com/pod-product-compliance
Lightning Source LLC
Chambersburg PA
CBHW030754180526
45163CB00003B/1015